COAL MINING IN
LANCASHIRE
& CHESHIRE

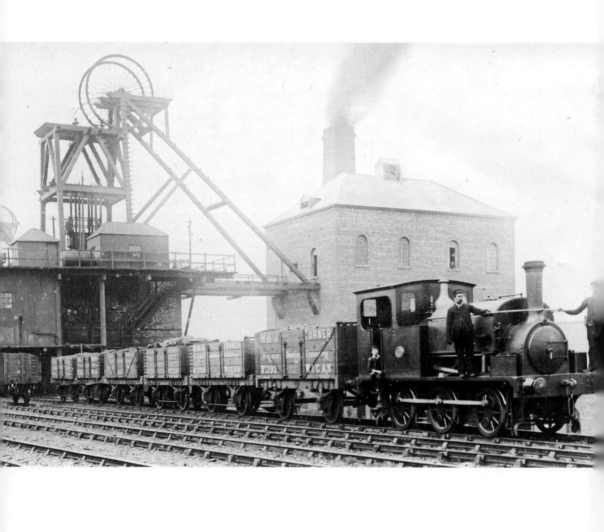

COAL MINING IN LANCASHIRE & CHESHIRE

ALAN DAVIES

AMBERLEY

Front cover (top): A fine view of Wigan Junction Colliery No. 4 Pit *c.* 1900 from the south-west. On the raised pit bank are the two pit tub checkweigh cabins, one for the union man and one for the company. The loco is probably the 0-6-0ST internal cylinder saddle tank *Junction*, purchased new in 1891 from the Hunslet Engine Company of Leeds, scrapped around 1906.

Front cover (bottom): Author Alan Davies in old workings at Hilltop Colliery, Bacup, in 2009. Ochre sludge oozes into the roadway, supported by wooden pit props and bars. (Stewart Parr)

Back cover: The Revd William Wickham at St Andrews church, off Woodhouse Lane, Wigan, was a keen amateur photographer. During the sixteen-week-long 1893 miners' strike, he provided a soup kitchen for his suffering parishioners.

First published 2010

Amberley Publishing Plc
Cirencester Road, Chalford,
Stroud, Gloucestershire, GL6 8PE

www.amberley-books.com

Copyright © Alan Davies 2010

The right of Alan Davies to be identified as the Author
of this work has been asserted in accordance with the
Copyrights, Designs and Patents Act 1988.

All rights reserved. No part of this book may be reprinted
or reproduced or utilised in any form or by any electronic,
mechanical or other means, now known or hereafter invented, including
photocopying and recording, or in any information storage or retrieval system,
without the permission in writing from the Publishers.

British Library Cataloguing in Publication Data.
A catalogue record for this book is available from the British Library.

ISBN 978 1 84868 488 1

Typeset in 10pt on 12pt Sabon.
Typesetting and Origination by Amberley Publishing.
Printed in the UK.

Contents

Preface	7
Acknowledgements	9
The Lancashire and Cheshire Coalfield, Historical Background and Geology	11
The Collieries	
St Helens and Haydock	39
The Central Area and Wigan	62
Bolton, Bury & Radcliffe	108
Salford & The Underground Canals	125
The Burnley Area	147
Around Oldham	168
Manchester, East Lancashire & Cheshire	174
Opencast Mining	193
Mines Rescue	206
Appendix: Mining Deaths, Accidents and Disasters in the Coalfield	217
Bibliography of Consulted Works and Other Sources	222

Preface

To attempt to cover in depth all aspects of former coal production in the Lancashire Coalfield and the Cheshire extension is of course impossible in one volume; the archive record is enormous as is the photographic record. This is primarily an illustrative compilation for the general reader and certainly not meant to cater for the academic reader with more references than text.

Virtually all the important early references to mining activity in Lancashire and Cheshire quoted in the introduction can now be found on the internet. The massive digitisation projects ongoing worldwide have made previously un-indexed and rare volumes or obscure transactions of learned societies accessible and searchable. The researcher does not now have to travel to specialist reference libraries or have advanced knowledge of the existence of rare publications (no doubt making the work of 'academics' much easier). Large amounts of primary archive sources related to the Lancashire coal industry still await consultation, transcription and possible digitisation and many areas of potential study exist. The large deposits from estates are often a good source for early documentation of the industry, as these estates often kept virtually every document they produced and received.

Enough illustrations, in a variety of media comprising drawings, watercolours, oil paintings, etchings, and engravings, have survived to fill many similar volumes. Here, a large selection has been made of photographic images with the importance of their content in mind. If only one image survives of a colliery and that image is very poor then I feel it should be included. However much archive information survives relating to a colliery, for me the photographic image always adds much needed meat to the bone. Every coal mine was totally different in layout and technical or architectural surprises are always to be found. Some collieries operated well over a century and that was reflected in their range of surface features.

That this ancient industry sadly only recently came to an end (for the time being) in the Lancashire area due to incomprehensibly inept political decision-making makes the photographic record of vital importance for future generations. A small number of collieries in Cheshire (for which photographs are very rare anyway) are included, as they worked the same continuous coalfield as those just 'over the border'.

Wigan colliery owner, manager, surveyor and mining historian Donald Anderson's *Mines & Miners of South Lancashire* of 1980 was the first compilation of its kind for the coalfield and very expensive to produce due to the use of so many images. Technology has moved on, allowing much larger numbers of images to be included at no great additional expense. This selection of images has been drawn from a number

of very large private collections including most importantly that of the late Donald Anderson, Jack Lane and Tony France. Images taken very recently are also included as a result of mine exploration, opencast mining and aerial study. Certain public archives in the North West hold images that I would have really liked to include but their insistence on prohibitive charges for their use in publications has meant those images will not feature – a sign of the times sadly.

<div style="text-align: right;">
Alan Davies

Tyldesley

Lancashire

July 2010
</div>

Acknowledgements

In the past, Donald Anderson (1912-2003), mine owner, colliery manager, colliery surveyor and mining historian, inspired me (and many others) in my enthusiasm for mining history. Former longstanding colleague of Donald's, Tony France, consultant geologist and surveyor, continues to advise me and supply me with all manner of historical resources. Steve Unsworth for scanning my transparencies and negatives, a soul-destroying task. The section of the Burtonhead Estate Plan showing bell pits is reproduced by kind permission of the Scarisbrick Estate Trusts and is held in the Lancashire Record Office, Preston, reference plan DD Sc 32/1. Dave Kitching for access to his large database of industrial historical information and his Poynton and Whaley Bridge photographs. Jack Nadin for Burnley area photographs and information, Jimmy and Billy Clayton at Hilltop Colliery, Bacup, Mark Wright. Dennis Sweeney for railway and locomotive information. Stuart Oliver at The Coal Authority. Les Hampson's mines rescue experience and knowledge. Stewart Parr for his recent colour photographs. Alastair Macmillan, my old mining lecturer, for his enthusiastic and inspired teaching. Finally, Helen Sinclair for allowing me to turn the house upside down for months as I researched the book, and for doubting me that anyone would ever want to read such a book, which inspired me even more!

The Lancashire and Cheshire Coalfield, Historical Background and Geology

Putting things into general perspective, coal as a fuel was probably known to the ancient Greeks. Theophrastus, a Greek philosopher around 350 BC, wrote as follows:

> These fossil substances that are called coals and are broken for use are earthy. They kindle, however, and burn like wood coals. These are found in Liguria and in Elis, and are utilised by smiths.

Even though coal lay all around in most parts of Britain, turf or peat was in abundance and preferred. The large mosslands at Astley, near Tyldesley, for example, with their flat deposits, were easily worked and those digging could return to their own land and retain it for farming rather than potentially damage it by coal extraction. Coal seams very rarely lie totally flat, especially in Lancashire so, after the initial outcropping of coal exposures, to have to drive tunnels into the ground was not regarded as worthwhile for hundreds of years. In the very early days, it was even thought that coal seams only lay near the surface and did not extend beyond shallow depths.

Peat may have been preferred in the days before chimneys due to the less noxious fumes and the ease of burning; peat also smouldered on for long periods without attention. Until the end of the seventeenth century, the general superstition was that peat, once dug, grew back, although the lack of visual evidence does not seem to have put an end to this! Coal, if used pre-twelfth century, would most likely have found favour in the burning of lime for mortar and fertilising.

The Romans, during their occupation of Britain, appear to have established several military stations close to the outcrop of coal seams, although that does not necessarily mean that is why they established them there. Coal remains and cinders have been found at many sites, Castlefield, Manchester, for example. In other areas, actual evidence for working and mining tools found nearby have been shown to belong to the Roman period.

Geologist Edward Hull, in his *Coalfields of Great Britain* of 1861, recalled an encounter with supposed 'Roman' workings. Driving a tunnel in the 1850s at Arley, north-west of Wigan, to divert the course of the River Douglas, the Arley seam was encountered and found to have been worked in a manner never seen before. This consisted of a series of polygonal chambers interlinked by short passages. Certainly, definite Roman workings with polygonal chambers have been found elsewhere in Europe in metalliferous mines. Sadly, a detailed account was not made at the time of this discovery either in publications of learned societies or the press.

Records have not survived indicating that coal was used to any extent in Great Britain from the time of the Roman occupation until the ninth century. Around AD 852, the Abbot of Peterborough let certain land on condition twelve loads of coal were sent each year to the monastery.

The Thirteenth Century and Lancashire's Earliest Record

Avoiding earlier references to the use of 'cole', when almost certainly charcoal was meant, the earliest mention of the use of coal and hence its being mined nearby in Lancashire is one of 1295. In the rent roll of Henry de Lacy, Earl of Lincoln, amongst receipts for Trochdene (Trawden near Colne) is one for ten shillings worth of '*carbonibus marinis*'. This translates as sea coal, the old term for coal due to the early seaborne coal trade between the North East and London. Coal was also bought at Clivacher (Cliviger) where incidentally drift mining only very recently ended.

Into the Fourteenth Century

On 5 July 1310, Edward II granted to William le Boteler of Warrington and Robert le Norays the right to set tolls to raise funds for bridge repairs at Warrington and Sankey. The comparison between the various fuels carried over the bridges is interesting and gives an idea of their status; for every cartload of coal a halfpenny was levied, for every thousand turves a farthing was charged and for every cartload of wood a halfpenny was charged. The coal probably came from St Helens or Wigan.

Around this period, many local charters mention '*minera carbonum*' or mines of coal. An Assignment of Dower made at Warrington in 1330 mentions *minera carbonum* exisiting at Burnhill, near Ashton-in-Makerfield, Wigan. In one of the Standish (near Wigan) deeds of 1350, the right to any *'Fyrston'* (fire stone) and *'Secole'* (sea coal) found on site is reserved. *Fyrston* may be *freestone* or general rock as found in local quarries; another possibility is fireclay, refractory in nature and hence useful for lining kilns, hearths and smithing furnaces.

The rent roll of Bolton Abbey actually mentions a coal mine existing at Colne in 1370. Digging of 'sea coal' at Bolton (north-east of Leigh and Atherton) is mentioned in 1374. In 1376, the Sheriff of Lancashire takes note that Sir Jeffrey Massey, Lord of Worsley, made a profit in Worsley 'for digging and selling sea coals worth six shillings and eight pence per year'.

The Fifteenth Century, Little Change

An intriguing entry on a document of 1428 from the Worsley estate archives (but unrecorded as to its identity) mentions that 'three tenants paid 6s.8d each for the coal mole'. One of the tenants is named as John the Colier. Could this be a payment to a miner who would go into the workings and extract coal on demand, the 'coal mole'?!

At Tyldesley, one landowning family was for generations notoriously aggressive, the Shakerleys. In 1429, a legal dispute arose between landowner Hugh Tyldesley and the Shakerleys, who, it was claimed, had unlawfully taken sea coal from his land.

In 1472, in a rent roll of Edward IV, the rent of a mine of sea coals for one year in Padiham near Burnley for 20s and in Colne and Trawden at 6s 8d is mentioned. In

Latin, the document is in itself fascinating in terms of word origins, whether you can read it or not!

> *De firma minere carbonum maritimorum in Padyham ct Brodehede in villa de Penhull sic dim' Rog' Cockshote ct sociis suis per annum xx$^{s.}$* [20s] *Et de firma carb. Marit. In Colne & Trawden sic dim' Laur' Lyster ad terminum annorum vjs viid.* [6s 8d].

Into the Sixteeth Century

A manuscript of 1510 relating to repairs to Walton Church includes the following mention of coal usage: 'Item, paide for viij [8] lode of colis ijs.,[2s]'. This equates to 'Item, paid for 8 loads of coal 2 shillings'. The coal was probably carted from Prescot, eight miles away. Walton must have been fairly dependent on coal being in an area devoid of extensive woodland and peat bogs.

In 1521, Lord Derby is recorded granting a lease of coal mines in Whiston. In the rent roll of Whalley Abbey for 1521 occurs the entry *'pro carbonibus marinis* [for sea coal], *0.0.0'*. This tells us that coal was known of and had been previously bought but not during this year. In the record of the division and enclosure of Padiham (near Burnley) town fields of 1529 a coal mine is actually mentioned.

Moving away from the Burnley and Colne area to Leigh in the south, we find, in 1534, Davyd Pennyngton in action against Squier John Urmeston:

> for digging and taking Turves and Coles in Westley [Westleigh] in the Countie of Lanc. As also for c'ten wayes and gates for carriage of Turves Coles Corne and oy' necessar's thorough a Close in Westley called ye Psons p'ke …

Pennington and others won right of access and the right of use of the paths in question. A year later, the matter was in court again, the parson this time successfully opposing the extraction of turves and coles from his lands altogether.

A fascinating glimpse back to the time of the exhaustion of the forests came in 1527 when James Roberts aged seventy-nine of Burnley stated in a lawsuit that no one had

> any need in time past to get coals for their fuel, by reason they had plenty of wood from the forests and turves [peat] at their liberty, which now be decayed and restrained from them.

In 1536, an award was made securing the common lands in Hindley and Aspull near Wigan where 'within late years coal has been found within the said waste and all tenants of Hindley shall henceforth have coal for fuel within their tenements …'

Haigh Cannel 1540

In John Leland's *Itinerary* of 1540, we find the classic description of the famous Haigh Cannel coal being mined and its value:

> Mr Bradeshau [Bradshaigh] hath a place caullid Hawe [Haigh] a myle from Wigan. He hath founde moche Canel like Se Cole in his grounde very profitable to hym. The great Myne of Canale [Cannel or Parrot coal] is at Hawe two Miles from Wigan. One Bradshaw dwellith at Hawe.

Leland also mentions, 'They burne at Bolton sum Canale but more Se [Sea] Coal of the wich the Pittes be not far of. They burne Turfe [peat] also.'

So, around 1540, mines close to Bolton were accessing both Cannel and Bituminous coal, also taking peat turfs. This might well be the mines on the land belonging to the ancient Smithills Hall. This is only a few hundred yards from the peat moors at Winter Hill and possesses thin coal seams of the lower coal measures on its land. Records for this house and associated land begin in 1335; the building is probably far older.

That coal mining was taking place within the ancient Hulton Park, north of Atherton, owned by the Hultons for centuries (Madoc Hulton had come to Bolton from Wales in 1167) is seen in an award of 1556 to Elizabeth Hulton ensuring that she received coal for the rest of her natural life after the recent death of her husband. The miners who were to ensure this coal was produced are named:

> Eddard Chetam [Edward Cheetham], Thoms Worthyngton [Thomas Worthington], Oiliuer Cromton [Oliver Crompton], Adam Pendulbere the elder [Adam Pendlebury the elder], Thoms Meloner [Thomas Milner] and Roger Turnor [Roger Turner].

Whiston, Merseyside, resident Richard Halsall's will of 1557 included the bequeathing to his son of 'all my tacke of the delfe of coales'. Tacke relates to 'take', a term which was still in use in coal mining well into the twentieth century, an area of coal for which permission or a lease had been granted for mining to take place. Delfe relates to a delph or bay of coal, the term also being used in quarries; the term was to be attached to coal seam names in the area and also around St Helens, examples being Flaggy Delph, Potato Delph and London Delph. At this time, miners still thought coal was found in isolated bays or pockets rather than (apart from faults) being present over large areas.

Among the effects of Thomas Leyland, Esq., of Morleys Hall Tyldesley (surviving today, adjacent to the East Lancashire Road, A580 near Astley) in a will of 1562 were:

> Item one cage wth cole and canell vs vjd. Item iij
> Hundredthe loode off turves xls.

Cannel was a dense coal formed from settled and compressed lake sediments and not found in all coal districts. High in gas content and highly prized due to its clean burning and low ash qualities. Occasionally, thin slivers of cannel were stuck in a lump of clay and burned like candles.

At this period, collieries around St Helens, Prescot and Whiston were exporting coal to Ireland. Coal shipments from Liverpool averaged about 500 tons a year between 1565 and 1599 (rising to 1,200 tons between 1611 and 1621, and to more than 4,000 before the Civil War).

In Greenfield, east of Oldham, in 1568, from *The spending of the money of Robert Newell*, the following entries are included which show how coal size, great coal and small coal brought varying prices:

> Great coole iij [3] Loode vi (6) Sackes - - lijs [3 shillings]
> Smale [small] coale x [10] sackes -- iijs iiijd [3s 4d]

On 15 June 1568, Rychard Jones, Rector of Bury, is seen to have relied on all three common fuels. By his will he bequeathed 'all the turves woodde and coolles that he shall happen to haue at the tyme of his decease'.

Competition Arrives

The increasing value and demand for coal can be seen in a dispute of 1572 where the winding rope at Anne Towneley's mine in Great Marsden, Nelson, north of Burnley, had been cut, and the turn [windlass], together with an assortment of stone, coal and timber had been thrown into the pit by rival miners working nearby.

In 18 Elizabeth (1575-76) Edward Fleetwood, clerk, parson of Wigan, filed a bill in the Duchy Court complaining that some local men had virtually commandeered pits at Scholes (very close to the town centre) for their own use. Some believe Scholes to be a corruption of sea coals, an area rich in coal.

> Charles Banke, Robert Asteley, Raffe Fayrebrother and Reynold Maudesley since Michaelmas last past had entered into one parcel of waste ground known by the name of Whelley Lane containing twelve acres and lying on the East part of a parcel of the said manor called the Scoles, with force and wronge, and thereof have by lyke force and wronge disseised and expulsed your seid Orator and [deprived him] of the profittes, thereof in digginge coale pyttes and taking coales out of the same to a great value ... and had appropriated the same to their own use.

Coal had been mined in Wigan from at least the mid-fourteenth century. The Rectors of Wigan were, from early days, well aware of the coal riches beneath their township and the lucrative income possible. Many individuals in Wigan had illegal shafts in their backyards, entering into the workings when coal was needed. The Rector claimed (as Lord of the Manor) all coal under roads, because roads (as in Whelley Lane) were deemed part of the lord's waste.

The antiquity of coal mining in Lancashire remarked upon as far back as the sixteenth century can be seen in 1580 when Edmund Robinson of Old Laund in Pendle stated that his ancestors had dug for coal 'time out of mind'.

Aspects of coal mining in Prescot, Merseyside, in 1592, appear in documents relating to the activities of three prominent townsmen whose offences included:

> Mr Thomas Meade, his servants and workmen, for falling [felling] of trees in Prescott woode to cover cole pitts.

> Mr Philip Layton, his colliers, for fallinge of trees in Prescotte woode for timberinge of cole pitts, propps and stakes.

The lease of a farm at Little Hulton in 1595 included a phrase which gives a fascinating insight into the understandable geological suppositions related to coal formation of the time. The lease reserved the lessor the right

> to come with horses, carts, carriages and workmen to dig and carry away all such coals as shall be found growing within or upon the lands to be leased.

More and more people were becoming aware of the location of and value of coal, at times ignoring land ownership. George Hulton of Hulton Hall, north of Atherton, complained in 1598 that certain persons were intruding on his lands in Farnworth and Kearsley and digging coal pits there.

The Seventeenth Century

A colliery was being sunk in 1600 within central Wigan on Ralph Worsley's land. The account of the operation survives, including entries for the celebration at reaching coal:

> for drincke and breade at the fyndinge of the coale 12d, three mens wages, two days and a half, 3s 2d, to John Smethurst for a prop, 3d, for three pounds of candles 1s 2d, for a rope for the coale pitte 3s 6d.

Some landowners decided to set up inactive leases of coal beneath their land purely to avoid damage from others working beneath it. In 1604, John Hartley of Great Marsden, a copyholder (the predecessor of modern-day freeholding) offered to buy a lease for the coal beneath his land for twenty-one years at 2s 6d per year

> to stay the spoilage of their lands which would happen if strangers got a lease thereof and make many holes searching for and getting coal, rather than for the benefit which they were likely to get.

Also in this year, miners from Great and Little Marsden, Nelson, north of Burnley, were brought together to inquire as to the possible profits mining there would bring to the King. They refused to make an assessment

> because oftentimes suchlike mines do lie uncertain in the grounds and can very hardly be gotten by reason of great quarrels of stone [faults] or abundance of water, which are very chargeable to dig through, and perhaps not possible at all to be gotten through with any reasonable charges.

Randle Barton died at Smithills, north of Bolton, on 10 December 1611. By an indenture of 1607 he settled

> the capital messuage called Smithills, the lands, meadows, &c., in Heaton, Halliwell, and Sharples, known as the demesne lands of Smithills, the water-mill in Halliwell called Smithills mill, and all pools, waters, water-courses, multure, toll, and suit thereto belonging; certain messuages and lands in Halliwell and Horwich, the coalmines found or to be found in the said tenements, &c., to the use of himself and Elizabeth his wife for life, for jointure of Elizabeth, and then to the use of Thomas Barton for life and heirs male.

William Hulton the younger, described as 'of Manchester, gentleman', died on 6 September 1613, holding Harpurhey and other lands near Manchester, Hulton, Farnworth, Heaton, and Wigan. In 1610, he engaged that before Whitsuntide 1612 he would provide for his wife Katherine, daughter of Robert Hyde of Norbury in Cheshire, mention being made of 'mines of coal and cannel' on his land.

A Prescot, Merseyside, inquest from January 1617 indicated the dangers of walking home in the dark in mining areas:

> ... the said Lawrence Harrison, the seaventh day of this instant January 1617, att Prescott afforesayd, in a certayne wood called Prescott wood, about viij [8] of the clock in the afternoone, beinge in the night tyme, going on his way, by misfortune and against his well fell into a pytt there, called a cole pytt, and there, by misfortune and against his will, was drowned.

Coal mining in the early seventeenth century was always speculative due to lack of geological knowledge. The use of prospecting iron bore rods had arrived around 1618, although only a few valuable sets were in existence, apart from the lack of knowledge of their use and interpretation of findings. Investors in coal mining usually sank a number of shafts and hoped that coal was accessed. In the first twenty years of the seventeenth century, Lawrence Towneley sank eight pits in Great Marsden. Coal was worked from four of these pits, but none at all from the other four.

Coalopolis

In central Wigan, in the early seventeenth century, many individuals were by now probing into the ground for coal. In Millgate in 1619, Peter Plat felt it best to get permission to drain his mine (in today's town centre near the top of and west of Millgate) into the River Douglas. Lord of the Manor Bishop Bridgeman's ledger records:

> On November 2nd, 1619, William Ormshaw, alias Ashcroft, and Robert Jolly, the two bailiffs of the town [of Wigan], with Roger Bullock, a burgess of Wigan, came to the hall at the entreaty of Peter Plat, of Wigan, chandler, and desired the bishop to give the same Plat leave to continue a gutter or passage on to the lord's waste, which is the street of Milgate, to conduct the water from a coalpit which he had digged in his own ground near to Milgate, and which is now full of water, so that he cannot work it. He promised to content the bishop for such license in whatever fashion he should demand and he only asked this liberty for a month that he might try what benefit he could make of that pit, and afterwards he will pay the bishop either in money or in coals what he [the bishop] shall think reasonable so long as his said coalpit lasts.

A few months later, his widow, Anne Plat, requested to continue this privilege, so that the water might run down the side of the street to the river (about 150 yards away) and agreed with the bishop to pay a rent of 52 shillings,

> 12d. a week, and fifty loads of coals, and to pave [cover the channel with flagstones] the way all along, so that the water from the pit should not hurt the said highway of Milgate.

The slow rate of extraction of the coal around Millgate can be seen nearly three years later:

> July 25th 1621, Roger Bullock and Oliver Plat came to the bishop at Chester and asked leave to dig a pit near the midst of the street called Millgate at Wigan, adjacent to the river, whereby they might make use of the coalpit before mentioned [the 1619 entry], which is higher up in that street, and which is filled with water and useless, offering to pay him 12d. and a load of coals weekly so long as they should get coals from the higher pit or elsewhere near the old coalmine. This he gave them permission to do, but only for the purpose of drawing water from the said pit; and they bound themselves to fill up the said pit whenever they should leave off digging and sufficiently to amend the highways, so that no annoyance or danger should come to anybody there.

Plat's workings are probably the six- to seven-feet-high pillar and stall roadways in the Wigan Six Feet seam, uncovered in 1960 when the public baths in Library Street were being constructed. At the time of writing, November 2009 to July 2010, the

baths are being demolished, a new one being built. A shallow filled shaft has been found on the eastern edge of the site and an ancient, filled mine shaft has been found higher up Millgate.

Near St Helens, soon to become a major coal producer in the Lancashire coalfield, the local squire seems to have been aggressively sending his men out digging for coal to the annoyance of freeholders:

> At Easter, 18 James 1, [1621] Richard Roughley, Thomas Worsley, Robert Sutton, John Wood, William Sutton, John Sutton, Peter Kenyon, William Naylor, and all other freeholders of Sutton, near St Helens, claimed against Richard Bold, Esq., common of pasture upon the wastes of Sutton, and alleged that Squire Bold and his uncle of the same name pretended to be lords of the soil, and caused enclosures to be made which hindered their common, the residue of the wastes not being sufficient; and they further alleged that Squire Bold continually made coalpits upon the wastes and got great store of coal to the prejudice of their common and great danger of their cattle. The record states that most of the enclosures were anciently made, some twenty, some forty, some sixty years ago, and some before any man's remembrance, and those which the defendants made did not exceed three acres; and that Squire Bold and his ancestors had usually got coals upon the wastes, which is a usual thing for Lords of wastes to do in that country; and that the plaintiffs had sixteen several times pulled down divers of the enclosures which this Court altogether mislike.

The court sanctioned the ancient enclosures, and authorised Squire Bold to dig and get coals in the wastes until the case was heard,

> he causing the pits and holes to be carefully looked to and filled up after the work is ended to prevent any danger to the plaintiffs' cattle.

On 9 September 1622, Squire Bold agreed with Richard Eltonhead and the other freeholders and charterers in Sutton to divide the wastes, and Thomas Wolfall and Richard Mollineux were appointed by the court to view and allot the same. Land was to be reserved for bowling!

> ... except the part called Peasley Crosse and all places on Markalls Moss where turves are to be got with the Langotts and ways thereunto belonging and the lanes and passages in Sutton and except the ground on Horston Heath whereon recreations for bowling have been and are used all which are to lie open.

Squire Bold was not to enclose the ways lanes, and passages, nor make any coalpits for getting 'coals or other pits upon the ways, nor dig under them'.

On 20 October 1625, Edmund Taylor Senior and Junior of Horsedge, Oldham, demised to John Leaver of Manchester, gent, property at Horsedge, including

> all coal pitts mynes of coal already found digged or opened or to be &c. and Liberty to cutt down Tymber for making and upholding the Coal pitts.

Skilled Men in Demand

In February 1636-37, Bishop Bridgeman entered into a one-year contract with some Wigan colliers to work his pits of coal and cannel at Farnworth. This shows that experienced colliers were in short supply and that the skilled Wigan miners were

highly regarded. The conditions were difficult and the men hoped for an advance (a practice which would be made illegal later). It seems they virtually had nothing to enable them to work the pits with:

> Apud [at] Lever ffebruary the thirteenth AP 1636. It is agreed between John Lord Bp of Chester and Hugh Bradley of Aspull, Humfrey Gregson, Robt Burges, and Robt Harp of Wigan colers who do all and every of thern covenant wth the said Lod Bp to digg in his pitts at ffarneworth cole and cannell all this yeare ensuing beginning on St. Matthias Eve next and ending that day twele moneth. And they are to have for every quarter of cole or cannell wch they dig and gett upp eight pennce a quarter and nothing more either for candles ffireing tooles [stone hammers and iron rods for making shot holes] gratuities or anie other thing or payment. Only because the worke is now hard and troublesome in one of the pitts wherein they are presently to worke they hope his Lop [Lordship] will give them somewhat of his free giufte for these three next weekes but they will stand to his curtesie therein and do covenant wth him to worke as afforesd for eight pennce each quarter and no more for these twelfe monthes next ensueing. And they covenant wth him to worke the worke substantially fairly justly and honestly as may bee best for the safetie and upholding of the Mines and most for the p'fitt of the sd lod Bp and his assignees.
>
> In witnesse whereof they have hereunto set their hands
>
> Jo Cestrien
> Hugonis Bradley
> Humfrey Gregson
> Robt Burgess
> Robt Harp
>
> Md in part of payment they have receaved each one half a crowne in toto 10s. The Lod Bp doth p'mise to build them up a Hovell this sumr and they p'mise to bring their bellowes and sharpen their owne tooles; The Lod Bp also p'mised to find them baskets and ropes but nothing els and they to fynd Drawrs [people to drag the coal from the face to the shaft] and all other thinges.
>
> In p'sence of Law. Booth
> Tho. Wasse
> Deodatus. Paulett
> Richardi. Booth

By a codicil (an instruction which is added to a will) dated 29 March 1639, Dame Dorothy Legh, of Worsley, widow, gave

> unto the workemen in or at the coalepitts and cannell pitts in Middle Hulton every one tenne shillings a peece.

In her inventory, dated 15 April 1639, appear the following items giving an insight into the equipment on site at a small windlass wound colliery:

> Item fewell [fuel] at Worsley vijll [£7] Item coales cannell and basse upon the banke at Hulton cvjll iijs ijd [£56 3s 2d] Item two stithes [timber coal staithes or stagings for screening and loading the coal], two payre of bellowes, windles [windlass] ropes, chaines, arks [coal containers with runners beneath dragged along by drawers], timber, and other things there vll xiijs viijd [£5 13s 8d].

An estimate has been made that, in the early years of the seventeenth century, around forty-three of the 774 'gentry families' in Lancashire had coal-mining interests.

Only a small number though used coal mining as the major income source. Thomas Charnock, of Astley, had a very profitable colliery at Bradford near Manchester, valued at £150 in 1662.

The Heavy Toll Begins to be Recorded

Records start to appear in parish registers in the seventeenth century of individuals being killed by falls of coal at the coalface, explosions, suffocation or even by falling down shafts. Wigan All Saints Church of England first mentions a female mining death by the burial on 4 October 1641 of Elizabeth Higenson 'of the Woodhouses killed in a cole pit'.

Richard Barron of Standishgate also died in the same accident, so it is probable that Elizabeth was loading and dragging away baskets of coal for Richard when either an ignition of methane gas took place at the coalface or a roof fall occurred.

Landowner John Grimshaw, whose estates included land in Clayton, Eccleshill, Burnley, Yatebank and Preston, was fined and had much of his property sequestrated for recusancy (not complying with and conforming to the established church, the Church of England) during the period of the Commonwealth. A petition of Nicholas Assheton, dated 21 January 1650, includes the following indication that his collieries had been neglected during the Civil War and would need substantial repairs:

> In which sayd sequestered lands there are certaine collieries of good value which for want of repayrs are almost utterly lost, the sayd premises consisting much of coalmines and the same will require at least L500 [£500] to put them in good repayre and made useful for the Commonwealth ...

Picton's *Memorials of Liverpool*, Vol. 1, 1873, states that, in 1667, the coal from the collieries at Whiston, near Prescot, and the rude pottery (basic household 'black ware') made at the latter place constituted an important part of the exports from Liverpool, and a town's order was issued to lessen the damage by reducing the loads carried,

> as the streets are much decayed and abused by the frequent driving of carts laden with coals and mugs to the waterside through the same instead of over the pool bridge or the Water Street end ...

Major Investment and Planned Mining

Around this period, the expansion of uncontrolled working and often the lack of accurate surveys led to encroachments into neighbouring workings – lawsuits following. Expensive drainage 'soughs' began to be driven, extending the life of mines and allowing access to new areas of coal without the financial burden of winding water.

Sir Roger Bradshaigh, at Haigh, Wigan, conceived the idea of driving a drainage tunnel through the coal measures, from the northern higher level of his estate to the River Douglas, or more precisely into a little brook feeding it, known today as Yellow Brook.

It was commenced in or about 1652 when Bradshaigh was twenty-five, and completed in 1670 after seventeen years' continuous work. Called the Great Sough, it was more than two-thirds of a mile in length, at times 6 feet wide by 4 feet high. It was ventilated by ten shafts, 9 feet in diameter, the deepest being 49 yards, these shafts

originally used for removing the rock from the tunnel. The rock removed must have been made use of, as very little can be seen around the shaft tops today.

At this time, practically nothing was known of the geological stratification and faulting, no underground surveys of old workings existed, and there were no accurate maps even of the surface. A surveyor and his assistant would walk the fields on the surface and 'range' the route of the sough, avoiding any intervening landowners' property (probably not a problem within the large Haigh estate). The resulting survey formed the basis of the line set for the miners driving the sough.

Bradshaigh left a record of the work in his own handwriting in one of the most important British coal-mining records to have survived, the *Haigh Colliery Orders, 1635-1690*, held at Wigan Archives, Leigh. It consists of seventy-four leaves of paper bound in a piece of vellum that was originally part of a fifteenth-century missal. The entries are made from both ends, forty-five leaves in the middle blank. In addition to the account of the Great Sough, it contains the 'Orders' drawn up by Sir Roger's grandfather in 1636 for the safer working of the coal; revised Orders drawn up by Peter Shakerley in 1687, then guardian to the third baronet; and many records of fines imposed on the miners for transgressions against the Orders.

Also included are many signed contracts between the workmen and the proprietors covering the whole period. Often the men signed in the form of a cross or other mark. To see the marks made by the actual miners themselves is indeed exciting. The volume begins,

> An Account of the condition of the Great Sough from the Brooke neare Bottling Wood to the Maine Delph of Cannell, being in all 7 score Roods and one yard, at eight yds to the Rood, and for the soughing wch theare hath been 10 Pitts suncken; one with another being 3 yds wide; and the depth one with another coming to 300 yards, and two foote, wch I have sunk, besyde the charge of Timber, workmanship, & setting & alsoe boaring, winding the water, maintaining the workmens Tooles, workmanship & setting Timber in many parts of the sough as by al ... all shall apeare. With observations wheare the dangerous faults in the sough and Pitts are wch ought to be lookit into once a quarter at least; alsoe observations for (my posterity) what ... ted Cannell Delfes there are (never before discovered) and what Cannell may be gott in ould Pitts and places laid drye by virtue of the great and chargeable Sough (after above 17 yeares Labor, Charge, and Patience) by the blessing of God finisht, for the good of my Posterity.
>
> By me
> Roger Bradshaghe
> 8 Oct. 1670 Aetate sua [his age] 42

The sough was still draining active mines in 1929. Bright orange ochreous water (ochre is hydrated iron oxide) until very recently still emerged from it into Bottling Brook, the section known as Yellow Brook. A treatment system recently installed has diverted the outflow so as not to be visible to visitors to the country park. Surely we should be preserving such features rather than hiding them?

Moving right across to the outskirts of Manchester we find in 1671 the churchwardens of Prestwich 'Paid to Edw. Chatterton ffor a carte load of coles 00.02s.08d'.

Cannel coal was pretty much similar in quality wherever it was found although not being found in all coalfields so it is strange when, in 1673, R. Blome's *Britannia* states that 'Wigan is famous for the choicest coal in England, called cannell'.

Cannel had been mined within the Haigh estate probably from the mid-fourteenth century at least, so had become widely known before the coalfields in other areas were extensively developed. A visitor to Haigh Plantations (entered opposite Wigan

Infirmary) today can still find pieces of cannel once off the beaten track. Surface spoil was beginning to be noticed around this period as being an eyesore. On 5 October, 15 Charles II (1675), at Church Lawton, Cheshire, Stephen Smith was ordered to

> Remove his soyle in the head of his field called the Colepit field and set it in its right place where the soyle anciently stood.

Miners and their skills were much in demand. William Hulton of Hulton Park, north of Atherton, tied down his men with a bond of £40 'that they will well and truly serve for a year in the coal mines of Hulton and Denton'.

An early record of coal mining at Clifton, near Swinton, Salford, the mines of which were to become very extensive by the mid-eighteenth century, is on 13 February 1688, when an Exchequer Commission was issued in an action by James Butler against Thomas Gooden relative to 'colemines and cole pitts within the manor of Clifton'.

During the seventeenth century, wills proven at Chester begin to state occupations of the deceased as collier, coalminer, coal man:

 1639. Thomas Whalley, of Coal-pitts, in Blackburn.
 1663. John Boardman, of Middle Hulton, collier.
 1664. Josiah Clarke, of Windle, in Prescott, coalminer.
 1665. John Thropper, of Atherton, par. Leigh, collier.
 1671. Edmund Stott, of Lower Milne in Hundersfield, collier.
 1676. Robt. Grundy, of Clifton, coalminer.
 1687. Robert. Brearley, of Ogden, par. Rochdale, collier.
 1689. Rob. Harpur, of Kersley, collier.
 1689 Rob. Harpur of Macclesfield, collier.
 1690 Peter Martlu of Latham, collier.
 1692. Thomas Brighouse, of Lathom, collier.
 1692. Rich. Yate, of Farnworth, collier.
 1694. Nathl Sankey, of Altham, near Burnley, co. Lancaster, collier.
 1699. John Travis, of Pendleton, par. Eccles, coal man.

The celebrated traveller, Celia Fiennes, was born in 1662 at Newton Toney, Salisbury, the daughter of a colonel in Cromwell's army. She is today famous for the extensive journeys she made and the accounts she wrote of them. She rode through every county in England, accompanied by two servants. Although she lived in the south, in 1697 and 1698 she made two long journeys through northern England and Scotland. She called at Wigan, mentioning its famous cannel coal and how it was often offered to people in deception as black marble!

> Wigons is another pretty Market town built of stone and brick. : here it is that the fine Channell Coales are in perfection – burns as light as a Candle-set the Coales together wth some fire and it shall give a snap and burn up light. Of this Coale they make Saltcellars, Stand-dishes and many boxes and things wch are sent about for Curiositys and sold in London and are often offer'd in the Exchange in Company wth white or black marble and most people deceived by them wch have not been in those Countrys and know it, but such persons discover it and will Call for a Candle to trye them whether marble or Coale: its very finely pollish'd and Lookes much like jett or Ebany wood for wch one might Easily take it when in boxes &. &. I bought some of them for Curiosity sake.

The Science and Art of Mining

The curious notions prevailing at this time about coal, its nature of deposition, properties and distribution are very well seen in Dr Charles Leigh's *Natural History of Lancashire and Cheshire and the Peak in Derbyshire* (Oxford, 1700). He mentions the *'Kennel Pits'* at Haigh and the coal mines adjacent to Lathom and states,

> Coal and Kennel-Mines [cannel] are always found in strata shelving towards the center or as the miners call it Dipping, Insomuch that the same which in one part perhaps cannot be discovered under Twenty Fathoms is yet at the Rise of the mine frequently found near the surface of the ground. If the mines ly in any considerable strata, or as the workmen stile it, ly true, their usual dip is east or west, or, as they vulgarly word it, to the Twelve-a-clock or Four-a-clock sun.
>
> If the luxuriant springs of acidulae did not ly in this shelving posture the quantities of water would be too great for any engine to discharge. No specifick gravitation is observed; for coals, strata of marle, coal slats, (in all the mines I have seen), always ly promiscuously. From which it is evident that in their subsidence they were not determined to any specifick gravitation.

Into the Great Era of Expansion, the Eighteenth Century

In 1698, Captain Thomas Savery invented the first practical steam engine, a non-reciprocating type, but it was used solely for pumping water from mines. This was followed in 1711 by the Newcomen atmospheric engine which was used for the same purpose (and by 1763 adapted for winding coal or men). Between 1730 and 1735, Abraham Darby, after many attempts, was successful in the substitution of coke for charcoal in iron smelting, and from this time onwards, as wood became more scarce and the iron industry more prosperous, the demand for coal became greater. It is interesting to note that up to the time of Newcomen the deepest shaft in Great Britain was not more than 120 yards, and the greatest distance of the workings underground from a shaft seldom exceeded 200 yards. The introduction of the steam engine, however, for haulage, winding and pumping purposes provided facilities for laying out the workings on a scale before thought impossible.

Daniel Defoe travelled England between 1724 and 1727. In *A tour thro' the whole island of Great Britain, divided into circuits or journies*, he recalls his visit to Wigan and Haigh:

> In the neighbourhood of this town, that is to say, between Wiggan and Bolton, in the estate of Sir Roger Bradshaw [at Haigh], is found that kind of coal they call Canell or Candle Coal, which, tho' they are found here in great plenty, and are very cheap, are yet very singular; for there are none such to be seen in Britain, or perhaps in the world besides. They so soon take fire, that, by putting a lighted candle to them, they are presently in a flame, and yet hold fire as long as any coals whatever, and more or less, as they are placed in the grate or hearth, whether flat or edg'd, whether right up and down, and polar, or level and horizontal.
>
> They are smooth and slick when the pieces part from one another, and will polish like alabaster; then a lady may take them up in a cambrick handkerchief and they will not soil it, though they are as black as the deepest jet. They are the most pleasant agreeable fuel that can be found, but they are remote; and though some of them have been brought to London, yet they are so dear, by reason of the carriage, that few care to buy them; we saw some of them at Warrington too, but all from the same pits.

In the early years of the eighteenth century, the great transport drawback to the expansion of the Lancashire coal industry began to be remedied. Under an Act passed by George I (1720), the River Douglas was rendered navigable, affording a cheap outlet for the sought-after coal of Wigan. It was in 1720 also that the rivers Mersey and Irwell were made navigable up to Manchester.

The Duke of Bridgewater had long considered converting Worsley Brook into a canal from the Irwell to the large coalfield north of Worsley, and in 1737 (10 George II), an Act was passed to make Worsley Brook navigable from the Irwell to Worsley Mills, but the idea was abandoned.

An awareness that not only miners suffered in the process of coal production is instanced by the case of The Old Woolpack, Deansgate, Bolton, rebuilt in 1752, by Edmund Riley, of Turnotle, Rumworth, west of Bolton. It was renamed The Bay Stoned Horse after a favourite animal which became blind through overwork by turning a coal wince or winsey (horse gin) at Chequerbent, near Westhoughton.

The Canals Finally Arrive

Elsewhere in 1755 (28 George II), an Act was passed allowing construction of the Sankey Canal, St Helens, to provide the Haydock coalfield with a waterway. This must have revived ambitions at Worsley, as, four years later, the Duke of Bridgewater obtained another Act in 1759 to cut a canal between the same points as before, this time shelving the idea of canalising the brook. By 1760, the Duke had started driving the two entrance tunnels of the underground navigable canal system to intersect his coal mines, to become regarded as one of the wonders of the world.

With eventually four horizons of canals, an internal inclined plane and, by the 1960s, extending to over fifty miles of canals on four levels, the system deserves a massive study all of its own. Glen Atkinson's *The Canal Duke's Collieries (*Richardson 2nd ed. 1998), still in print after over twenty years, has so far been the only serious attempt. As with the Bradshaigh Sough at Wigan, those in positions of influence and power in local government yet lacking in creative foresight are just hoping somehow the underground canals will go away and be forgotten rather than ensuring at least partial access, ironically at the same time declaring the site as of worldwide importance!

On 26 July 1765, the Oldham surveyors paid Samuel Stansfield 0.1.5 (1s 5d) 'for leading 4 of sleck' and James Ingham 0.2.2 'for 4 load of sleck at 6qd per load' and on Aug 3 they paid James Greenwood 0.0.2 'for 2 Hors load of sleck'. The sleck or slack (coal with dirt bands or shaley coal) was possibly used in road mending or preparation. The use of pack horses is indicated.

On 2 June 1774, a serious accident is recorded at Alkrington near Middleton:

> A terrible accident happened at Alkrington coalpit by the works falling in owing to the negligence of one of the workmen by which three of the Poor Coaliers were terribly hurt, limbs and back broak and other ways sadly bruised so that their lives were dispared of, one of which was most dangerous was taken to the Infirmary.

With the advent of the steam engine, designed by Watt in 1784, and improved by him gradually, difficulties in winding and pumping which were formerly thought to be insuperable were to be successfully overcome. From this date, coal mining commenced to rank in importance as one of the greatest industries of the country.

Coal was now in great demand, landowners lucky to have coal beneath their lands leased mining ventures whilst taking large royalties. The more aggressive of them even ventured onto others' lands near to their own under the false pretence of having the ancient right to do so. William Hulton had ample reserves of coal within his Hulton estate, yet in 1787, it was recorded that

> William Hulton, esquire, of Hulton Park, claims the lordship of the waste of this township [Halshaw Moor, Farnworth near Bolton]; hath frequently exercised the right of driving the commoners and hath gotten coal under Halshaw moor; but he holds no court.

In 1787, the noted Dorning Rasbotham, Esq., of Birch House, Farnworth, wrote a description of Farnworth, in which he says,

> William Hulton, Esq., of Hulton Park, claimed the lordship of the waste of the township, and had gotten coal under Halshaw Moor. There are mines of coal and cannel. The only mines of coal now [1787] worked in the township are those of the Duke of Bridgewater [via branch levels of the underground canal system], held by him under lease from Sir Henry Bridgeman and other persons. The coal is found at various depths, and the strata of various thicknesses from half a yard and less to that of two yards. The dip is nearly to the one o'clock sun, and when they lie regularly their inclination is about one inch in six.

Mr Rasbotham also states that in Chowbent, part of Atherton,

> coal sells at 2 ½ d. per hundred, and is carted to the most distant parts of the township at 3 ½ d ... The coalmines have been long worked; in the deepest part they do not lie more than sixty yards from the surface, they are freed from water by pumps and are not liable to damps [gas].

On 20 April 1789, the first three boat-loads of coal from the underground canal-accessed mines at Worsley arrived at Bank Top, Manchester. In 1792, we read of mining expertise developing in Wigan, in Walker's *Tour from London to the Lakes*:

> That excellent coal called cannel is got under the town [of Wigan] and in its neighbourhood in great abundance. Besides making the most brilliant fire, this coal is capable of being turned into snuffboxes and many other useful and ornamental toys. Many families have a cannel pit in their back-yard and when they are in want of coals they send down a collier who will dig as many in a few hours as will serve the family many months. The pit is then shut up. Wigan has produced many excellent self taught mechanics. Dick Melling's bucket engine drained a valuable cannel mine for many years at a small expense. Indeed the machinery necessary in such extensive coalworks has called forth the genius and invention of many more mechanics that do honour to human abilities.

John Wilkinson, the famous ironmaster, erected some of the early steam engines in Lancashire, not of the atmospheric type but pirate versions of James Watt's separate condenser engine. In 1791, Peter Ewart, of Boulton & Watt, was in the neighbourhood of St Helens and saw a coal-winding engine of Wilkinson's make which he described as

having a 14 in. cylinder and a 3 feet stroke, worked double, with a rotative motion the same as those at the [Coalbrook] Dale, only the working gear was very different.

This is thought to have been the pirate engine built in 1790 for Nicholas Ashton's colliery near St Helens.

The by-now-famous Wigan miners were realising their importance and began to flex their arms as a strike is recorded for the first time in 1792. Some of the earliest organised groups of miners in the country were found around Wigan, their early meetings at sites such as the Old Ben Johnson Inn at Goose Green being held in secret. The Combination Acts were to be passed in 1799 suppressing workmen's associations and their requesting of advances from employers but miners carried on meeting in secret.

Geological knowledge was still not yet refined across the coalfield. Some years prior to 1795, thick seams of coal were accidentally discovered in Sir George Warren's lands at Poynton, Cheshire, during the sinking of a well for a tenant.

The demand for coal increased considerably from 1803 as coal gas commenced to be used for lighting purposes, and the gradual introduction of the blast furnace further increased coal requirements.

Expansion and Foreign Attention

The rapid expansion of the British coal industry, particularly in Lancashire, and the accompanying technological advances made quite an impact on foreign visitors. J. Dutens in his *Mémoires sur les travaux publics d'Angleterre* of 1819 stated,

> A vast plateau that belongs to the coal measures lies six miles north west of Manchester, Lancashire. This coal plateau spreads north-west towards Leigh and Wigan and to the north towards Chorley. It is not only outstanding by the abundance of fuel but also by the industry generated by some of the collieries opened there.'

Mr Dutens commented that 'it was the biggest and most important operation that has ever been formed in a country'.

The rapid increase in the numbers of miners along with men in all forms of industry led to the Combination Acts being repealed in 1824, employers by now realising they might have to allow their workforce some form of freedom to negotiate their terms of employment. In 1830, the South Lancashire miners formed the Friendly Society of Coal Mining at Bolton, but, a year later, pressure from employers led to it being disbanded. Bolton was later to be the home of the Lancashire and Cheshire Miners Federation and then, after 1 January 1945, the National Union of Mineworkers, Lancashire Area.

In 1831, the Truck Act was passed outlawing the practice particularly used at William Hulton's collieries at Over Hulton of payment in goods, or credit notes, which could only be redeemed at the employer's shop.

Evidence submitted by men, women and children mineworkers to The Children's Employment Commission of 1841-1842 exposed horrific working conditions and practices in the Lancashire coal mines. The Coal Mines Act of 1842 removed women and girls from the mines, and boys had to be older than ten years of age. It was though to be eight years before the first full-time Inspector of Mines assigned to the coalfield was in place: Joseph Dickinson, in November 1850.

The importance of coal mining as compared to other minerals in Lancashire by the mid-nineteenth century can be seen in the total annual value of real property in the county assessed in the year ending 5 April 1843. This amounted to £7,756,228, of which £4,777,536 was for houses, £1,636,416 for land, £39,728 for tithes, £593,515 for railways, £71,590 for canals, £348,007 for mines, chiefly of coal, and £21,038 for quarries; the remainder of the sum being for other miscellaneous forms of property.

There was a price to be paid for the great expansion of the industry. The late 1840s onwards had seen the sinking of many shafts in the Lancashire Coalfield, now regularly extending well beyond 100 yards in depth. Accessing more extensively than ever, the deeper seams, with their associated higher levels of gas, led to a regular series of explosions and occasional major disasters.

Skilled and educated men were now in demand to supervise the large-scale mining of coal in increasingly challenging conditions. The long-established mining genius of Wigan led to the setting up in the town of the first purely coal-mining college in Britain in 1857. This was one of the reasons Wigan would later become the most important coal-mining district in the world, and known as 'Coalopolis'.

Working the Coal

Mathias Dunn, a noted north-eastern colliery manager and 'viewer' stated in 1851 how the Lancashire seams were generally worked by rise headings followed by retreat pillar working creating a maze of roadways impossible to fully ventilate:

> The mode of working which generally prevails in Lancashire, under a depth of 50 or 60 fathoms, may be described as follows. The levels are driven out narrow, the dip-level being generally adopted as the horse road and intake, and the rise level the return air course. Out of the rise level, at right angles are driven narrow drifts in pairs having a 4 or 6 yard pillar, 6, between; and extending towards the former range of workings which may lie at the distance of 60 or 80 yards. Between each pair of drifts a barrier of coal is left, containing from 25 to 40 yards and, as soon as the said rise drifts have arrived at the proposed length, they are communicated with each other, and conjointly bring back the working of the intermediate pillar of coal.

Rise faces were still to be found in Lancashire collieries at the end of the twentieth century.

Not all the Lancashire coal seams were laid out at reasonable inclinations. Dunn describes the Astley Pit, Dukinfield, Cheshire,

> The coal lies at an angle of about one in two, and the black mine seam has been exhausted by successive winnings, till it is now working at the depth of 200 fathoms from the surface. As the coal is too steep to work the wickets [coal panels] from dip to rise, the plan has been to extend parallel levels at the distance of 60 or 80 yards, to the dip of each successive range of old workings, similar to the method used in Lancashire, and at every 130 or 140 yards, to drive up a pair of drifts [Jigg or gravity haulage brows]; out of these drifts again to turn level workings, 5 or 6 feet wide with a pillar of 8 or 10 yards between, which pillars were to be worked in returning towards the jigg brow. The low level is the horse road, and the upper one the air road; and, steep as the coal lies, the working is carried on by means of tubs, containing 8 cwt [1 hundredweight = 112lbs, 20 cwt = 1 ton] of coal.

Fifty-four men were to die after an explosion at Astley Pit on 14 April 1874.

The Most Dangerous Coal Mines in Britain

In 1851-53, the highest rate for mortality from explosions in all the coalfields was in Lancashire due to its gassy seams coupled with ventilation systems unable to efficiently service the extensive workings. Candles were amazingly still in widespread use in Lancashire's mines at this time (and still in the 1870s in Atherton), expensive miner's lamps were only used for gas testing in known gassy areas. In 1850, on 9 October, at Bent Grange Colliery, Oldham, sixteen men and boys died. On 20 May 1852, thirty-six men and boys died at Coppull Colliery near Wigan. Ince Hall Colliery, Wigan, suffered two disasters within one year; on 24 March 1853, fifty-eight were killed, while on 18 February 1854, eighty-nine were killed. Explosions and occasional major disasters were a regular occurrence from now on (see the appendix).

In 1858, there were 380 mines in Lancashire producing 8 million tons per year; by 1874, 558 mines produced 16 million tons.

Into the Twentieth Century

At the peak of working in 1907, there were 358 collieries operating in Lancashire producing over 26 million tons of coal per year, employing 94,500 men. During this era, coal was virtually all got by hand, pick and shovel. After the First World War, machine mining became more extensive with chain coal cutters undercutting the seam at the face. Lancashire's first installation had been of a Walker cutter disc machine at Ladies Lane Colliery, Wigan, in 1869, one of the first installations in the country. Steel roof supports gradually replaced wooden supports and steel-bodied pit tubs slowly replaced wooden ones. Pit ponies were replaced by mechanical haulage and electric safety lamps were gradually introduced. The collier in those days still had to purchase all his tools for his work. Picks, spades, hammer, wedges, powder, tallies, lamps and oil would all be available locally in mining districts.

The various district unions came together to form the Lancashire Miners' Federation on 19 April 1881. Thomas Seddon, the first secretary, was a Bradford Colliery, Manchester man. He was elected as secretary of the Miners' Federation of Great Britain, from its inception in 1889 until 1910. The Lancashire and Cheshire Miners' Federation was founded in 1897 and based at Bolton (wound up on formation of the National Union of Mineworkers in 1945).

Decline

During the late nineteenth century, Lancashire had failed to keep pace with other coalfields, and early in the twentieth century the trend of production turned downwards. Official coal output statistics had been obtained for the first time for the British coalfields in 1854 at 64,660,000 tons and in 1873 national output was nearly doubled at 126,590,000 tons. The output of coal in Lancashire in 1874 from 558 mines reached 16 million tons, certain districts around Wigan and Haydock having up to 73 per cent of males working in the pits, as this survey of 1904 shows;

Abram	73.4%
Ashton-in-Makerfield	69.1%
Aspull	58.8%
Haydock	70.5%
Hindley	65.7%

Ince-in-Makerfield	50.7%
Standish	64.1%
Westhoughton	58.9%
Skelmersdale	65.0%
Golborne	47.1%
Little Hulton	56.3%
Little Lever	41.4%
Orrell	52.8%
Pemberton	58.3%
Swinton and Pendlebury	36.2%
Worsley	34.4%

The peak Lancashire output figure of 26,184,033 tons in 1907 was followed by gradual decline and sadly followed in 1910 by the largest death toll in a Lancashire colliery disaster, at Pretoria Pit, Over Hulton, near Atherton, on 21 December 1910. A total of 344 men and boys died after a gas and coal dust explosion, the third largest disaster in British mining history.

The Effect on the Landscape

In 1911, a researcher (probably not from Lancashire) for the Victoria County History of Lancashire gave a rather exaggeratedly cruel description of one mining town, Hindley, as though similar to a battlefield:

> Hindley lies in the centre of the great Lancashire coalfield, and consists of a level-surfaced country dotted over with collieries and black pit-banks. A close network of tramways and railways covers the face of a singularly dreary stretch of country, where the pastures are scanty and blackened. Frequent pools of water lie between the collieries, indicating subsidences of the earth caused by mining. What trees remain standing appear as dead stumps, with leafless branches reflected weirdly in the 'flashes' of water.

A glance at the 1909 OS map of Hindley shows that the above description must have applied to some areas of Hindley but certainly not all.

From 1907 to 1914, output had declined further but only by 3 million tons; six years later, output had dropped to 18,784,699 tons. Even with the substantial output maintained by the Lancashire miners over the previous fifty years, a monograph prepared for the Twelfth International Ottawa Geological Congress of 1913 entitled *The Coal Resources of the World* assessed the coal reserves of the Lancashire Coalfield as 5,636,427,289, a mere five and a half billion tons!

The pits in Lancashire and Cheshire by 1925 were the deepest in Britain. Parsonage Colliery, Leigh, had a shaft depth of 1,008 yards and for many years this was actually one of the deepest shafts in Europe.

The 1925 Royal Commission on the Coal Industry found that the average distance the men in Lancashire had to travel to the face was over half a mile, often much farther. The Commission stated that the average time taken to raise and lower men in the Lancashire coalfield was eighty-four minutes, the national average being seventy-two minutes. The predominantly local consumption of coal in the Lancashire industrial area declined after the First World War.

The 1926 Strike

The British coal-mining industry suffered an economic crisis in 1925, caused by various factors.

The First World War. The heavy domestic use of coal in the war led to the better quality seams being depleted. Britain exported less coal in the war than it would have done in peacetime, allowing other countries to fill the gap. The United States, Poland and Germany and their large strong coal industries benefited. The main reasons for the sorry state of the industry were:

Low productivity, output per year per man had fallen to 199 tons in 1920–24, from 247 tons in the four years before the war, and a peak of 310 tons in the early 1880s. Total coal output had been falling since 1914. Another factor was the fall in prices as a result of the 1925 Dawes Plan, which allowed Germany to re-enter the international coal market by exporting 'free coal' to France and Italy as part of their reparations for the First World War. Also the reintroduction of the Gold Standard in 1925 by Winston Churchill had made the British pound too strong for effective exporting of coal to take place.

During times of economic instability, mine owners tried to maintain their profits in the form of wage reductions for miners. Coupled with the prospect of longer working hours, the industry was thrown into turmoil. The mine owners announced that their intention was to reduce miners' wages; the Miners' Federation of Great Britain rejected the terms with the classic phrase 'Not a penny off the pay, not a second on the day'. The Trades Union Council responded by promising to support the miners.

The Conservative government under Stanley Baldwin intervened, stating that they would provide a nine-month subsidy to maintain the miners' wages and that a Royal Commission under the chairmanship of Sir Herbert Samuel would look into the problems of the mining industry. The subsidy in reality gave the mine owners and the government time to prepare for the expected major labour dispute.

The Samuel Commission published its report in March 1926. It concluded that the coal industry needed to be reorganised but rejected nationalisation. The report also recommended that the government subsidy should be withdrawn and that the miners' wages should be reduced to safeguard the industry's profitability.

The mine owners published new terms of employment for all miners. These included an extension of the seven-hour working day, district wage agreements, and a reduction in wages. Depending on a number of factors, the wages would be cut by between 10 and 25 per cent. The mine owners declared that if the miners did not accept the new terms then from the first day of May they would be locked out of the pits. The Miners' Federation of Great Britain refused the wage reduction and regional negotiation. The strike lasted from 4 May to 29 September. By the end of November, most miners were back at work, although a number remained unemployed for many years afterwards. Miners returning to work were often victimised, forced to accept longer hours, lower wages, and new district wage agreements. The men felt as though they had achieved nothing. In 1927, the British Government passed the Trade Disputes and Trade Union Act. This act made all 'sympathetic' strikes illegal and also made mass picketing illegal.

The Coalfield Limps Along

In 1929, consumption was 5-7 per cent less than in 1913; by 1930, the output was 15,000,000 tons, and 13,205,019 tons in 1933. Government still found time in the midst of depression and decline to pass the Mining Industry (Welfare) Act in 1931

to help fund pithead baths, miners' welfare clubs and convalescent homes across Lancashire. Many of these solidly built structures survive today, examples being Gin Pit Miners' Welfare and Nook Colliery pithead baths at Tyldesley.

By 1937, the number of men on the colliery books in Lancashire was less than 60,000, compared with 110,000 in 1920. Most of the unemployed were concentrated in the old central district of the coalfield, Wigan, Ince, and Westhoughton.

Lancashire Associated Collieries estimated that about 12 million tons of the output of Lancashire was disposed of locally whereas other coalfields, South Wales for example, relied heavily on exports. When the Lancashire cotton industry suffered post-First World War, the knock-on effect on the industry was predictable. Of the 12 million tons produced in 1937, about 4 million tons went to industry, about 3 million tons to domestic users and 2 million tons to public utilities. Over 1 million tons were retained by the collieries for their own use. Mechanisation at this time was advanced in Lancashire compared to other areas; 58 per cent of the output by 1938 was being produced by coal cutters with conveyors at the coalface rather than tubs.

The National Coal Board 1947

By the time of nationalisation of the industry in 1947, many of the smaller collieries had ceased working and the coalfield had been restructured into a small number of large concerns working a relatively small number of large mines. The largest of these was Manchester Collieries, which brought together seven colliery companies in 1929 and later added two more. At the other end of the scale, Tyldesley Coal Co. Ltd operated just one mine, Cleworth Hall, yet still produced a healthy 250,000 tons in 1938.

The coalfield on nationalisation comprised eighty-six collieries having a total annual output of some 11 ½ million tons. Twenty were in the No. 1 Manchester area, twenty-six in the No. 2 Wigan area, twenty-two in the No. 3 St Helens area and eighteen in the No. 4 Burnley area. After closures, seventy-four pits were taken over by the National Coal Board, the remaining twenty small mines allowed to be privately operated under licence. The mining workforce both above and below ground totalled 61,064.

After 1947, the number of working mines slowly reduced as reserves became exhausted in the older mines and those to the north of the area being of limited dimensions and number of workable seams available. The first ten years after nationalisation saw little change in the number of pits. The decline in output during the Second World War was halted. By 1955, the output of 1940, when ninety more pits were working, was nearly equalled. In the ten years after 1947, fifteen collieries were closed and twelve collieries were opened. Major mechanisation schemes were embarked on with overhead tower 'Koepe' friction winders, skip winding and pit bottom bunkers, shearer loader coalfaces, more efficient transport of men below ground and increased mechanisation of the drivage of rock tunnels.

The National Coal Board was an enormous concern, with the finest geologists, scientists, planners and mining engineers at work. From 1947 onwards, virtually every mine was to have, apart from mining staff, mechanical and electrical engineers, a ventilation officer, training officer and a safety officer. The educational system in place allowed a boy starting as a haulage hand to progress to colliery manager if he had the determination and commitment. Educational scholarships for the children of miners were also available.

A Bright Future

As major coal reserves and the future of the coalfield lay to the south, the Board embarked immediately after Vesting Date (1 January 1947) in a heavy boring programme. The NCB also felt it important to access coal from short-life surface drifts, a relatively cheap and profitable process. Often these small drifts would have outputs per manshift of over 40 cwt, substantially higher than the larger and more costly deep-mined operations. In 1948-49, Fence Drift near Burnley was opened, Salterford No. 1 Drift again near Burnley opened in 1948, No. 2 in 1955, Thorny Bank and Hill Top drifts in 1951, Fir Trees Drift in 1954. Around Wigan in 1950, Standish Hall Drift and Seneley Green Drift opened. Dairy Pit, Haigh, near Wigan, opened in 1954. Wood End Drift near Burnley opened in 1954.

The problem at this time though was a severe shortage of manpower. In 1949, the NCB were banking on 2,500 foreign workers including 550 EVWs or European Volunteer Workers topping up the Lancashire workforce, mainly Poles and Ukrainians. Recruitment of Irish and Scottish men also took place. Around 300 ex-Lancashire miners were still in the forces but with jobs assured on return. The men's experiences during the war had changed them and their attitude towards working in mining; other emerging industries were now more attractive.

The Coal Mines Act 1954 brought together the previous legislative controls of the nineteenth and early twentieth centuries to establish the safest system of working in the world (when adhered to). From the arrival of the Mines Inspectorate in 1850 to 1950, 100,000 men had died in British coal mines, a heavy price indeed to pay for this the ultimate mining safety framework, and just as the industry was to face its most severe period of decline.

Enshrined within the national 'Plan For Coal' of 1950 (to be revised in 1959), the National Coal Board prospective boring programme continued, to try and prove the suspected deep reserves of good-quality coal. This was to pave the way for the expansion and modernisation of the remaining collieries along with a completely new mine, Parkside, Newton le Willows, in 1959. These mines would be the major producing units (it was thought at the time) up to the year 2000 and even beyond.

The sinking of Parkside in 1959 coincided ironically with a revised 'Plan For Coal' with reduction of output a priority. Seven Lancashire collieries were earmarked for closure, whatever their reserves: Deane Colliery, Bolton, 135 men; Giants Hall Colliery, Standish, 512 men; Welch Whittle Colliery, near Coppull, 372 men; Mains Colliery, Bamfurlong near Wigan, 575 men; Park Colliery, Garswood near Wigan, 745 men; Reedley Colliery, Burnley, 232 men; Salterford Drift near Burnley, 205 men.

Competing fuels, like electricity, oil and gas, hit the Lancashire coal industry hard in the late 1950s; the Clean Air Act of 1956 had taken its toll. Coal demand plummeted and those Lancashire mines producing a low-quality dirty product, collieries working seams with thick dirt bands of shale or stone which could not be separated at the point of mining, had major problems.

The coal washeries were not always able to produce a saleable product. Grading of good-quality coal with poor for a while kept the industry alive in Lancashire, but as top-quality coal could be obtained from other coalfields, the future was bleak. Nevertheless, the 'new' Agecroft Colliery, Salford, reopened in 1960 and the brand-new Parkside Colliery, Newton le Willows, opened on 30 April 1964.

The coalfield had been reorganised in January 1961 into two areas: the West Lancashire Area and the East Lancashire Area. From the early 1960s onwards, the NCB began to do the unthinkable, closing pits which still had coal in reserve or ones which had large water burdens offsetting profitability and even, it is suggested, others where trade union relations were poor. One way of closing a colliery was by the

setting of unrealistic output targets by the NCB (rather than being set at local or even regional level). Local colliery management must have been very frustrated to see their collieries treated in such a manner but had to apply the Board's intentions. By 1962, the number of mines had been reduced to forty-one and by 1967 to twenty-one with output at 7,618,255 tons.

Invest and Close Madness

From 1947 to 1965, £95,000,000 had been invested in the Lancashire coal industry by the NCB. £7,500,000 of this had been earmarked for the transformation of Mosley Common Colliery into a 'superpit' with huge reserves to the south. Reorganisation was complete by 1962. The colliery was to be set unobtainable target outputs by the NCB, who closed it in February 1968.

In the midst of all these events, area reorganisation once more took place with the National Coal Board (North Western Area) being formed in April 1967 (surviving as such until March 1974).

1972 and 1974 Miners' Strikes

The Lancashire miners could never be thought of as having been the most militant workforce, yet it is interesting to note that in the twentieth century they were in various numbers to be found in dispute in 1911, 1912, 1920, 1921, 1926, 1937, 1942 (twice), 1944, 1948, 1949, 1955, 1960, 1961 and 1962, 1966, 1967 and 1968.

The National Power Loading Agreement of 1966 standardised coalface workers' wages nationally with miners in poor producing areas finding they were immediately 10s a day better off. The Lancashire miners were initially against the idea, as they had negotiated some of the best piecework 'deals' in the country over the years. At the 1971 NUM Annual Conference, a target of a 43 per cent pay rise was voted for. The Tories were offering around 7-8 per cent. In late 1971, the miners voted to take industrial action if their pay demands were not met.

1972 Strike

On 9 January 1972, miners from all over Britain came out on strike. This was the first major national stoppage since 1926. On 9 February, a state of emergency was declared and two days later the three-day working week was introduced to save electricity. On 19 February, an agreement was reached between the NUM and the Government. Picketing was called off, and, on 25 February, the miners accepted the offer in a ballot, returning to work on 28 February.

The result of the strike was that the miners' wages became almost the highest amongst the working classes. By 1973, the miners had moved from first in the industrial wages league to eighteenth. The Arab-Israeli War led to oil prices soaring. Relations between the industrial unions and the Government were hostile, the Tories attempting to introduce pay freezes and restraints to help the economy.

1974 Strike

In late 1973, the miners once more voted to take industrial action if their pay demands were not meet. They were not, and on 9 February 1974, they came out on strike. The Government refused to compromise on a 7 per cent pay rise. Edward Heath, Prime Minister, declared a state of emergency, introducing a three-day working week. The General Election and the Industrial Relations Act meant that picketing and campaigning were low key compared with the 1972 strike. Heath called a General Election for 28 February, believing that the country would be in sympathy with him, but the Conservatives were defeated. The Labour Government and the miners reached a deal shortly afterwards and the strike ended. New Secretary of State for Employment Michael Foot implemented the Pay Board Report showing how miners' pay had dropped since 1972. As well as increases in pay, there were two other important results of the strike; the implementation of a scheme for compensation for pneumoconiosis sufferers, and a new superannuation scheme which commenced in 1975. The year 1974 had brought further reorganisation to the Lancashire Coalfield as it became part of the NCB Western Area with headquarters in Staffordshire (with many top jobs going to Staffordshire men, it will be remembered by those working at the time). Western Area survived until 1986 when British Coal was established. The late 1970s brought Lancashire's last pit disaster when, in 1979, Golborne Colliery, Golborne, south of Wigan, suffered a methane explosion triggered by electrical sparking. Three men died instantly in an explosion over 1,800 feet below the surface on 18 March 1979, a further eight received serious lung and burn injuries. Seven of the eight would later die.

The 1984 Strike and the End of the Deep Coal Mining Industry in Lancashire

A strike had nearly occurred in 1981 when the Government was found to have a plan to close twenty-three pits. The threat of a strike was enough to force the Government to back down. In 1983, Conservative Prime Minister Margaret Thatcher appointed the American Ian MacGregor as head of the National Coal Board. In 1984, the NCB announced that an agreement reached after the 1974 strike had become obsolete, and that in order to rationalise government subsidisation of industry, they intended to close twenty coal mines. The Thatcher government prepared against a repeat of the 1974 industrial action by stock-piling coal, converting some power stations to burn petrol, also recruiting fleets of road hauliers to transport coal in case railway workers went on strike to support the miners. Lancashire's miners were initially reluctant to join the strike as they had not been balloted. The majority of miners nationally though were already on strike by March 1984 and they insisted that they did not need to have a ballot for the remaining minority.

The months passed by, financial hardships increasingly took hold and miners began to break the strike and return to work. Eventually a vote was taken by the NUM National Executive, a close 98 to 91 in favour of an organised return to work. The strike formally ended on 3 March 1985, almost a year after it had begun. The miners returned to work with their heads held high. They (including the author) had fought against a virtual dictatorship which pitched the police, MI5, the media and huge coal stocks against them, also cruelly twisting public opinion against them and their cause, the preservation of the industry. Behind their colliery banners the miners' wives also marched, they had supported them even as their families suffered. The year-long strike had brought extreme poverty to families who had spent a year without wages and had struggled to get by on what they could. The cruel break-up of long-standing mining communities in areas where coal had been mined for over 700 years began.

After the strike in Lancashire, closures, especially of collieries strongly supportive of the action, took place; these were to be the final closures. The St Helens area especially suffered. Cronton Colliery, St Helens, ceased production as the strike began in March 1984. Bold Colliery, St Helens, closed in 1985, Agecroft Colliery, Salford, the long-life pit redeveloped in the 1950s, closed in March 1991, the Bickershaw, Golborne and Parsonage three-pit complex was closed by March 1992 (the Golborne arm closing earlier in 1989). Parkside Colliery, Newton le Willows, only sunk from 1959 onwards, closed in March 1993, leaving behind large reserves, the last deep mine in Lancashire.

Lancashire's Last Miner?

This left a small drift mine near Bacup, Hill Top Colliery, to continue on and off the 700-year-old tradition of coal mining in Lancashire, at times with just one man, Jimmy Clayton, a miner's son, at the coalface with compressed air pick, hand-filling tubs. At the time of writing, Hill Top is 'ticking over' and ready to access a large panel of coal, the author helping out occasionally at the coalface. Otherwise, the controversial Cutacre Opencast site at Little Hulton, first mooted back in the 1980s, is nearing its end. Hundreds of millions of tons of coal still lie below ground in what was the Lancashire Coalfield in pockets of old workings, around shafts as support, left as pillars beneath buildings no longer there, at collieries closed before reaching exhaustion and at great depth to the south of the coalfield. Should the decision to mine any of that coal in future be taken, one thing will be certain, the large skilled Lancashire mining workforce will not be there any more. If the coal industry had been allowed to complete its course naturally rather than have been subject to the most inane political interference and total disregard for mining communities, we would not be anticipating the energy crisis lying ahead. It is indeed very sad to see such a great industry staffed by men who practised 'the art of mining' brought to its knees by those with little or no knowledge of its magnificent history and traditions.

The Geology of the Coalfield

A very simple overview is all that is possible here of this vast subject as the priority of the publication is the visual image. The first real attempt to make sense of the strata in the Lancashire coalfield was by an amateur fossil collector who associated with geologists and scientists. Elias Hall (1764-1853) of Castleton produced a number of maps of coalfields, one of which was *A Mineralogical and Geological Map of the Lancashire Coalfield with adjacent parts of Yorkshire, Cheshire and the Peak in Derbyshire*, first published in 1833. Hall is mentioned by John Farey in his *General View of the Agriculture of Derbyshire* of 1811 as 'Elias Hall, Fossilist of Castleton, near Tideswell, Mineral Collector and Models of Strata'. Farey speaks of him as a pioneer in Derbyshire geology yet 'a plain unlettered individual'.

Hall produced a very simplified cross section from over Hulton to Manchester, hand-coloured. The only aspect of the plan which vaguely makes sense (today) was the dip of the strata and its direction. The plan also showed the main level of the underground canal accessed at Worsley. It was a start, one which was to inspire others. The First Edition OS, geologically overlaid survey of Lancashire arrived in 1862, produced under the guidance of professional geologist Edward Hull. This was, most importantly, followed by the superb 1930s and 1940s geological surveys, with detailed memoirs accompanying the six in plans.

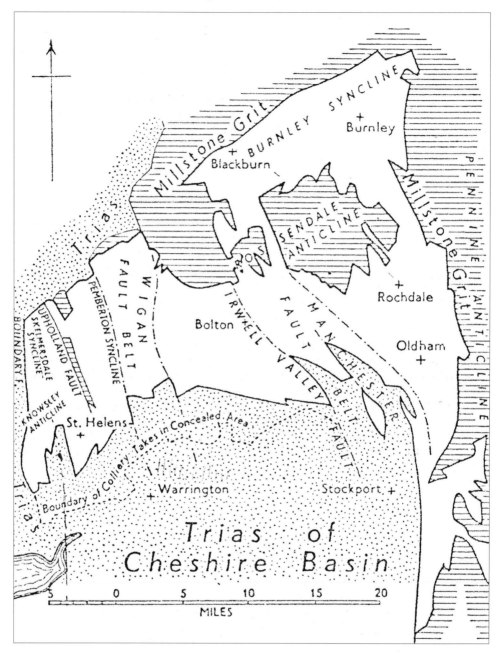

The Lancashire coalfield showing the general fault direction, NW to SE. The coalfield is concealed to the south with younger sandstone deposits. The expected continuation of the coalfield to link up with the North Staffordshire coalfield was proven recently not to be the case, a mountain range existing beneath the sandstone.

The Coalfield

The exposed (coal measures rocks lying on the surface) Lancashire and Cheshire coalfield is some 200 square miles in area. One unusual description said that it resembled an axe with the blade pointed to the west and the handle projecting southwards. The southern side of the blade extends from Ashton-under-Lyne past Manchester to St Helens. The western side runs northwards towards Burscough, then turning to the north-east as far as Colne. The eastern side trends southwards to the east of Littleborough, Oldham and Ashton-under-Lyne, whilst the narrow handle extends southwards as far as Macclesfield.

The northern part of the exposed field, the area around Nelson, Burnley, Accrington and Blackburn, is almost divided from the southern part by an expanse of Millstone Grit known as the Rossendale anticline whilst the area to the north-east, east and south-east of Manchester is separated from South Lancashire by the Irwell Valley fault, a major tectonic feature. The exposed Lancashire and Cheshire coalfield falls into three separate and distinct areas: the Burnley, South Lancashire and East Manchester coalfields; the southern part of the East Manchester field which falls in Cheshire is of course known as the Cheshire coalfield.

The main reserves of coal for the future (when efficient clean coal technology exists or when the next major fuel crisis occurs) lie along the southern sector of the South Lancashire field and along the eastern margin of the Cheshire field, where the Coal Measures are concealed by New Red Rocks. It had been conjectured that the Lancashire Coalfield would link up at great depth with the North Staffordshire Coalfield but this has now been shown not to be the case, recent boreholes showing that a hidden mountain range is in place.

Coalfaces at the great depths in the final days of working, especially in the Leigh area (at which geological structure is of fundamental importance), faced other problems, the heat being a major one. At Bickershaw Colliery, Leigh (closed 1992), workings in the Plodder seam in its final days reached 120F and necessitated the use of cooling fans chilling the intake air. Men regularly succumbed to the conditions, fainting and collapsing.

The Collieries

St Helens and Haydock

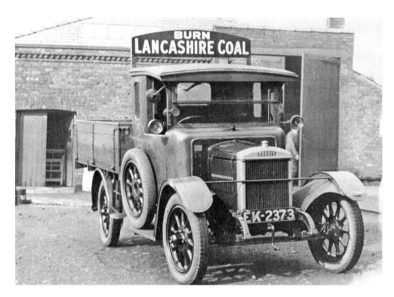

On 1 July 1936, a more effective marketing and sales amalgamation across the Lancashire and Cheshire coalfields created Lancashire Associated Collieries. Here at Haydock in the late 1930s, a Wigan-registered Morris gets the message over to use more Lancashire-produced coal (often more expensive) rather than from other coalfields.

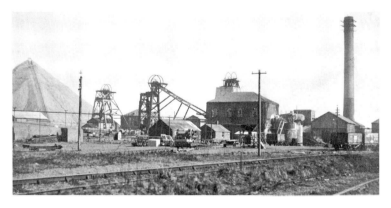

Sutton Heath & Lea Green Collieries Ltd, Bold Colliery, around 1947. Nos 1 (right) and 2 Pits (left) had been sunk by Collins Green Colliery Co. by 1884, No. 3 (middle) by 1892. Closed in 1940, it reopened shortly afterwards under Sutton Heath & Lea Green Collieries control. After nationalisation in 1947, the NCB invested £5 million in modernisation between 1949 and 1955. Note the conical waste tip being created.

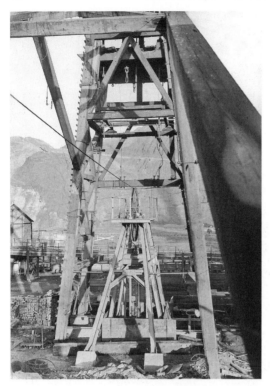

Left: Bold No. 3 downcast pit temporary steel headgear beneath the old wooden one around 1951. This 16-foot-diameter shaft became the upcast ventilation, supplies and manriding shaft after reorganisation. This shaft had been wound by a rare steam installation by Wilkinson. Note the enormous waste tips behind.

Below: NCB montage of Bold Colliery with its traditional surface layout on nationalisation in 1947, and below a panoramic view taken in 1956 after completion of the reorganisation. The adjacent Bold Power Station was built between 1956 and 1960. Utilising small coal from the pit, it supplied electricity in return at a load of 6,500 kVA.

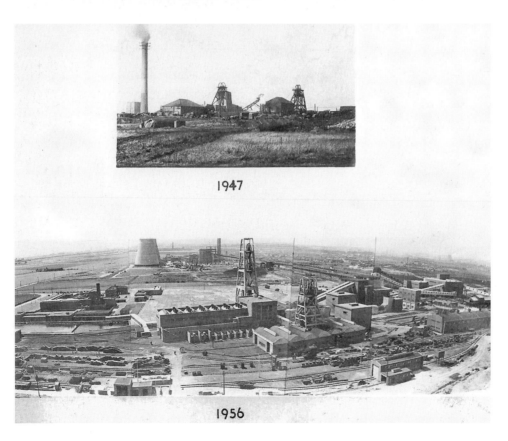

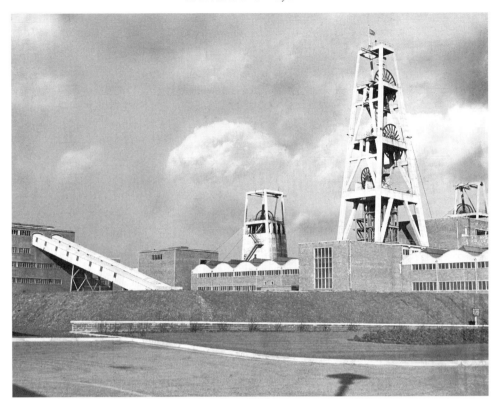

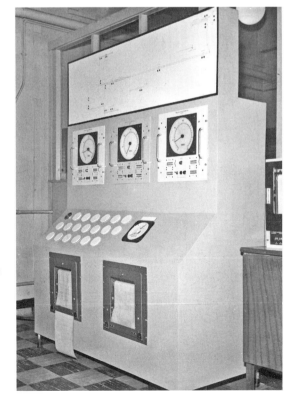

Above: The clean lines of the modernised Bold Colliery on 6 February 1957, from the left, Nos 3, 1 and 2 Pits. The tall No. 1 Pit headgear was unique in design using the 'Koepe' system of winding. The 1,140-yard rope passed round a driven friction pulley rather than a heavy winding drum. The 2¼-inch-diameter rope was made by Whitecross of Warrington; tested to 302.8 tons load, it was the strongest ever in Britain at the time.

Right: The ELSIE system (Electronic Signalling and Indicating Equipment) arrived at Bold Colliery in 1965, the first in the country to have a complete remote electronic and monitoring installation. From the ELSIE control room on the surface the progress of coalface bunkering, transport, and all other underground and surface operations was carried out. Looking very dated today but state of the art in 1965.

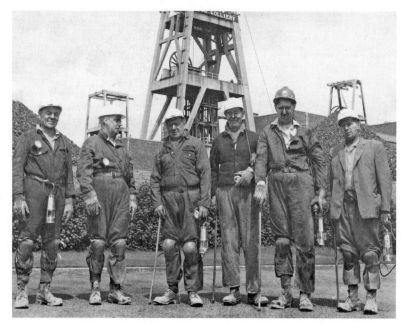

Management and officials group at Bold Colliery around 1966. Second right Bold Colliery General Manager W. E. Taylor with NCB North West Division Production Director E. J. Kimmins on his right. Manpower at this time stood around 1,450 below ground with 390 on the surface, the colliery producing yearly around 730,000 tons of coal.

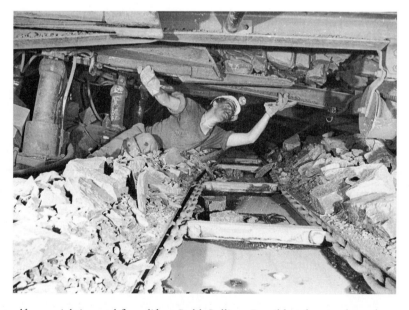

Severe coalface weighting and floor lift at Bold Colliery. Possibly taken to show the men on strike in 1984 the faceline deterioration. Faces in the Trencherbone seam were suffering from floor lift. The extension arm of the hydraulic roof support is nearly down to floor level as the floor rises and also the roof above breaks up and craters upwards. The hydraulic legs have been compressed to the limit and are close to being damaged by further pressure. Mining at Bold Colliery ceased in 1985, followed by the closure of Bold Power Station in 1991.

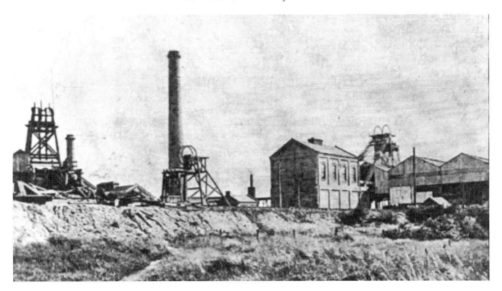

Clock Face Colliery, Gorsey Lane, St Helens, around 1910. Wigan Coal & Iron Co. acquired a 2,000-acre lease from Bold Hall Estates Ltd in 1904, and the pit began winding coal in 1908. The first workable seam, the Potato Delph, was only reached at 722 yards. The central headgear is above the pumping shaft of 183 yards depth.

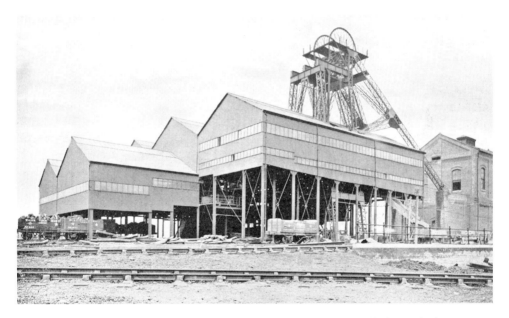

The recently constructed heapstead (tub circuit structure) and screen sheds at Clock Face Colliery, illustrated in the 1925 company brochure of Wigan engineers John Wood & Sons. The lattice steel headgear above No. 2 downcast shaft of 802 yards dominates the scene, with some Wigan Coal & Iron Co. wagons in view.

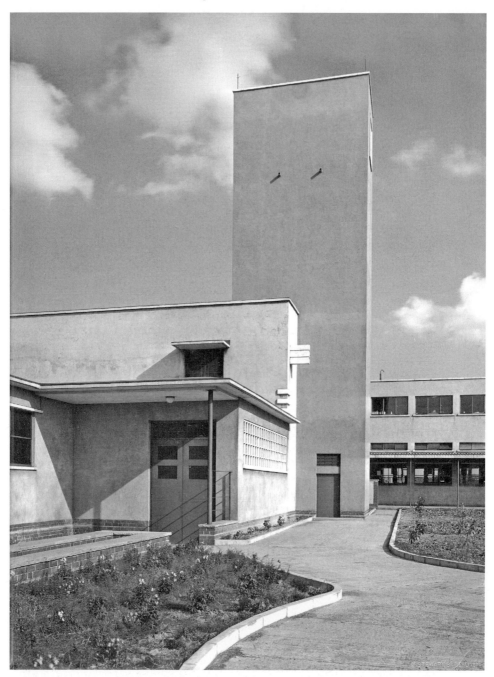

The clean, typically 1930s lines of the new pithead baths at Clock Face Colliery, opened on 29 July 1939. The scheme was funded by the Miners' Welfare Fund, which had originated in 1920 via the Mining Industry Act. In 1939, the colliery produced 357,798 tons of coal, with 997 men below ground and 289 on the surface. The pit closed in March 1966.

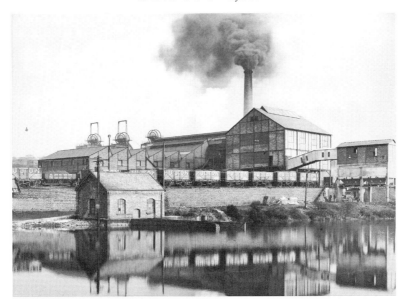

A fine view of Cronton Colliery, Halsnead Park, near Cronton and Whiston, Merseyside, taken around 1924. The three shafts, deepest being No. 2 at 562 yards, were sunk from 1914 to 1922 by the Hulton Colliery Co. near Bolton, owners of the ill-fated Pretoria Colliery where 344 men and boys died after an explosion on 21 December 1910. The colliery closed in 1984, being demolished in January 1985.

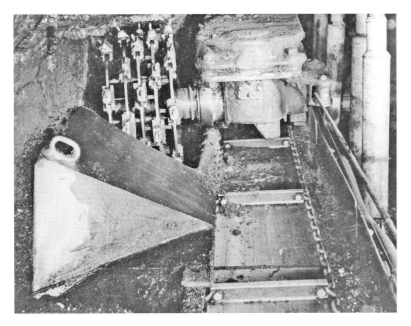

The first Anderton shearer-loader, designed by NCB fitters at Haydock and St Helens, was installed at Ravenhead Colliery, St Helens, in the Rushy Park seam in 1952, then Cronton Colliery and Golborne Colliery. Here an early open-disc design is in use at Cronton in August 1953. Later models enclosed the gaps between the discs, which also became spiral in design to direct cut coal to the conveyor. After cutting along the faceline, coal could be ploughed onto the face-scraper conveyor in the opposite direction.

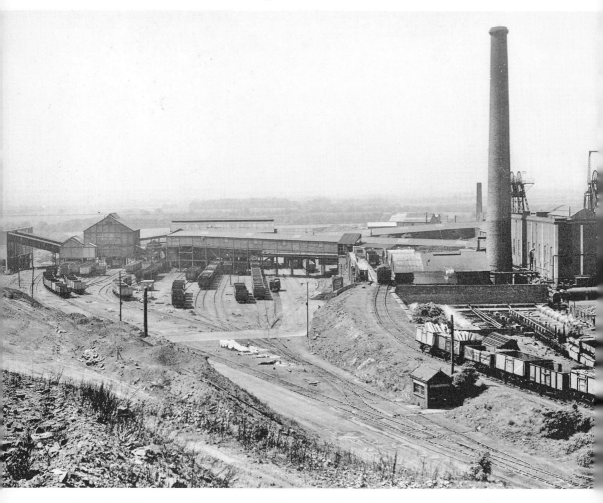

Cronton Colliery on 22 May 1957 with Nos 1, 2 and 3 Pit headgears in shot. Hand coal-picking sheds, washery and screens are to the left, offices and baths to the far right. Cronton was linked by rail to the Liverpool-Manchester line and also to the Liverpool-Wigan line at Huyton Quarry. Loco *Whiston* was of the Second World War Austerity design, built by the Hunslet Engine Co. of Leeds. Delivered new in October 1950 to the NCB at Haydock, it moved in April 1951 to Cronton, remaining there until 1961, then moving to Bold Colliery.

St Helens and Haydock

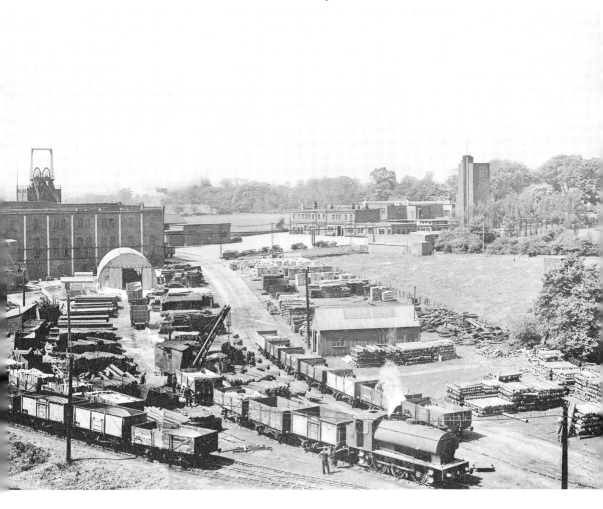

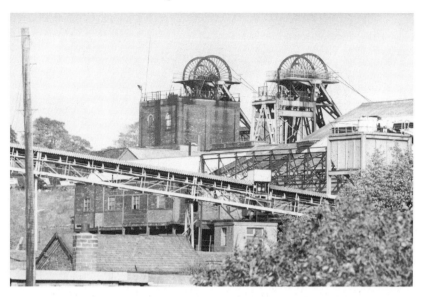

The headgears at Cronton were not particularly tall, and unusually, the three shafts were very close to each other, all served from one large engine house by a rare direct-current installation. Here in shot in the late 1970s only two are left, the 532-yard-deep No. 3 upcast ventilation shaft and the 562-yard-deep No. 2 downcast shaft. No. 1 shaft of 242 yards deep became disused after 1969, being filled in, as the workings it linked to were by then at deeper levels.

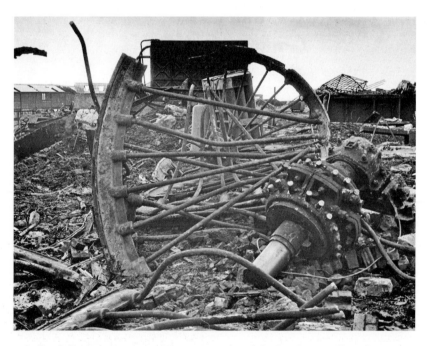

Cronton Colliery, late January 1985. The sorry sight of the headgear pulleys from No. 3 shaft cut from the central bearing-shaft boss. High percentages of methane under pressure forced through the 532-yard-deep shaft filling right to the surface. Cronton was one of sixty-five Lancashire collieries left on nationalisation in 1947. Exhaustion of economically viable reserves was on the horizon when Cronton colliery was closed in 1984. (Alan Davies, 1985)

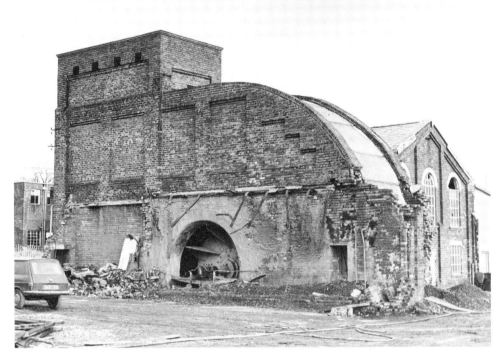

Cronton. Late January 1985 view of the fan house linked to No. 3 shaft. The 350-hp electrically driven Walker Brothers of Wigan Indestructible fan of 1923 could remove up to 500,000 cubic feet of air per minute. Five-inch water gauge pressure was produced at 137 rpm. Indestructible fans were used worldwide, being very rugged and simple in design with 'paddles' attached to a central boss. (Alan Davies, 1985)

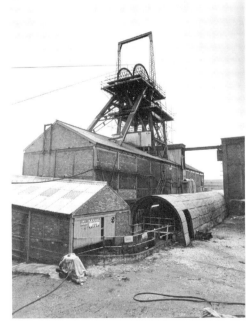

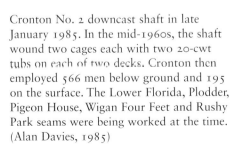

Cronton No. 2 downcast shaft in late January 1985. In the mid-1960s, the shaft wound two cages each with two 20-cwt tubs on each of two decks. Cronton then employed 566 men below ground and 195 on the surface. The Lower Florida, Plodder, Pigeon House, Wigan Four Feet and Rushy Park seams were being worked at the time. (Alan Davies, 1985)

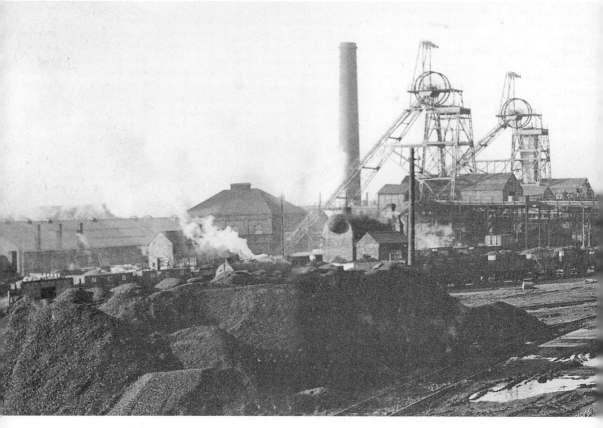

Lea Green Colliery, Eltonhead Road, St Helens, in December 1956. At this time, 1,042 men worked below ground and 245 on the surface, the colliery raising around 253,600 tons per year. 'Old Pit', far right, was sunk by James Radley in 1878 to 171 yards. New owners Sutton Heath & Lea Green Collieries Ltd sank the King Pit and Queen Pit to 510 yards and 498 yards respectively in 1894.

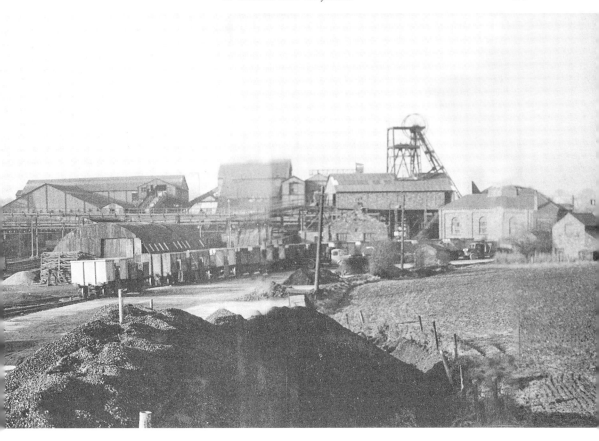

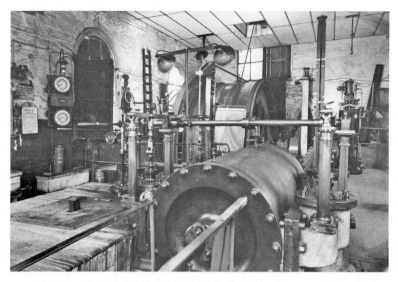

Old Pit steam winder at Lea Green Colliery in 1960. Maker unknown, possibly Daglish of St Helens. Single cylinder, 35-inch diameter of 1867. Cornish valve gear, hand-controlled cut-off, exhaust to atmosphere. The colliery ceased production from the top-quality Trencherbone and Arley seams in August 1964. In 1963, 646 miners and 191 surface men were at work.

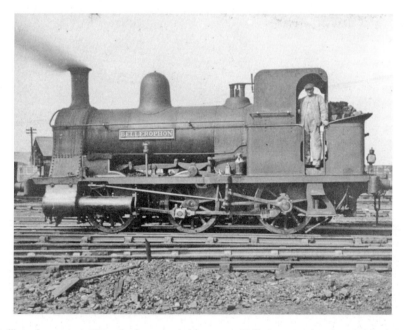

Loco *Bellerophon* seen at Haydock around the 1930s. Built in 1874 by the Haydock Foundry to the design of Josiah Evans, son of Richard Evans, who owned the Haydock Collieries. The NCB donated *Bellerophon* to the Keighley & Worth Valley Railway in November 1966. The Vintage Carriages Trust purchased the locomotive from the K&WVR and carried out the restoration, steaming again on 1 May 1985. For the technically minded – Steam pressure: 125 lb. Cylinders: 16 inches x 22 inches. Tractive effort: 11,000 lb (at 75 per cent boiler pressure). Wheel diameter: 4 feet. Coupled wheelbase: 12 feet 4 inches. Weight in working order: 35 tons. Water capacity: 600 gallons. Coal capacity: 2.5 tons.

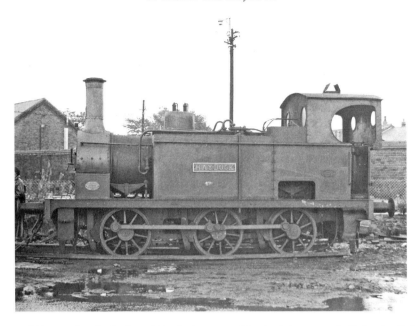

NCB 0-6-0T internal-cylinder loco *Haydock* seen at Haydock in 1966. Built by the Robert Stephenson works, Newcastle, in 1879, it was purchased by Richard Evans & Co. around 1900 to work at the Acton Grange Timber Wharf on the Manchester Ship Canal. After nationalisation of the coal industry in January 1947, it moved to the NCB Haydock Central Workshops in about 1952, working around that area until they closed in March 1963.

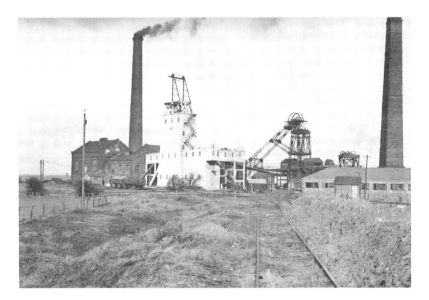

Lyme Pit, Haydock, No. 2 upcast shaft, sunk 1922 on the left, and No. 1 downcast shaft, seen in 1936 after construction of the new concrete clad headgear. No. 1 was sunk in 1876 by Richard Evans & Co. but met large volumes of water at 110 yards. Sinking stopped and was only resumed in 1922 to 397 yards, then again in 1922 to 547 yards. The small headgear to the right was above the 125-yard-deep No. 3 shaft. The colliery closed in March 1964, 180,541 tons being produced in that year by 419 miners and 187 surface workers. An explosion on 26 February 1930 killed five men initially, the death toll eventually reaching thirteen.

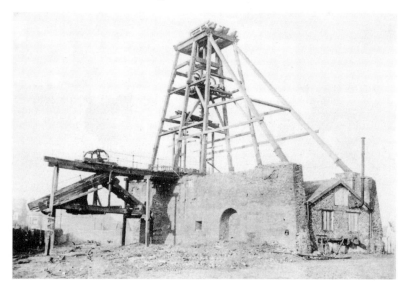

A fascinating view of the derelict New Boston Colliery, Haydock, around 1910. The colliery was sunk in 1854 and closed in 1907. The photo gives an idea of early colliery 'heapstead' layouts with splayed headgear legs mounted on high brick supporting walls. Tubs were pushed to the tippler (left), the coal dropping into wooden shutes above railway wagons or carts waiting below.

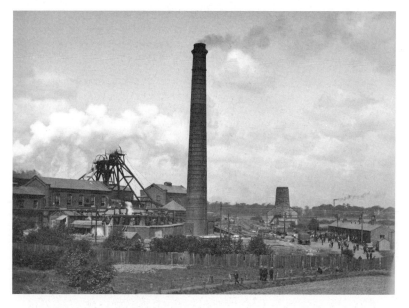

Old Boston Colliery, Haydock, in the 1930s. Looking at the numbers of men near the pay office to the right, it may be payday Saturday. Sunk by Richard Evans & Co. in 1868, No. 1 downcast (left) to 476 yards, No. 2 upcast (right) to 440 yards and No. 3 to 100 yards and used for pumping. A profitable pit, it closed in November 1952 after a fire near the pit bottom. A Civil Defence exercise took place in late 1953 with bombers simulating an attack, the mobile emergency winding engine from Boothstown Mines Rescue Station brought into use. The pit site gradually became the NCB training centre for miners (the author was trained there) and craftsmen from the north-west from 1953-56 until its closure in 1989.

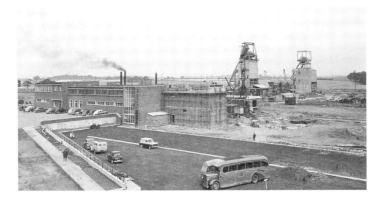

Boring on the site of the last sinking in the Lancashire coalfield at Parkside Colliery, Newton Le Willows, started in 1950, reserves of 100,000,000 tons being identified (later to be increased to 135,000,000 tons). Sinking began on 24 November 1957. Here on 10 September 1958, the two temporary sinking headgears are in place, the offices and pithead baths are completed. The canteen would be to the right of the scaffolded area. Coal was first wound on 31 March 1964.

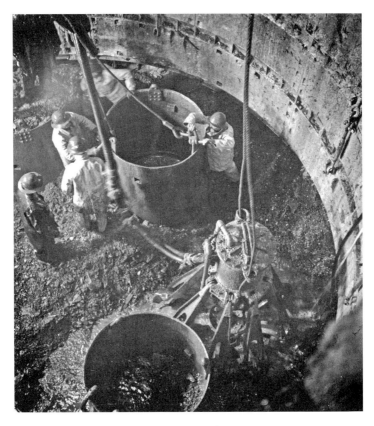

Kinnear Moodie & Co. Ltd's shaft sinkers at work down the 24-foot-diameter No. 2 shaft around 1958, two hoppets and the cactus grab in view. South African techniques and management performed the task with a team of twelve highly skilled men. The British record was broken in September 1958 when 309 feet was completed in one month. No. 1 shaft was to reach 886 yards and No. 2 889 yards.

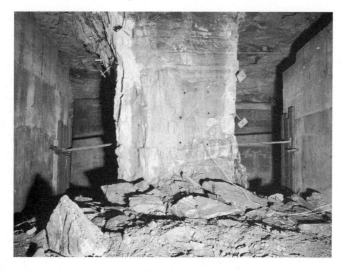

Parkside No. 2 shaft, No. 1 horizon inset level at 449 yards, looking west, 10 August 1960. The huge pillar or 'dumpling' of rock had been left in place to support the roof until a later stage in the construction of the inset. Here it has been drilled and charged with shots ready for blasting. No. 1 horizon was to become the main return air level. 1,000,000 tons of material was removed during sinking and roadway drivage.

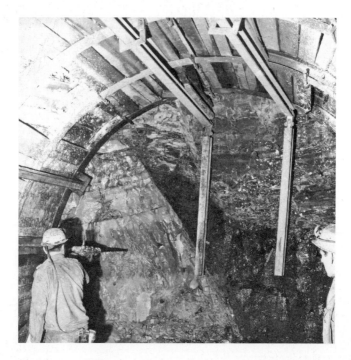

Parkside Lower Florida seam, L40s face roadway development drivage, photograph *c.* 1979-80. This face approached a heavily faulted area which restricted the faceline width. Here an 8-metre displacement of the strata (or fault) has been encountered. The photograph shows the effect of 'drag' on the strata along the steep fault line (see the uppermost section, the tapering off of the seam). The 'horse head' girders above were used to rest the top section of an arch on during setting, the drop girders holding back any coal in danger of falling towards the men.

Right: A portrait by NCB North Western Area Photographer Frank Grimshaw of a miner, probably down Parkside Colliery. Frank was a very modest yet highly skilled photographer, developing his own techniques of working in difficult conditions. He filmed the sinking of Parkside Colliery, as well as documenting all manner of colliery and miners activities both above and below ground. Here he uses a tripod and his caplamp plus long exposure to capture this 1960s miner.

Below: Parr, St Helens, Nos 1 and 2 Pits were also known as Havannah Colliery. The colliery closed as the 1926 strike began, later reopening in the 1930s. With an unusually squat and compact headgear above the ventilation shaft, the pit in its final year (1936) employed 138 miners and fourteen surface workmen.

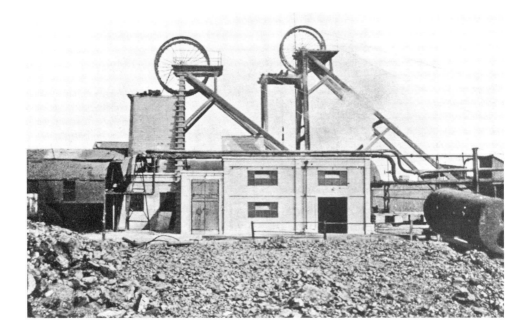

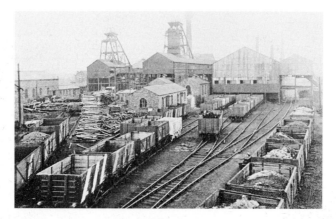

Ravenhead Colliery, St Helens, off Burtonhead Road, dated back at least to the mid-eighteenth century with the nearby Timberyard opencast site of 1992-93 uncovering possible late-sixteenth-century workings. The later shafts were sunk by Ravenhead Colliery Co. in 1866 to 540 yards. The pit trialled the famous Anderton Shearer Loader coal cutter in 1952. When it closed in October 1968, 362 miners and 144 surface men lost their jobs. (P. G. Hindley)

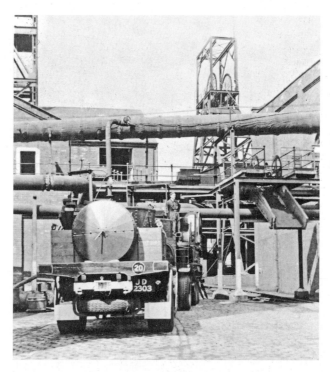

Ravenhead Colliery with the mobile emergency winding engine from Boothstown Mines Rescue Station on an exercise, late 1950s. With the approach of the Second World War, the Lancashire & Cheshire Coal Owners Association asked Walker Bros, the famous mining engineers of Wigan, to design a mobile winding engine to attend collieries in case of bomb damage. The unit was delivered to the Boothstown Rescue Station in early 1940. The winder had a 4-foot-diameter parallel drum with 1,250 yards of 5/8-inch-diameter locked-coil steel rope, fitted safety and warning devices found on static winding engines at collieries such as overspeed, overwind and slow banking devices.

Right: A late 1970s view of Sutton Manor Colliery No. 1 downcast shaft seen from No. 2 headgear. The 18-foot-diameter No. 1 was sunk by Sutton Manor Colliery Company from 1906 to 1909 reaching 1823 feet. During the colliery's reorganisation in the period 1952-57, the shaft was further deepened to 2,460 feet with a new pit bottom constructed. The Fraser & Chalmers cross-compound steam winder survived until reconstruction in 1986 converted the shaft to electric winding and a new headgear was built.

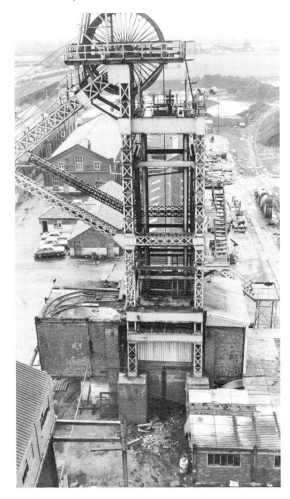

Below: The concrete-encased pithead structure around Sutton Manor No. 2 Pit, the upcast ventilation shaft. Jubits Lane on the right heads off to the M62; the colliery stockyard is far left. Sinking began in 1906 and was completed in 1912 to 2,343 feet, just below the Arley seam. The 1950s reorganisation took the shaft to 2,481 feet. Wound originally by a cross-compound Yates & Thom steam engine. A Walker Brothers of Wigan fan and engine exhausted up to 600,000 cubic feet per minute from the workings.

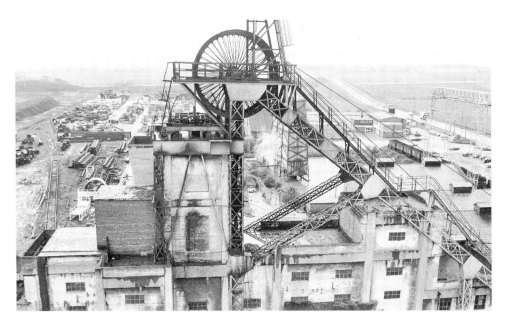

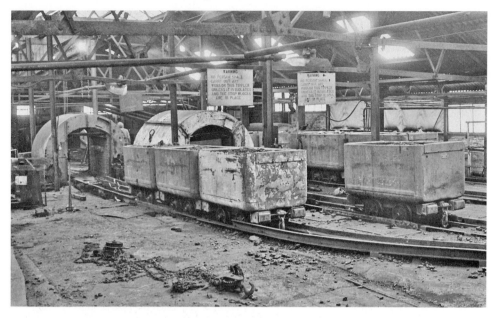

Surface tub circuit and tub tipplers at Sutton Manor. New screens and tipplers were constructed in the late 1950s reorganisation. The signs warn of the dangers of working inside the tipplers without stop blocks in place, fatal accidents having taken place at many collieries over the years. Closure of the colliery was announced in March 1991.

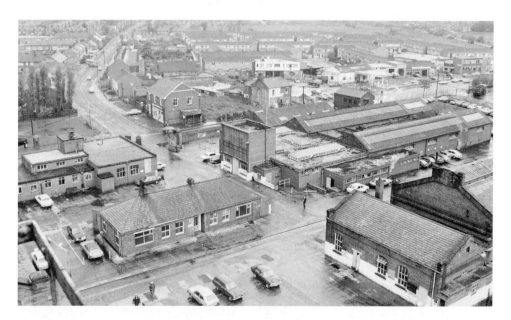

Late 1970s view from Sutton Manor No. 1 headgear towards the colliery entrance. From the left, the canteen, Forest Road heading off into the distance, main gates, manager's offices, pithead baths, lamproom and workshops. The gates remain to this day and hopefully will be preserved for future generations.

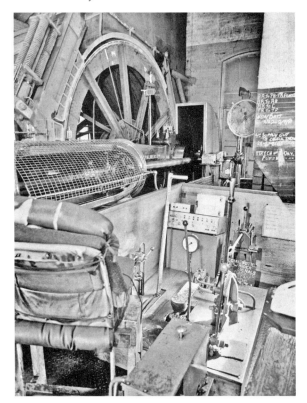

Sutton Manor No. 1 steam winder's engineman's controls. A 1200-hp Fraser & Chalmers of Erith, Kent, cross-compound engine; steam pressure 150 lb psi; HP cylinders 28 inches; LP 46 inches; stroke 5 feet; drum 16 feet diameter, original specification to wind 1,440 tons in eight hours. Replaced by an electric system along with a new pit headgear in 1986. (Alan Davies, 1986)

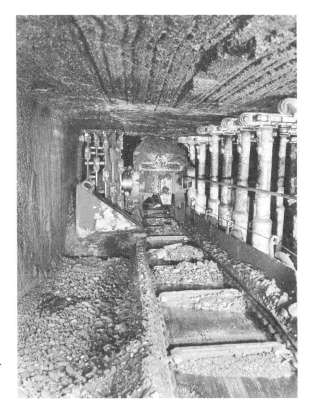

Wood Pit, Haydock. An early Anderton Shearer Loader on the coalface in August 1954. Dowty hydraulic props and link bars above support the faceline. The cutter drum is of the open five-plate type, later to be streamlined into a 'solid' spiral design. The coal plough is lower left, the scraper bar conveyor passing below the cutter. Steel haulage rope to the right.

The Central Area and Wigan

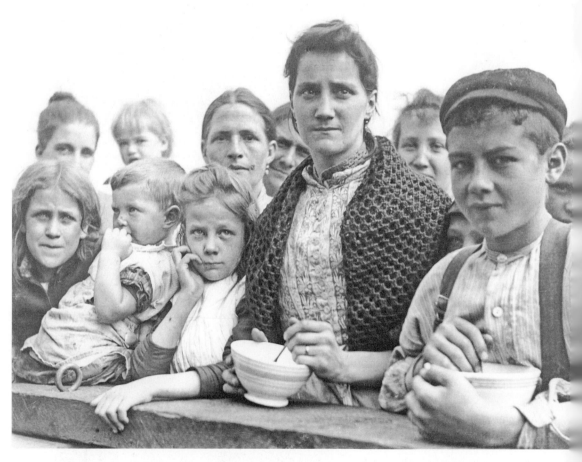

The sixteen-week-long strike of 1893 called after wages reductions being demanded by the coal owners led to severe hardships. Douglas Bank Colliery mining families at Wigan were lucky in that their local vicar Revd William Wickham set up a soup kitchen. The vicar was a keen photographer and took this superb photograph of his parishioners along with shots below ground, some of the first ever attempted in British coal mines.

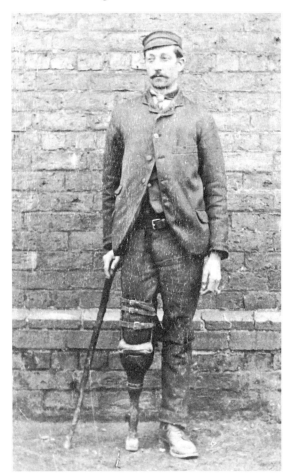

Revd Wickham documented many aspects of local life. Here, around 1893, he shows a maimed collier who had probably lost his leg at the coalface through a fall of ground followed by infection setting in. The Workmen's Compensation Act would not be law until 1897, so this man would be reliant on the company giving him a job on the surface or receiving assistance from the local Board of Guardians of the Poor.

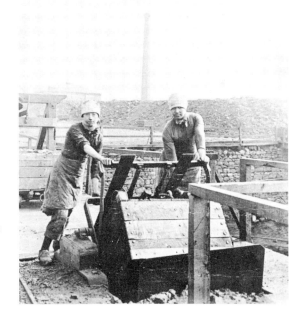

Wigan's pit-brow women were famous enough for postcards to be produced of them by 1904. Here, in about 1893, the Revd Wickham photographs women at Douglas Bank Colliery tippling a pit tub's load of coal onto the shute below, allowing women to pick off any dirt before loading up canal barges in the basin off the Leeds & Liverpool Canal.

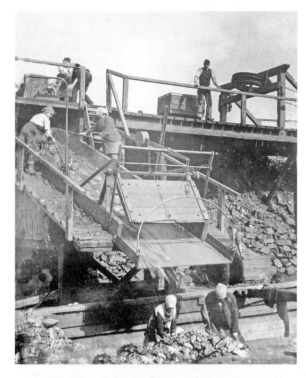

Another image by the Revd William Wickham. Tippled coal at Douglas Bank passes down to the screen, large coal carrying on down to the barge in the canal basin. Top right is an endless chain tub haulage return wheel. Tubs which had been tippled were sent back to the pithead and down the pit.

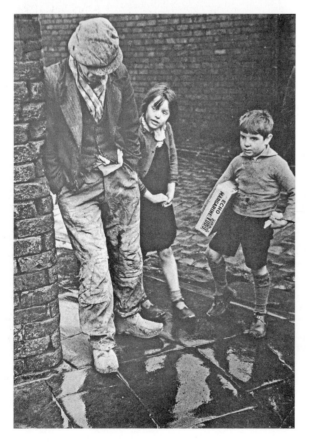

An unemployed Wigan miner stands in his pit clothes at the street corner in the 1930s depression, probably after hearing that there was no work available for the day. George Orwell would have been familiar with scenes such as this when he stayed near Wigan in early 1936 researching *The Road to Wigan Pier*. He highlighted the plight of the working classes and also studied why these people were not always keen to accept help.

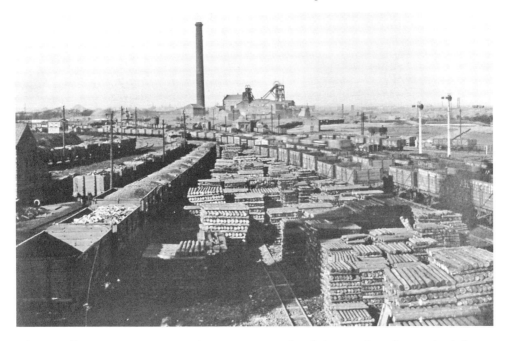

Abram Colliery, near Wigan, around 1928. Large stacks of pit props have been unloaded. Private owner mainline wagons await departure with Nos 1 and 2 Pits in the distance. Sunk 650 yards to the Arley seam around 1875 by Heyes & Johnson. Under Ackers Whitley & Co. control by 1933, the colliery was closed as a working mine by July 1934.

After closure, the Abram Colliery site lay derelict for many years, being fully demolished by 1948. It is thought that a cigarette end maliciously thrown down the shaft via a hole in the concrete capping led to an explosion on 19 September 1956. This ripped apart the capping giving an indication of the force of a methane explosion in a confined space.

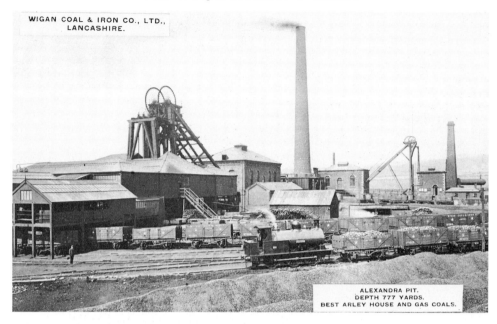

A lantern-slide image belonging to Wigan Coal & Iron Co. Ltd dating back to around 1908. In view is the 777-yard-deep Alexandra Colliery No. 3 Pit and Lindsay Pit, Whelley, near Wigan. The first shafts on site dated back to around 1856, Alexandra Pit winding around 800 tons a shift at the time of the photograph. The loco in shot is *Manton*, newly built at Kirkless Workshops. In 1904, 370 miners and 103 surface workers were employed. The colliery closed in June 1955 with a workforce of 189.

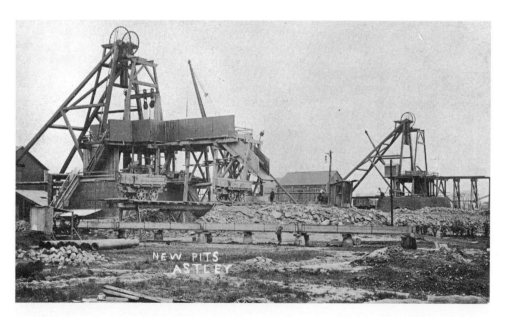

Sinking in progress at Astley Green Colliery, near Tyldesley, in April 1909, No. 1 left and No. 2 right. Geological knowledge and borehole evidence had shown that huge untapped reserves of coal lay south of Astley Green. Sunk by the Pilkington Colliery Co. Ltd, an offshoot of Clifton & Kersley Colliery Co. Ltd, heavily watered strata had to be tubbed off with cast-iron segments. The temporary wooden headgears were replaced by steel ones on completion of sinking.

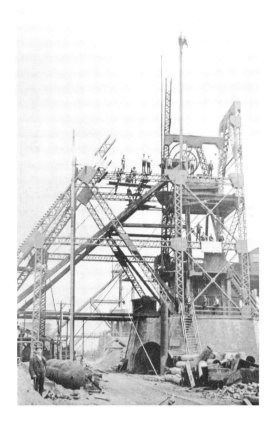

Shaft sinking is nearly complete and No. 1 Pit steel headgear is being erected in April 1911; note the wooden sinking headgear can be seen within it. Workmen from Head, Wrightson & Co. rivet the sections together on the headgear which still stands today. The brick pillar, its metal collar and twelve rams used to push tubbing through loose and heavily watered strata weighed 2,200 tons. The 21-foot-diameter shaft reached 890 yards in 1912.

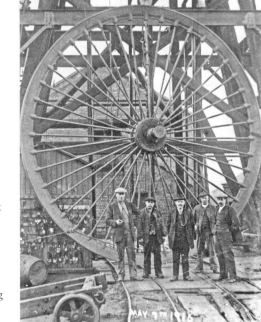

Astley Green No. 2 Pit, 7 May 1916. Sunk eventually to 833 yards with a 21-foot-diameter shaft completion of the steel headgear was delayed due to the First World War. Here the 18-foot-diameter pulley wheel (known as a sheave) is ready for placing above. The old wooden sinking headgear is still in use behind surrounded by new steel sections.

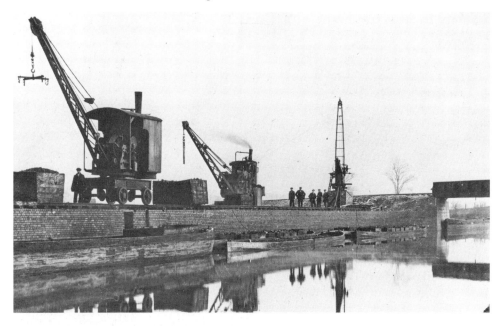

A shot from around the 1920s at Astley Green Colliery alongside the Bridgewater Canal. Rail-mounted steam cranes are loading containers of coal into 'box boat' barges, a practice Clifton & Kersley Coal Co. Ltd used at one of their other collieries, Wet Earth Pit near Swinton. As well as speeding up loading and unloading of coal, the aim was always to reduce as much as possible coal breakage and avoid the creation of small coal and 'slack'. Coal sizes brought varying prices and customers were very quality conscious of the product they purchased.

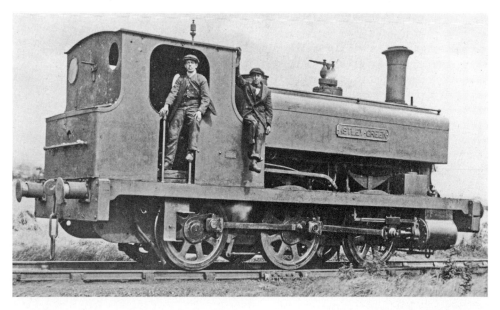

A photograph taken around 1920 of loco *Astley Green*. Originally named *John Waddell*, it was built by Andrew Barclay & Co. of Kilmarnock in 1880 for the Llanelly & Mynydd Mawr Railway. It arrived at Astley Green around 1914, purchased from J. F. Wake of Darlington. Out of use by 1930, it survived at Astley until heading off to Manchester Collieries workshops at Walkden Yard, being purchased for scrap in 1936.

J. H. Hewitt, thirty-eight, of Atherton, manager of Astley Green Colliery was one of the casualties after an explosion occurred during fire-fighting operations. He started his mining career as a pit lad aged eighteen, rising to undermanager at Astley, then manager at St Georges and Gin Pit, Tyldesley, for sixteen months, returning to manage Astley in early 1938. The waste area behind a coalface in the Crombouke seam was ablaze, known as a 'Gob fire', a difficult incident to tackle, and Mr Hewitt being a 'hands on' type of pit manager was in the thick of the action. The district had to be sealed off to starve the area of oxygen until the bodies could be recovered. In total, five men died and four were injured after the blast on Wednesday 7 June 1939. Note his style of dress, even for the colliery manager of a large concern such as Astley Green, basically his old suit and waistcoat and trousers tucked in his socks. Mr Hewitt is holding a Wolf 'Baby' lamp, a compact version of an official's gas-detection lamp and a rechargeable electric hand lamp. An explosion and fire in the same seam occurred on 18 May 1967 without casualties, but leading to the district having to be sealed off for six weeks.

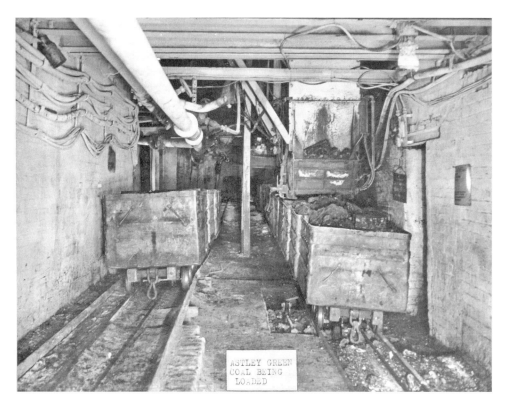

Underground overhead tub loading point at Astley Green Colliery. Men working on these were kept very busy loading 'sets' of tubs up and lashing them by chain to the slowly moving endless-wire-rope haulage system. Any delays or stoppages here would feed back to the coalface and a great deal of 'earache' would ensue for the men at this point!

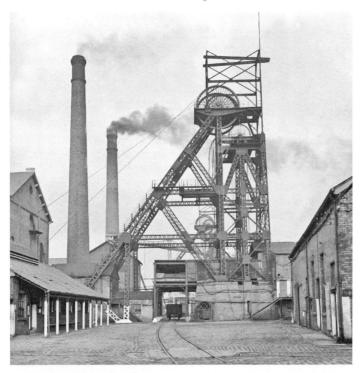

A good clear view of Astley Green from the pit gates, taken around 1960. No. 1 Pit headgear (still on site today) is in the foreground with No. 2 in the distance. Sixteen boilers fired partly by methane from below ground were linked to the two tall chimneys. The covered area to the left is alongside the lamproom, the building to the right which still survives today at the museum site was used as a garage and workshop with the rescue room above.

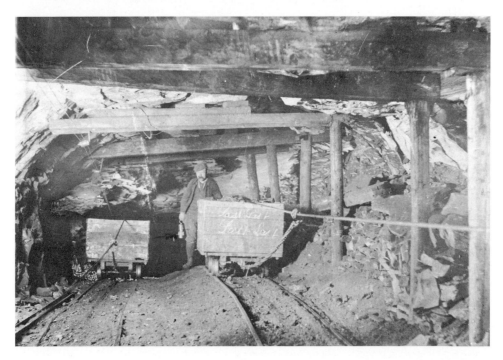

The year is 1898 and Bamfurlong, Wigan, colliery undermanager T. F. Ritson stands alongside a tub of coal being wound up a steep incline. The tub is 'lashed' with an iron chain and hook onto the endless-wire-rope haulage rope. The roadway is in rock and requiring substantial timbering. Undermanagers delegated for the colliery manager below ground and often held manager's qualifications rather than just second-class certificates.

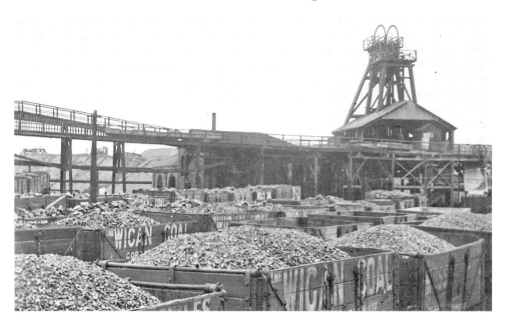

Bamfurlong Colliery No. 1 Pit around 1934 with its elevated tub circuit and a sea of Wigan Coal Corporation wagons in the foreground. The colliery was sunk by Cross, Tetley & Co. Ltd, c. 1866. By 1926, the Mining Industries Act encouraged rationalisation and amalgamation of mining concerns. Wigan Coal Corporation Ltd was formed on 1 August 1930. The colliery only lasted a few years under WCC control, closing in 1936.

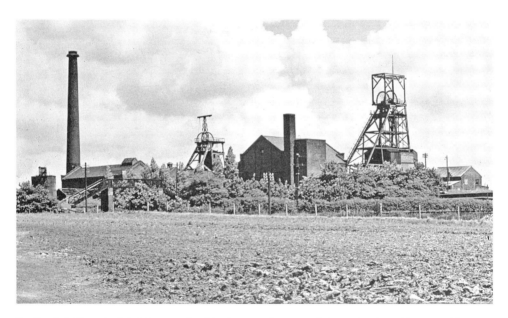

Bedford Colliery, Leigh, No. 1 and 3 Pits (431 and 880 yards) seen in the mid-1960s. The first pits in the area dated back to c. 1830. No. 1 was sunk by John Speakman from 1874 onwards. An explosion on (of all days) Friday 13 August 1886 killed thirty-eight men and boys. No. 3 Pit was sunk long after 1 and 2 in 1913-16. The colliery closed due to exhaustion of reserves in October 1967 with 581 miners and 131 surface workers heading off to the remaining collieries in the area.

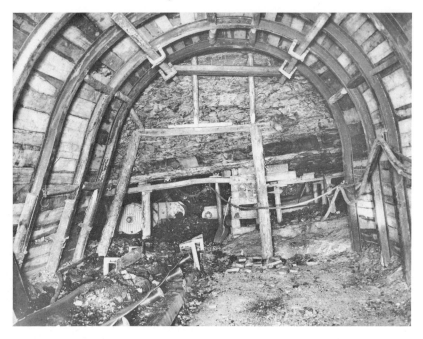

Bedford Colliery, Leigh, 1954. A view from the coal conveyor road towards the hand-filled coalface with 'ripping lip' temporary supports in place. The steel 'ring' supports have sliding base legs which allow a certain amount of roadway convergence. The two girders in the roof (horseheads) allow new top sections of rings to be temporarily supported during setting after bringing down the rock above the coal.

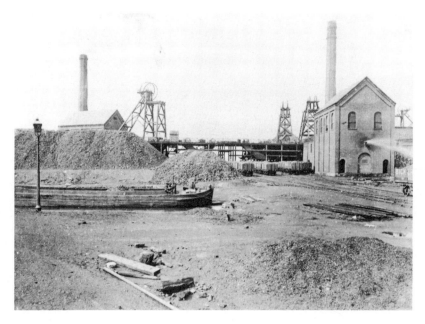

A view from the south of the Ackers Whitley Ltd Bickershaw Colliery, Leigh, in 1887. No. 1 Pit, No. 3 Pit, No. 2 Pit and No. 4 Pit can be seen. This shows how open early collieries were in surface layout with raised coal stacked in large 'heaps'. The pit had its own canal loading basin off the Leeds & Liverpool (Leigh) branch.

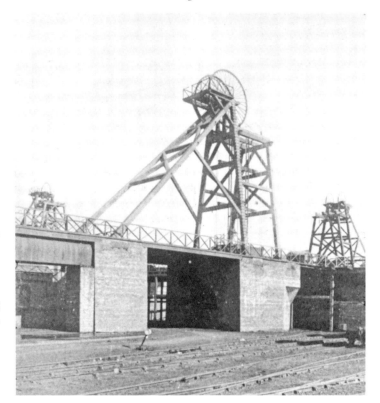

Bickershaw Colliery No. 3 Pit seen in 1887. This was 18 feet in diameter and sunk to 650 yards from 1877 to 1881, then to 779 yards from 1933 to 1938. The raised pit bank is typical of the period with the headgear mounted on a substantial brick shaft 'collar'. This allowed a network of tub circuits with hand tippler screening and loading of wagons to operate. No. 4 upcast pit (1881, 749 yards) is to the left, No. 2 Pit (1877, 479 yards) stands to the right.

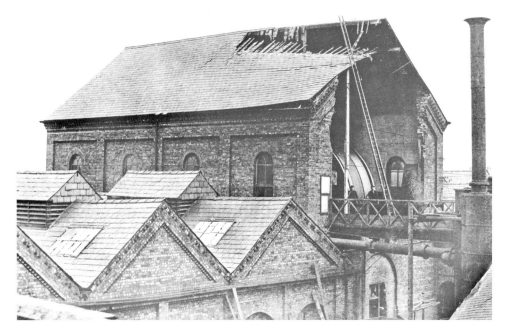

Bickershaw Colliery, damage to the winding engine house after the overwind at No. 3 Pit of 10 October 1932. The rising cage was detached from the winding rope by the detaching hook and held within the pit headgear, its winding rope and capel smashing through the roof. The twenty men in the descending cage plunged into the shaft sump, only one surviving.

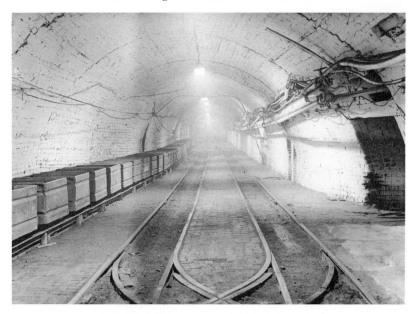

Bickershaw Colliery No. 3 Pit bottom around the early 1960s when tub transport was still in full flow. After the linking of Bickershaw Colliery, Parsonage Colliery and Golborne Colliery by 1977 conveyor coal transport was used; skip winding at nearby No. 4 Pit then took all the coal from the three pits, initially over 27,000 tons per week.

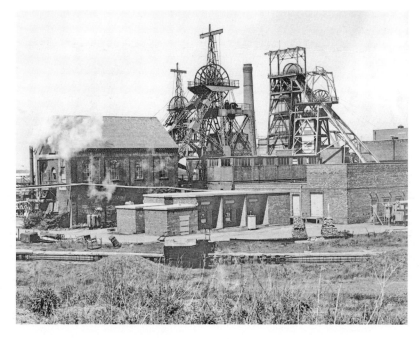

The view most Leigh people will remember of Bickershaw Colliery. Taken in the mid to late 1970s, this still has the canal loading ramp in place for coal barge transport to Westwood Power Station, Wigan, the last journey being on 11 August 1972. From the left: No. 3, No. 1, No. 4 skip winding shaft and No. 2 upcast shaft. The pit closed along with Parsonage Colliery in 1992. Golborne Colliery had closed earlier in 1989.

Castle Drift, Billinge, near Wigan, in September 1983 at the time the drifts were being driven. Old pit tubs with draw hooks as used by men and ponies supplied by contractors the Associated Tunnelling Co. of Lowton. Conveyors were to replace these when the pit began production. This short-lived drift (the author ended up working here for six months) accessed shallow reserves of the Orrell Yard but was plagued by water, bad ground and the coal market at the time and had closed by 1990. (Alan Davies, 1983)

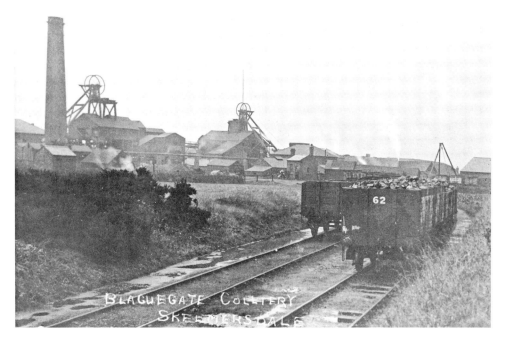

Coal mining in Skelmersdale probably dated back at least to the early eighteenth century. Up to twenty mining sites were active by the late nineteenth century. The area's collieries of the last century are sadly poorly documented as regards photographs. Here is a rare postcard view of Blaguegate Arley Pit around 1920. This had closed by 15 February 1933 and was abandoned the following year.

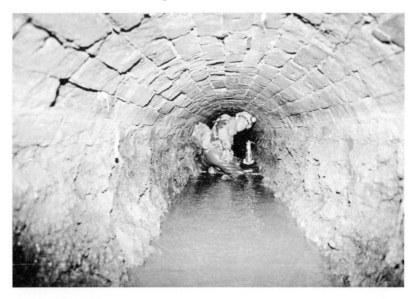

In 1991, the first and only photographs ever taken (by the author) inside Sir Roger Bradshaigh's Great Haigh Sough gave a glimpse into this seventeenth-century feat of mining engineering. The sough had last been travelled in 1923. Driven from 1652 to drain cannel coal workings, the first 1,121 yards took sixteen years. It was later extended between 1676 and 1866 to reach Aspull Pumping Pit at 4,600 yards. In 2009, the sough was intercepted part way in with a diversion system to treat the ochreous water emerging. (Alan Davies, 1991)

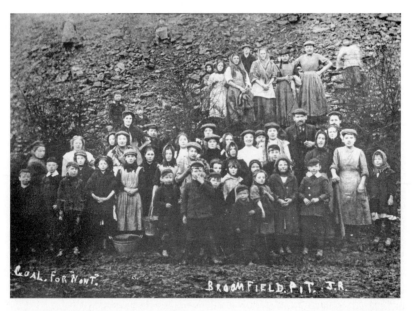

Miners' strikes begin to be documented photographically from around the 1890s. The search for coal on the waste tips, soup kitchens, and the attendance of police and military were the usual subject matter. Here in 1912 local photographer 'J. R.' has produced a postcard entitled 'Coal For Nowt'. Taken at Broomfield Colliery, Standish, west of Wigan, all the family is at work scavenging for scraps of coal or dirty coal which had passed through the picking sheds. This tip caused problems in 2002 when fires within it created fumes which headed towards nearby housing.

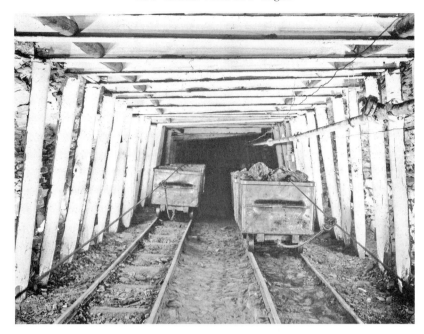

Over 600 yards below ground, whitewashed props with steel girders support the main 'over rope' type endless-rope haulage road at Fletcher, Burrows & Co.'s Chanters Colliery, Atherton, in 1929. These systems ran virtually continuously, tubs being 'lashed on' at various points while the rope was moving slowly, a dangerous practice which led to many fingers being lost.

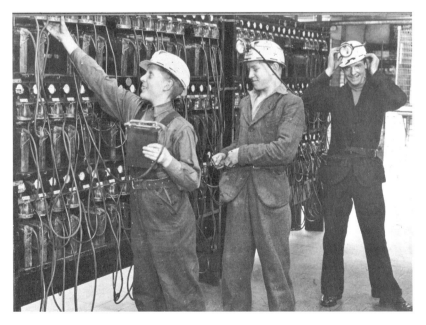

The wartime shortfall in coal production meant that by 1943 mining 'optants' and Bevin Boys were brought into the industry, some being trained at Chanters Colliery, Atherton. The training gallery was opened at Chanters No. 2 by January 1943. In the first year, 328 new entrants and refresher trainees from all the Manchester Collieries pits except Bradford passed through, including 132 Bevin Boys.

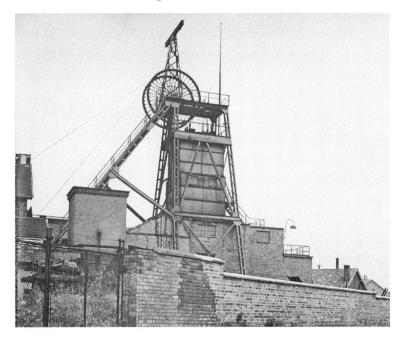

Chanters Colliery No. 2 Pit, Tyldesley Old Road, Atherton, was sunk by John Fletcher & Others around 1850 and later deepened to 600 yards. This was the upcast ventilation shaft, hence the casing around its structure to stop short circuits of surface air finding its way to the exhausting fan. The pit headgear in shot was made by Naylors of Golborne and replaced the earlier wooden one in 1926. The colliery closed in June 1966, this photo dating to 1967 just before demolition.

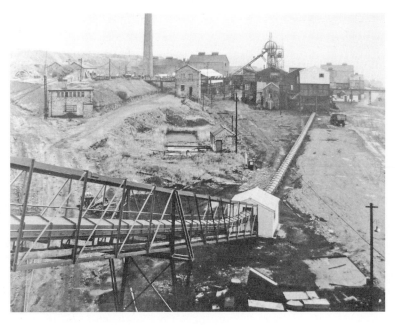

Cleworth Hall Colliery, Tyldesley, in the 1950s. Three shafts were sunk by Tyldesley Coal Co. Ltd between the 1870s and 1914, reaching the Arley seam at 681 yards. The company also operated Yew Tree Colliery, Peelwood & Combermere Collieries and Bank House Colliery. By 1929, it formed part of Manchester Collieries Ltd, closing in 1963.

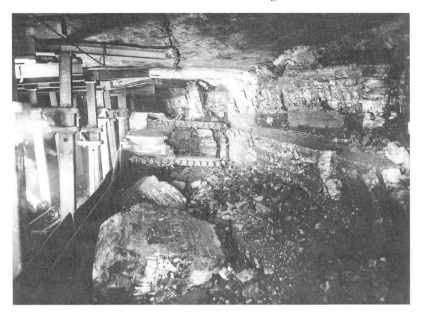

A Denaby coal cutter at work on the face at Cleworth Hall Colliery around the early 1950s. After nationalisation in 1947, mechanisation teams trialled many coal cutters. Here, two chain-driven cutting jibs cut to a depth of 4½ feet and ensured large coal was more likely to be produced. The upper jib is set to cut the dirt band. In Cleworth's closure year of 1963, 554 miners and 117 surface workers produced 113,911 tons of coal.

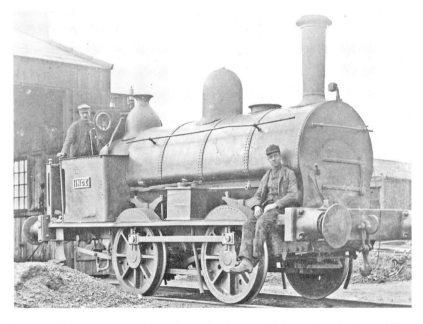

An early image of a Lancashire colliery loco, the four-coupled, inside cylinder, saddle tank *Ince*. Unusual in the very well-researched world of railway history as being of an unknown maker (Haigh Foundry perhaps?), it is known that it was transferred from Rose Bridge Colliery, Ince, near Wigan, on closure in 1894 to Douglas Bank Colliery, Wigan. It was eventually scrapped in 1921.

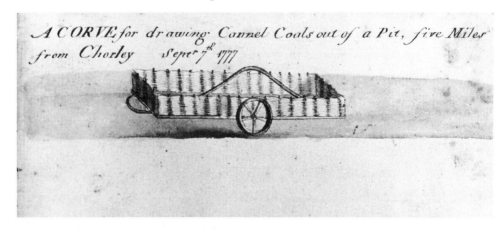

Amongst some documents which turned up at auction in the 1990s was this fascinating and rare sketch of a very unusual coal cart in use at 'a pit, five miles from Chorley' (tying in with the location of Haigh, home of Wigan's famous cannel pits) and dated 7 September 1777. It is of wicker-layered construction hence being called a 'corve', the term reserved for baskets. Running on the rough ground without rails, the loop at the front may have been for the attachment of a draw rope and hook for human haulage (often women and children) with the side handle for tipping.

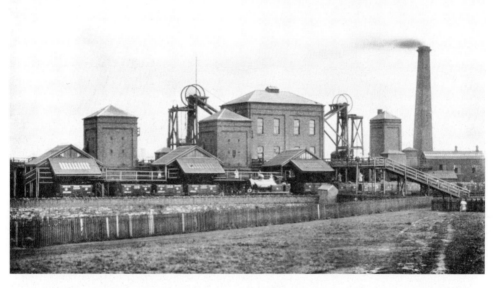

One of Wigan Coal & Iron Co. Ltd's show pits in terms of surface layout was Crawford Pit, Aspull, north of Wigan. Seen here around 1908 a central winding engine house containing two vertical steam engines serves both shafts, sunk in the 1840s. No. 1 Pit accessed the Bone seam at 223 yards, No. 2 the Arley seam at 318 yards. Closed in 1928, the workforce being 251 miners and fifty-nine surface workers.

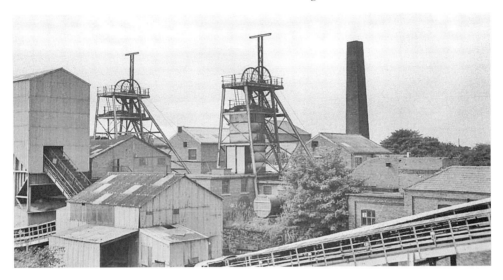

Ellerbeck Colliery, near Chorley, in September 1965, one month after closure. Hilton House and Red Moss Coal Co. Ltd sank the first shaft in 1876. The colliery closed in 1928-29. After small-scale operations, a few partners operating as Blackrod Colliery Co. ran the colliery successfully from 1932. Nationalisation arrived in 1947, and by 1958, Ellerbeck Colliery was employing 411 men with women in the screen sheds and raised its peak output of 174,172 tons.

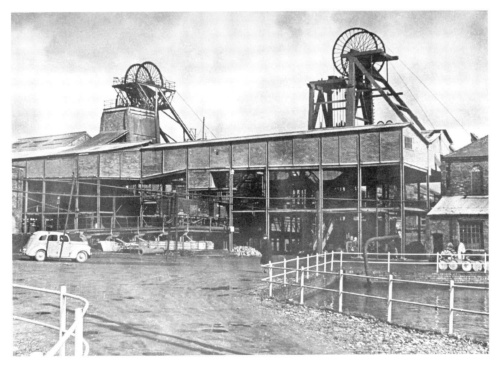

Garswood Hall Colliery near Ashton in Makerfield, Wigan, in the late 1950s. No. 6 Pit (sunk 1888 to 659 yards) upcast shaft is on the left and No. 5 downcast (sunk 1887 to 145 yards) on the right. The colliery ceased coal production on 15 August 1958 after raising 192,781 tons in the preceding year. A total of 910 men lost their jobs, a number being transferred to Sutton Manor Colliery and Bold Colliery, St Helens.

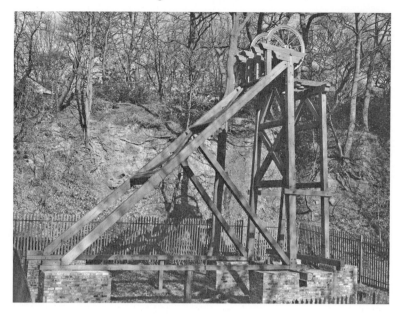

Bispham Hall Brick & Terracotta Company's Gauntley Colliery, Billinge, near Wigan, still used a wooden pit headgear until it closed in 1979, Lancashire's last example. By the time of the photograph in 1981 and through the hard work and influence of Donald Anderson, mine manager, historian and owner of Quaker House Colliery, Winstanley, south of Wigan, it had been remounted within the Plantation Woods at Haigh. Sadly, it was neglected and fell into a ruinous state, the remains being taken to Astley Green Colliery museum. All that remains now are the pulley wheels. (Alan Davies, 1981)

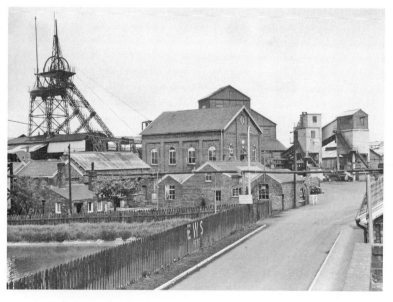

The 411-yard-deep Gibfield Colliery Arley Pit, off Wigan Road, Atherton, after the announcement of closure in August 1963. Mining on site dated back to the late eighteen century accessing the top-quality Trencherbone or Five Feet seam. The arrival alongside of George Stephenson's Bolton to Leigh Railway in 1828-29 gave a boost to potential markets for the coal. In its final year, 715 miners and 116 surface workers were employed.

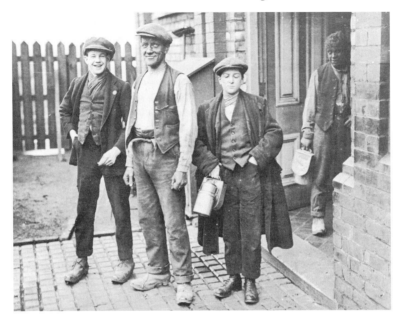

Captioned 'Before and After', this photograph of Gibfield Colliery mineworkers was taken in late 1913 or early 1914 shortly after the pithead baths were opened, the first in Britain. Philanthropic colliery owners Fletcher, Burrows & Co. Ltd had gathered information on European collieries where baths had been in use and decided to set up their own, even though legislation did not demand it.

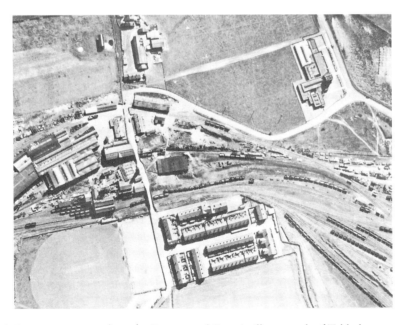

Gin Pit (1850-1955, 371 yards to the Brassey and Rams) village, south of Tyldesley around the early 1950s. Isolated in the fields, this really was a miner's settlement in the old-fashioned sense. Gin Pit is adjacent to the housing while Astley & Tyldesley Coal Co. Ltd's Nook Colliery (1848-1965, five shafts, deepest 945 yards to the Arley) was to the middle right just off the photograph. The houses still stand today, as do the 1937 pithead baths for Nook Colliery top right.

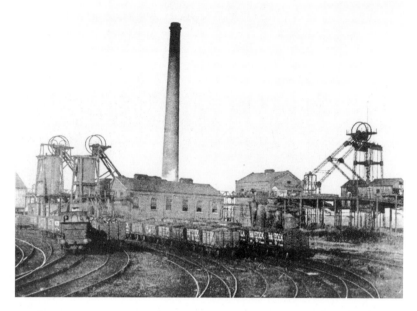

Golborne Colliery seen in 1927, from owner Richard Evans & Co. Haydock Collieries Co. Ltd's booklet *The Romance of Coal*. From the left we see Nos 2 (upcast, eventually 589 yards), 1 (143 yards) and 3 (downcast, 598 yards) pits were sunk in 1882. Mining was active on site from 1878 under Edward Johnson, who began the sinking of Nos 1 and 2 Pits until Evans & Co. purchased the colliery in 1880.

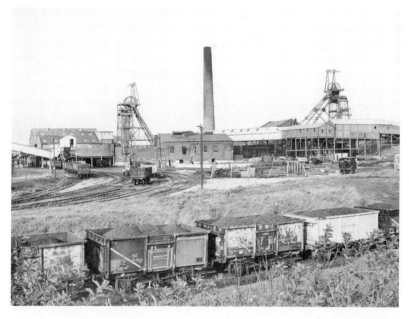

An interesting comparison view of Golborne Colliery from around 1975. By now No. 1 Pit had been filled in, the headgear dismantled. A steel headgear now stands above No. 2 upcast shaft. The tall chimney has been shortened, as often happened at collieries and mills. In 1975, Golborne employed 801 miners and 184 surface workers. Seams mined were the Crombouke, Lower Florida and Ince Six Feet.

The driver of a car entering Golborne Colliery is questioned by pickets during the long miners' strike of 1984. Lancashire miners had originally been lukewarm about striking (asking for a ballot) which was already taking place in Yorkshire. The Lancashire National Union of Mineworkers leaders announced on 22 March that the strike was official. Sensitivities were high at Golborne being a close-knit mining community. The strike officially ended on 3 March 1985, giving the Conservative government free reign to decimate the industry for purely political reasons.

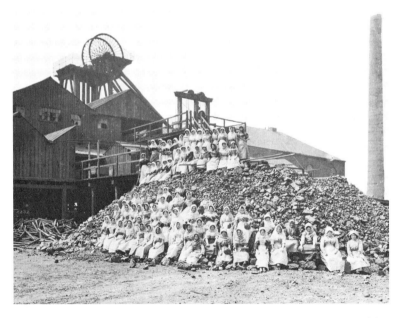

Ince Moss Colliery No. 4 Pit, Lower Ince, south of Wigan, around 1910. One of five shafts on site, sunk to 169 yards in 1874 by the Pearson & Knowles Coal & Iron Co. Ltd. Seventy-three 'pit brow women' are visible in the photograph near the coal screening sheds. The women 'cleaned' the coal by separating out dirt and dirt attached to coal. Women still worked at the colliery when it closed on 14 January 1963, 336 miners and ninety-three surface workers losing their jobs.

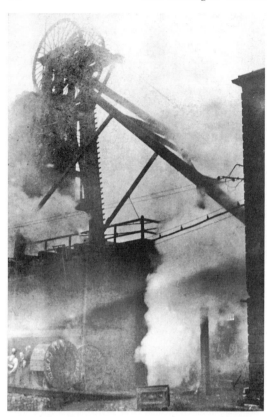

Left: A dramatic photograph of smoke and fumes emerging from Ince Moss Colliery upcast shaft and headgear casing in 1937. A fire had taken hold near the Ravine seam shaft inset mouthing necessitating the attendance of a team from Boothstown Mines Rescue Station.

Below: Ince Moss Colliery in the late 1950s. In shot is the neat and tidy North Western Division, Area No. 2 (Wigan) Stocking Ground, its travelling crane unloading steel-arch roadway supports.

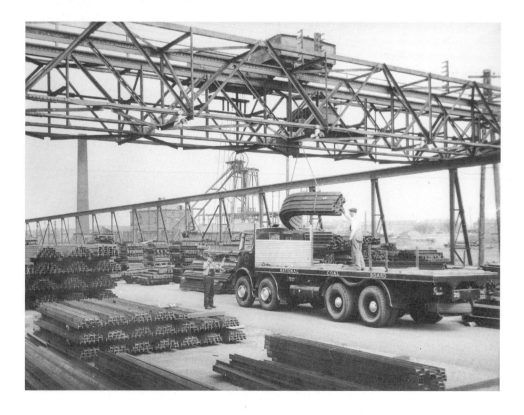

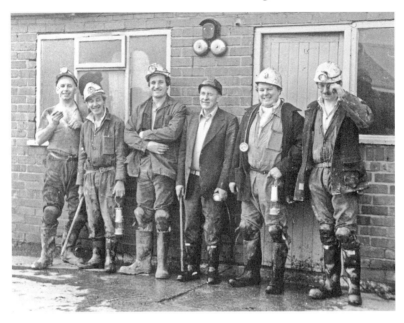

Officials, miners and the Mines Inspector stand in 1981 outside the offices at Leyland Green Drift, a small licensed mine situated off Leyland Green Road west of Garswood. After nationalisation in 1947 private coal mining was allowed to be carried out under licence, the workforce limited to thirty men below ground. At the time of the photograph, the mine (driven in 1972) worked the Wigan Four Feet and Five Feet seams employing around thirty-two miners and ten surface workmen. Operated by Quaker House Colliery Co. Ltd which also owned nearby Quaker House Colliery. That worked the Wigan Six Feet and employed approximately thirty-one miners and ten surface workmen. From the right: colliery manager John Anderson, -?-, the Mines Inspector, Donald Anderson mine owner, agent and mining historian, a miner, undermanager Mr Williams, a miner. Leyland Green closed around 1986. (Alan Davies, 1981)

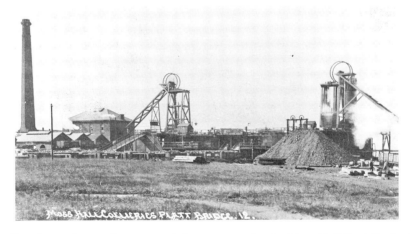

Low Hall Colliery, Platt Bridge, was sunk from c. 1851 by the Moss Hall Coal Co. In this postcard view of around 1905, we see No. 6 downcast shaft to the left with No. 5 upcast shaft on the right, both with wooden headgears. The company operated eight shafts in total on site. An explosion on 15 November 1869 killed twenty-seven men and boys. The colliery closed when No. 5 Pit was abandoned in 1931.

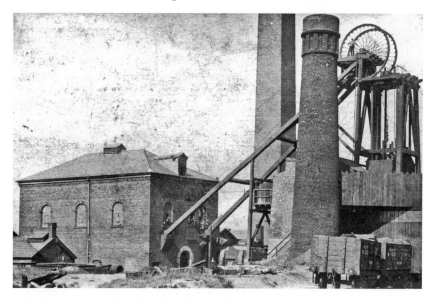

A closer view, possibly around 1900, of Low Hall Colliery No. 5 upcast shaft. This was sunk from around 1851, later reaching the Arley seam at 526 yards. Note the furnace ventilation chimney alongside the shaft. This was linked to the shaft via a short inclined tunnel diverting fumes away from the pit bank. The man stood next to the headgear pulley wheels gives an idea of their scale. In the early years of the NCB, a training centre for Wigan-area miners was operated at the Low Hall Colliery site.

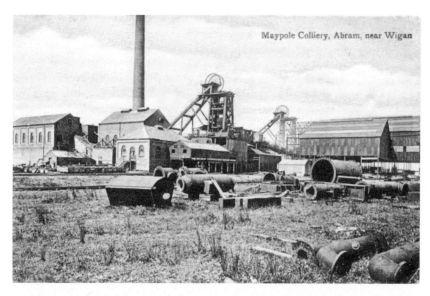

Maypole Colliery No. 1 and 2 Pits, Abram, south of Wigan, was sunk by the Moss Hall Coal Company from April 1895. Seams worked included the Haigh Yard, Wigan Six Feet, Pemberton Five Feet, Bickershaw Six Feet, Bickershaw Seven and the Arley Mine. This postcard view was taken a few days after the explosion of Tuesday 18 August 1908 which killed seventy-five men and boys, three survivors escaping via a connecting road to Wigan Junction Colliery. The remains of many of the victims were only to be gradually found over the following years.

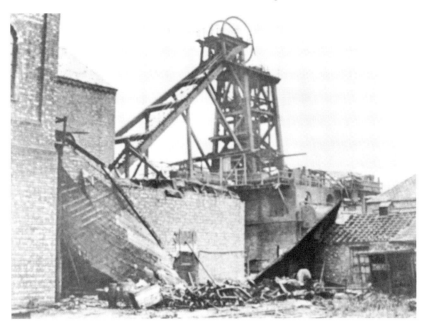

Blast damage at Maypole Colliery No. 1 upcast shaft after the explosion. The blast shock wave smashed apart the ventilation surface fan drift along with wooden shuttering around the pit headgear. The fan exhaust now has two wooden bars holding back temporary covers (near the pile of tub axles). Maypole Colliery was abandoned in March 1959, many of the 1,093 miners and 291 surface workers moving to remaining pits in the area. Interestingly, the colliery chimney survived until 2009.

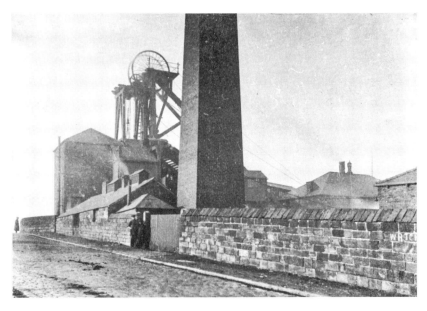

Meadow Pit, Meadow Pit Lane, Haigh, north of Wigan, around 1910. This was on the site of early mining activity dating back to 1780. Reopened and deepened in 1851 to work the Arley seam at 947 feet, it was raising 60,000 tons a year by the 1860s under Wigan Coal & Iron Co. Nearby William Pit served as the ventilation upcast shaft. By 1924, 462 miners and ninety-nine surface workers were employed on site. Closed in May 1927.

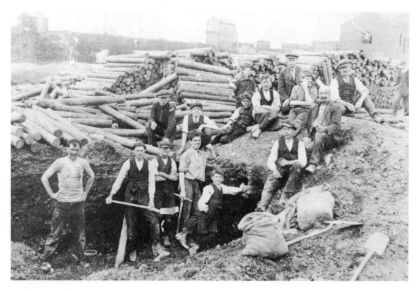

Miners on strike at Mosley Common Colliery, near Boothstown, in 1921. The colliery company is allowing them to dig coal waste in the prop yard. The mines had been returned to private ownership by 1921 following the First World War era of government control. The men had improved their pay and conditions during the period 1917-21, but were now back to square one with a three-month strike to maintain the levels attained.

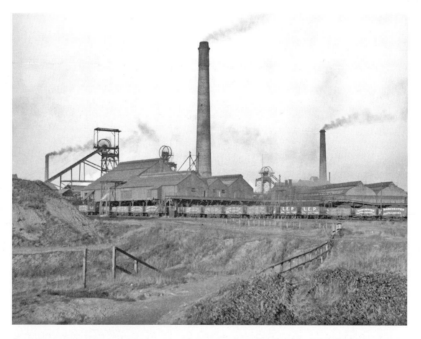

An early 1940s view of No. 2, No. 1 and No. 4 Pits, Mosley Common Colliery. A large colliery with huge coal reserves lying to the south and heading to ever-greater depths (beyond 1,000 metres below ground). The long line of private-owner coal wagons includes Manchester Collieries and Lancashire Electric Power Co. The five shafts on site were initially sunk at depths ranging from 332 yards to 588 yards by the Trustees of the Duke of Bridgewater from 1861 to 1885, accessing sixteen workable seams.

An unusual but effective approach to coal cutting at Mosley Common Colliery came in the early 1960s with the use of a coal plough in the Binn seam. This seam, in a six-foot section, had a two-foot dirt band above the lower three feet of coal. Ploughs had seen use in Germany and were basically a steel frame with cutting teeth attached. A steel-wire haulage rope was attached which could drag the plough cutting into the coal in one direction, later modified to cut both directions. As the plough cut the seam base the top coal and dirt would fall, the unit then ploughing the coal onto a conveyor alongside. Cast 'Schlom' link bars and friction props support the face in the photograph, also German in design origin.

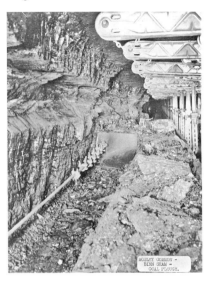

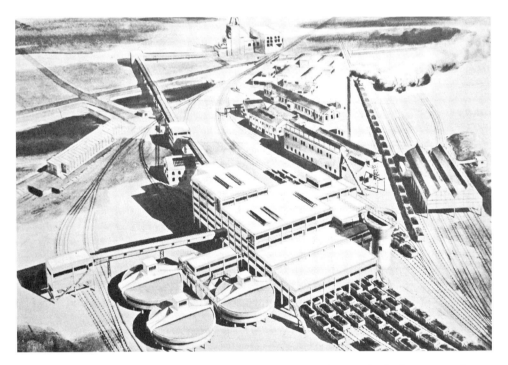

Sir Humphrey Browne had been a director of Manchester Collieries who had commenced reorganising Mosley Common Colliery. After nationalisation in 1947, he became Deputy Director of the NCB and pushed to continue the scheme. He was aware of the vast reserves of coal south of the adjacent Astley Green Colliery. The reserves of Mosley Common had been assessed at 145 million tons. After nationalisation, two of the shafts were deepened to 1,000 yards, another widened from 12 feet to 22 feet. Phase 1 was completed by 1957, including building the largest coal washery in Britain, capable of washing 600 tons an hour, dominating this architect's drawing. Phase 2 was completed by 1962, including the installation of the most powerful colliery winding engine in the world at No. 3 skip winding pit, a Ward Leonard electric 2 x 4,500 hp (9,000 hp) system. At times, the pit had the most men on the books at any colliery in Britain. By 1962, there were 2,641 miners and 428 surface workers employed.

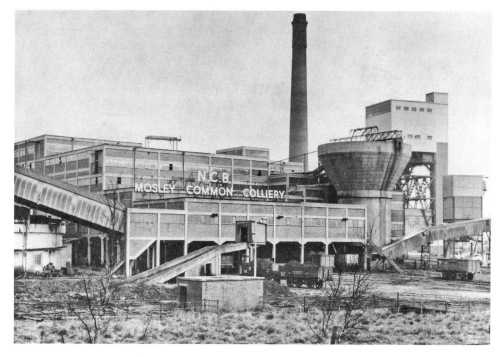

The view from the East Lancashire Road of the massive washery and new overhead 'Koepe'-type winder at Mosley Common Colliery. By the 1950s, the pit was becoming the sink for men from closing collieries such as Moston, Oak and Woodpark Oldham, with hundreds being taken on at a time. In an era of many alternative jobs, wastage of manpower averaged around 400 a year. A ban on the recruitment of outside labour stopped this in late 1957. Around this time, the number of strikes at the pit began to increase, with eight in 1958. At work, some men were taking an hour to get to their coalfaces in the Crombouke seam over a mile from the pit bottom, and an hour back, a huge waste of man time. The NCB pressurised the colliery to improve output to offset losses; this was not achieved, and the colliery closed, ceasing production on 9 February 1968, leaving behind over 100 million tons of coal.

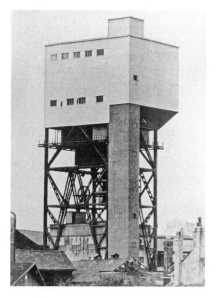

The landmark feature in a visible sense at the end of the reorganisation of Mosley Common Colliery was the continental-type overhead 'Koepe' winding system in use at the 1,000-yard-deep No. 4 Pit. A 2500-hp AEI Vickers electric winding engine with a 12-foot-diameter by 6-foot-wide drum was mounted directly above the shaft winding the single cage as a balance rope travelled the other side of the shaft. Winding rope length was 1,100 yards; the cage had three decks, each of which could carry a 6-ton mine car or fifty men per deck unloaded simultaneously. Nearby No. 3 shaft had been converted to skip winding with a massive 9,000-hp AEI DC electric winding system. This raised 12-ton skips with a 5,000-ton-a-day capacity, the most powerful ever used at a British colliery.

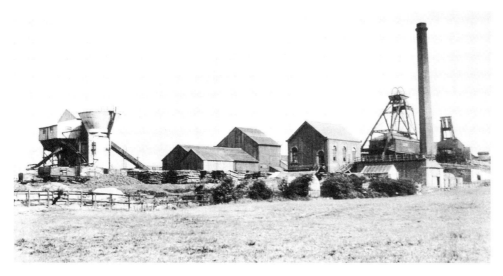

James Roscoe & Sons Ltd (Peel Hall Collieries Ltd), New Lester Colliery, Mort Lane, Tyldesley, was sunk around 1867. A small colliery as regards the area of coal it accessed, but with six seams available: the King, Yard, Denner Main, Arley, Four Feet and Plodder (deepened to 535 yards in the mid-1890s to access the top-quality Arley seam). Although small, it boasted a coal-washing plant and survived until 1944, when 480 miners and 190 surface workers had been employed. An old miner told me around ten years ago of a miner who died at the pit in the 1930s, his body being delivered to his house on the back of a coal cart.

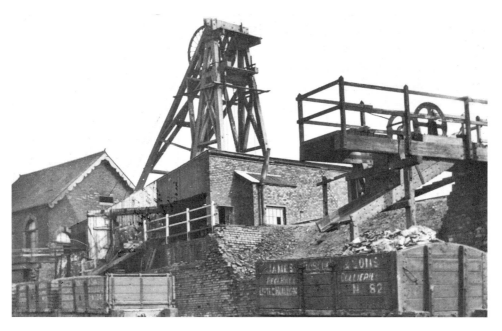

A close-up view of the 1,413 foot deep No. 2 Pit at New Lester Colliery showing its distinctive 'trestle'-type wooden pit headgear dating to around 1866. A similar type was in use at the company's other pit three quarters of a mile to the north: Peel Hall. On the raised-level pit bank to the right is a hand tub tippler with a shute feeding directly into the waiting James Roscoe & Sons (Peel Hall Collieries Ltd) four-plank wagon. The colliery was linked to the nearby Lancashire & Yorkshire Railway via Peel Hall sidings a quarter of a mile to the north.

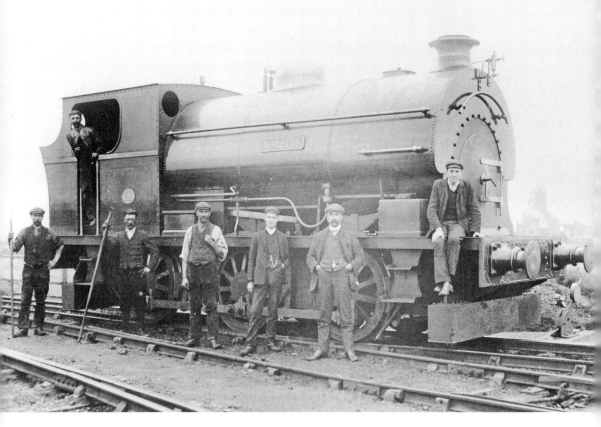

Driver Ludovic Berry on the footplate of loco *Dorothy* at Platt Bridge around the late 1920s. Colliery and industrial locomotives in general have a wide and well-documented following as regards their working lives. Loco *Dorothy* had a normal working life, but one which was brought to an end in a unique manner. Moss Hall Coal Co. Ltd purchased the impressive Class X2 six coupled-wheel internal-cylinder saddle tank in 1908 from Pecket & Sons of Bristol. On 30 April 1945, driver Ludovic Berry was shunting a load of thirteen loaded wagons near the site of the old 12-foot-diameter, 334-yard-deep, New Zealand No. 7 Pit shaft, Platt Bridge, south of Wigan. The line passed directly over the shaft, which had been filled in 1931, with a rail joint over the shaft centre. The rails split as the ground opened up below, the last wagon entered the shaft and began to pull the train of wagons backwards down the shaft. The brakesman shouted to the driver, who applied the brakes yet stayed on the footplate. The whole train and loco plus driver were pulled into the shaft, jammed with the loco visible around 20 yards down. The driver was never recovered, the shaft was refilled and in the 1990s, despite family requests to try to recover the driver and loco, the Coal Authority insensitively drilled and grouted the infill at the shaft top. A memorial is now in place near the site of the accident.

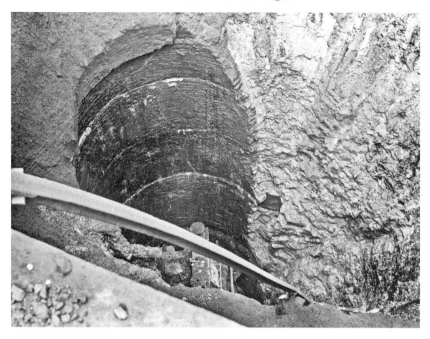

Low Hall Colliery New Zealand No. 7 Pit shaft collapse of 30 April 1945. The collapsed 12-foot-diameter shaft infill and walls after loco *Dorothy* was pulled back into it along with thirteen wagons. One of the loco's buffers can just be seen along with a length of rail. Note the shaft curbing rings spaced about every twenty courses of brick and keyed into the rock. Shafts were, in a sense, a series of separate walls resting on curbing rings. Curbing rings were often in four or more sections and made from either timber or cast iron.

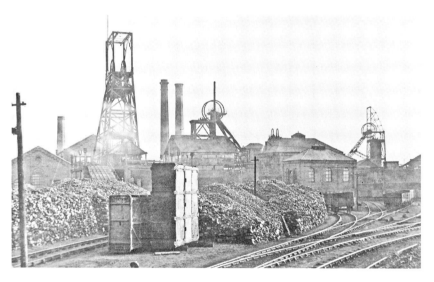

Astley & Tyldesley Coal & Salt Co. Ltd, Nook Colliery Nos 4, 3, 1 and 2 Pits, Tyldesley, around 1936. Another shaft No. 5 Jubilee Pit is out of view to the right. Sunk from around 1864, No. 4 reached 944 yards, accessing the famous Arley and eighteen other workable seams. The heat was oppressive working at that depth, often reaching 100 degrees Fahrenheit at the coalface, where men were supplied with water barrels and salt tablets. Two spare pit cages can be seen in the foreground.

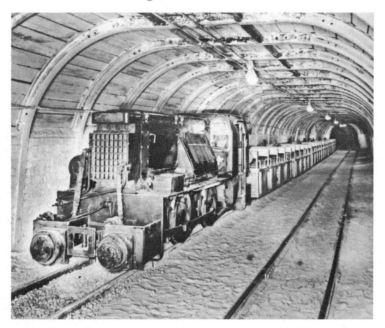

Nook Colliery, Tyldesley, in the late 1940s. A Hunslet Engine Co. Ltd of Leeds flameproof diesel locomotive, in use for hauling the manriding train at the No. 4 Pit Arley level. The level had been driven in 1945-46 over a mile to the east of the colliery. This was one of the first such installations of loco haulage in the Lancashire coalfield. Capable of giving the men a frightening and no doubt hard 12-mph ride and able to work a gradient of up to 1 in 20, it was one of 150 ordered by the NCB at the time.

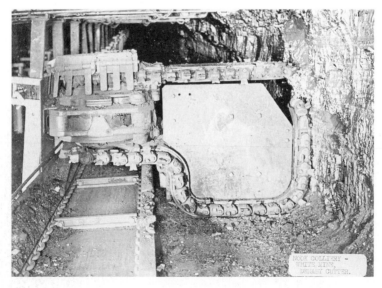

Nook Colliery White Mine coalface with a Denaby coal cutter-loader mounted on the armoured scraper bar conveyor, mid-1950s. Four feet four inches of mixed-quality coal suited the trial of this equipment, expected to produce more large coal due to the jib layout. In practice, the cutter suffered from a lack of power and reliability. The cutter was also trialled at nearby Cleworth Hall Colliery. Friction props and cast link bars support the faceline.

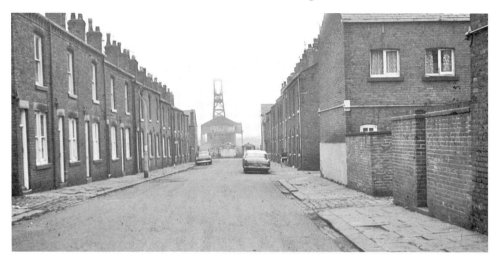

Peace Street, Gin Pit village, Tyldesley, in the mid-1960s with Nook Colliery No. 4 Pit in the distance. If ever there was a classic colliery community view of the period, this is it. Astley & Tyldesley Coal & Salt Co. Ltd built the housing after 1874, (naming the streets after their directors) *c.* 1880 with additional streets added by 1909. The village was, until a couple of years ago, isolated; since then, new housing totally out of keeping with the area's heritage has come close to the village, on the site of the old Gin Pit itself and the later Manchester Collieries and NCB Gin Pit Workshops. The village itself still has a lively community spirit with regular events taking place.

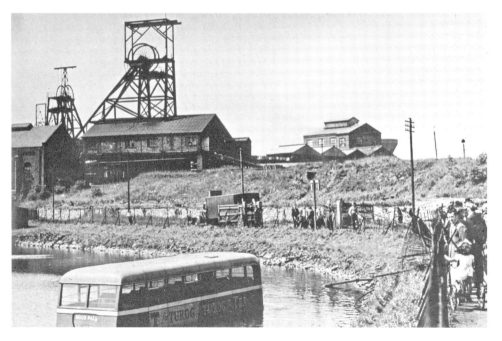

It is 3 August 1950 and the Lancashire United Transport pit bus has ended up in the lodge at Nook Colliery after hitting the kerb and going out of control. A group of miners who had just been dropped off by the bus ran back, some diving in to rescue the driver who was in his cab unconscious. In the background is, from the left, No. 3 Pit and No. 4 Pit, then the screens and washery.

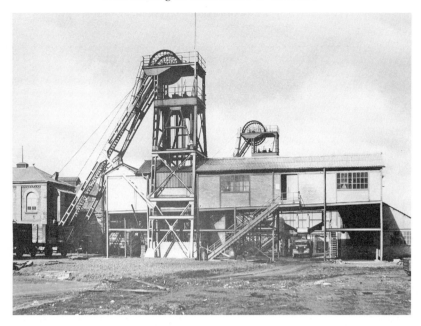

Park Colliery, Ashton-in-Makerfield, seen in the 1950s. No. 1 downcast pit (170 yards) is in the foreground with No. 2 (320 yards) behind. Three shafts were sunk in 1887 by J. & R. Stone Ltd who owned the colliery right up to nationalisation in 1947, the pit being nicknamed locally as Stones's. The colliery closed in June 1960, raising 195,165 tons in its final year, 350 miners and 108 surface workers losing their jobs.

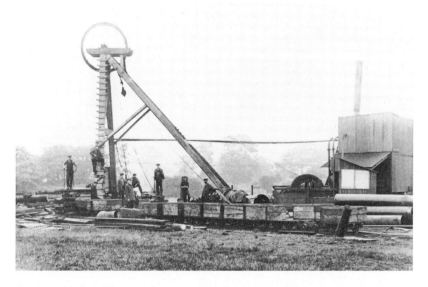

A rare photograph of a colliery sinking in progress, Park Pit, Winstanley Park, Wigan, around 1905. The Bankes family had owned the estate since 1596, mining the coal beneath their land for centuries. A simple tripod-type wooden headgear wound by a steam capstan engine is winding one tub at a time as the pit is developed. Sinking was an expensive process and only carried out after trial boreholes had proven a large enough reserve of coal to justify the outlay. Sinkers, being specialists, travelled the mining districts, moving from coalfield to coalfield, as did the men who drove drainage tunnels or 'soughs'.

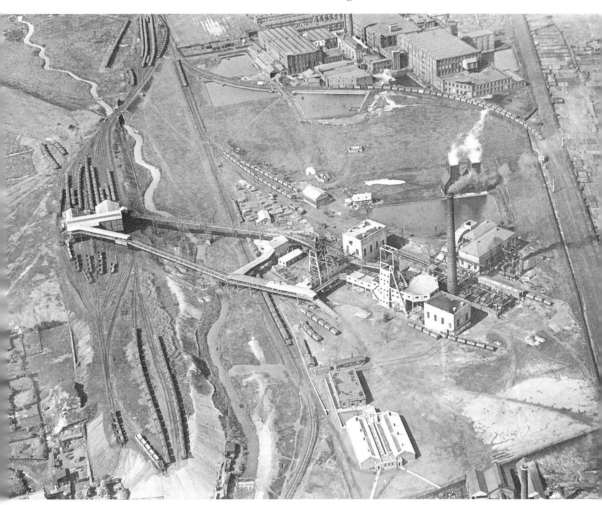

A fascinating 1940s aerial photograph of Wigan Coal & Iron Co. Ltd's Parsonage Colliery, Leigh. No. 2 downcast pit is to the left, its tub circuit linking it to the screens top left. The growing waste tip is being fed by the screens lower left. George Stephenson's Bolton to Leigh railway line of 1828-29 is to the right. The shafts were sunk by Wigan Coal & Iron Co. Ltd from 1913 to 1920, the delay due to the First World War. They eventually reached 1,008 yards, for many years the deepest shafts in Britain. No. 2 Pit was equipped with two deck cages, each holding 8 x 10-cwt tubs and wound by a Markhams of Chesterfield steam winder of 4,000 hp until 1978. The deep Arley workings reached around 4,000 feet below the surface with temperatures up to 118 degrees Fahrenheit, men often losing 7 lb in weight a day. The colliery ceased winding coal in 1983-84 when nearby Bickershaw Colliery became the winding point for the three-pit complex, Parsonage-Golborne-Bickershaw. The colliery closed in early 1992.

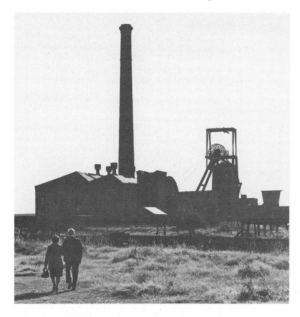

The distinctive outline of Parsonage Colliery No. 1 Pit headgear and tall chimney as seen in 1980 from the old Bolton to Leigh railway line (now the A579). No. 1 upcast shaft was for most of its life wound by a Galloways of Manchester steam winder of 3,000 hp installed in 1923, cylinders 40 inches by 6 feet stroke. The winding drum ranged from 16 to 22 feet in diameter. The first ventilation fan linked to it was huge, a Walker Brothers of Wigan Indestructible, 28 feet diameter by 9 feet wide, circulating 750,000 cubic feet of air per minute. A Howden radial flow fan from Maypole Colliery, Abram, was installed by Easter 1962 circulating up to 445,000 cubic feet per minute. (Alan Davies, 1980)

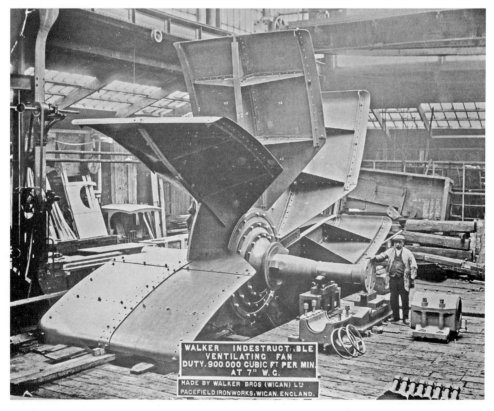

An idea of the size of a Walker Brothers of Wigan Indestructible fan rotor, a slightly larger version than that used originally at Parsonage Colliery, Leigh. By the late nineteenth century, these fans were much in demand, Walker's sending them to most parts of the British Empire. The one illustrated could exhaust 900,000 cubic feet of air a minute out of the upcast shaft, and was probably destined for a very deep South African metaliferous mine.

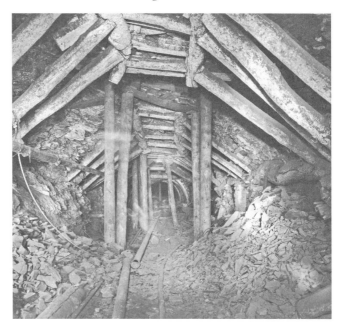

'Cockering' or Herringbone timbering in use in the Bickershaw Seven Feet seam down Parsonage Colliery. Examples dating back to the 1930s were still in place at the time; this photograph was taken on closure of the colliery in 1992. The author had a rare opportunity to photograph the workings using 'painted light' methods, and also collect documents and signs from the area. The white covering on the timber is stone dust thrown on to damp down any potential coal-dust explosions. (Alan Davies, 1992)

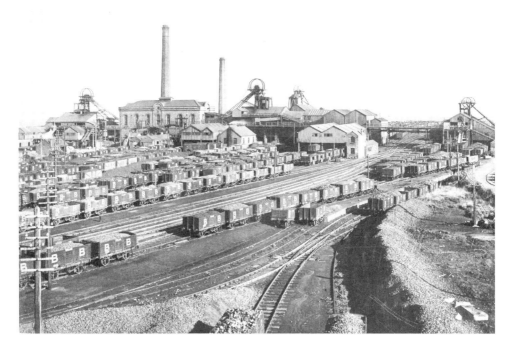

Blundell's Pemberton Colliery, Pemberton, south of Wigan, in October 1931. From left to right: Queen Pit, King Pit, Prince Pit, and the old Bye Pit (sunk from 1815 to 1827 to the Orrell Yard seam at 130 yards). The distinctive engine house served both the Queen Pit and King Pit, two 18-foot-diameter shafts sunk around 1870 to 633 yards and the Orrell Four Feet. In its early-twentieth-century heyday up to 250 pit ponies were stabled below ground. At the time of the photograph, 1,365 miners and 473 surface workers were employed. The company owned nearly 2,000 mainline wagons distinctively marked 'BB'. Closed on 3 November 1946, thus avoiding nationalisation by a few months.

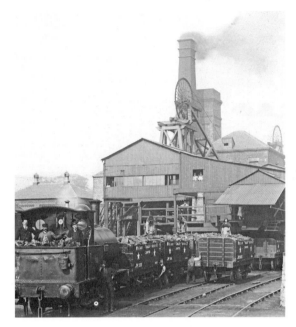

Prospect Pit Nos 1 & 2 Pits, Standish, west of Wigan, was one of the Wigan Coal & Iron Co. Ltd group. This image of around 1900 comes from one of their sales staff lantern slides. Neat screens layout and a central vertical steam winder serving both single-cage shafts. Alongside the engine house stands the square furnace ventilation chimney, 20,000 cubic feet per minute being circulated round the workings. Locomotive *Shah* is on duty with Ebenezer Rudd on the footplate. Built by Wigan Coal & Iron in 1874 to designs obtained from the LNWR works at Crewe in 1864. It ended its life at Clock Face Colliery, St Helens, in 1957. The colliery had been sunk 390 yards to the Arley seam around 1860, ceasing coal production around 1910, being retained for pumping until 1934.

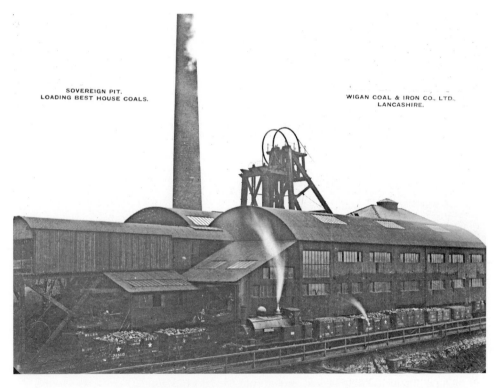

A Wigan Coal & Iron Co. Ltd sales lantern-slide image dating to around 1900 of Sovereign No. 1 Pit, Leigh. The label on the slide states 'Sovereign Pit, Loading Best House Coals'. WC&I sank the 651-yard-deep pit from late 1876 accessing the top-quality Arley seam. In view is loco *Crawford*, built at WC&I's Kirkless Workshops north of Wigan in 1883 (scrapped at Gibfield Colliery, Atherton, in May 1964). A few years after the opening of the adjacent Parsonage Colliery, Sovereign Pit closed in December 1927.

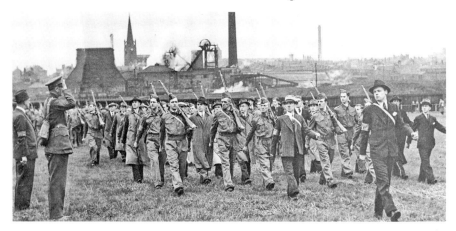

Joe Tinker, the miners' MP for Leigh. inspects in summer 1940 a march past by the local defence volunteers with St Georges Colliery in the background. The march past is taking place on the fields alongside Gin Pit Miners Welfare Hall. St Georges Colliery was known locally as Back O't Church Pit, sunk by Astley & Tyldesley Coal & Salt Co. in 1866 to the Rams seam at 234 yards. Another shaft, 16-foot-diameter No. 3, was sunk in 1883 to the Trencherbone seam, and in 1893, No. 2 enlarged and sunk further to the Arley seam at 786 yards. It was linked below ground with Chanters Colliery, Atherton, after becoming part of Manchester Collieries Ltd in 1929. St Georges ceased winding coal in 1941 but survived for many years afterwards as a source of ventilation for Gin Pit and Nook Colliery a few hundred yards to the south and also as a training centre for miners. The site finally closed in 1964.

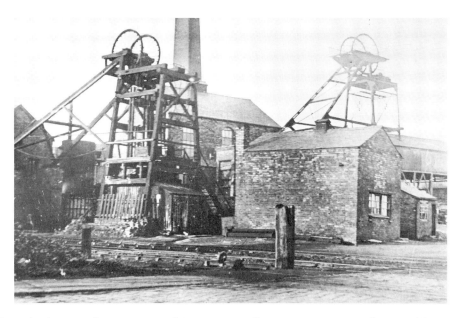

The only photograph in existence of Swan Lane Colliery, Swan Lane, Hindley, possibly taken on its closure in 1927. Sunk around 1864 by John Johnson, the colliery was linked to the LNWR near Hindley Green station, the branch line visible in the photograph. Edward Johnson operated the colliery from around 1868 to 1886. Moses Morris and his Swan Lane Brick & Coal Company, later Ltd, then ran the colliery until 1910. The colliery closed in 1910 then was reopened shortly afterwards by Swan Lane Collieries Ltd. It finally closed in 1927 when 384 miners and ninety-nine surface workers had been employed.

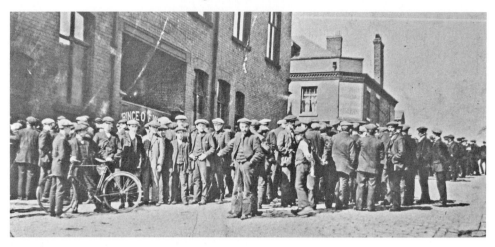

The 'great' strikes of 1893 (four months), 1912 (seven weeks), 1921 (three months) and 1926 (seven months) were often documented by local photographers, being before the days of the roving press cameraman. Here outside Tyldesley Miners' Hall the men assemble, possibly after a meeting or after a vote. The hall was erected by Tyldesley Miners' Association (established 1862) in 1893 with a seating capacity of 750, an indication that the size of the association's membership around Tyldesley made it one of the largest branches in Britain. The long 1926 miners' strike was complex in its causes, the main ones being a proposed wage reduction and increase in working time; the miners' extension of the earlier General Strike in total lasted from 3 May until 29 September.

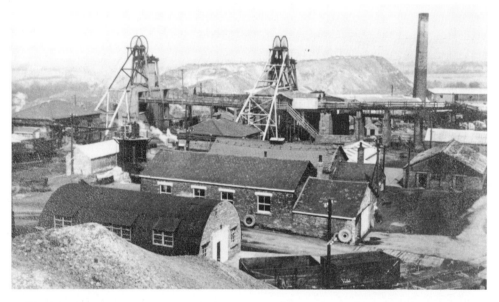

Welch Whittle Colliery, Coppull, west of Wigan, around 1953 with Chisnall Hall Colliery tip behind. Sunk by John Darlington around 1855, it closed in 1880 to be followed by reopening by Blainscough Colliery Co. Ltd in 1894. Nos 1 and 2 Pits eventually reached the Bone seam at 246 and 248 yards respectively. Intake and return drifts were laid out to access the Trencherbone seam in 1924, haulage being by steam engine. The pit ceased coal production on 31 December 1959 and closed in February 1960. British Railways had ended its contract with the NCB at the colliery for steam-raising coal.

Westleigh Colliery Heyfield Pit east of Abram near Leigh during the 1912 minimum wage strike, the Lancashire Fusiliers in attendance. The dispute, which had started at the beginning of March, was over claims for a minimum wage, which would ensure that men working in difficult conditions could still make some sort of living. The men went back to work with what nationally was considered a victory but militants continued to cause trouble, even minor riots around Leigh and Atherton. Westleigh Colliery Co. started life early, around 1845. By 1858, James Diggle was in control, his name always to be associated with the area even today, which still shows signs of its former mining past. Heyfield Pit was sunk 410 yards to the Wigan Six Feet seam, a high-quality coal also known as the Rams. Diggle's executors ran the collieries from 1880 to 1884 and from 1884 to closure in about 1937 when West Leigh Colliery Co. Ltd is shown as the owner. The pit employed 555 miners and 120 surface workers in its last year of operation.

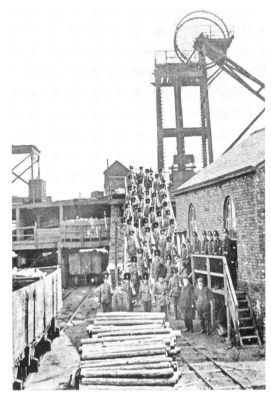

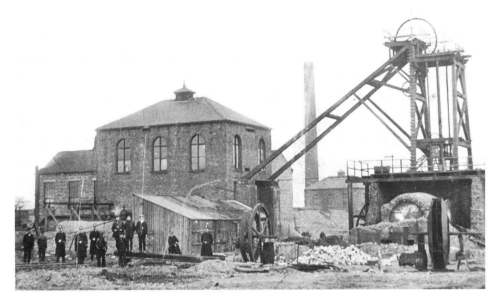

Police in attendance at Westleigh Colliery during the 1912 strike. This was the second of the three Diggles pits, Heyfield, Westleigh and Lower Hall, and was only 200 yards away from Heyfield Pit to the north-east (Heyfield Pit winding engine house, chimney and pit headgear can be seen in the distance). Some surface construction work seems to be in progress, with what looks to be the rotor of a fan mounted on trestles lower right. West Leigh Colliery employed 523 miners and 123 surface workers in its final year.

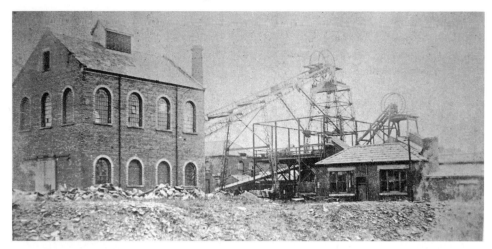

Wharton Hall Colliery seen here around 1888-89 was situated adjacent to the LNWR line from Walkden to Atherton and close to Little Hulton, north of Tyldesley. Sunk by Wharton Hall Colliery Company around 1873, it was to be taken over by the Trustees of the Duke of Bridgewater 1879-80. Their vast underground canal mining system came very close at Brackley Colliery, a few hundred yards north. Wharton had its own sidings off the LNWR and did not need to make use of the canal system. This early photograph probably documents the setting up of the colliery. No. 2 Pit is to the left, steel-lattice headgear, 14-foot-diameter shaft 555 yards deep. No. 1 Pit stands behind, wooden headgear, 14-foot-diameter shaft 305 yards deep. The colliery had an immense amount of water to handle, up to 40 million gallons a year. Coal winding ceased in 1927, Brackley Colliery taking on its coal reserves. Wharton Hall remained after closure as a full-time pumping station, its headgear on site until 1964. The Cutacre opencast site of 2009-10 exposed the shafts and uncovered early workings of the colliery in the Rams seam.

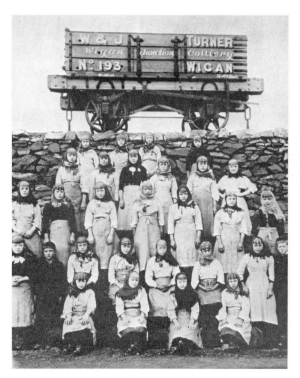

A superb image of pit-brow women at Wigan Junction Colliery, near Abram, west of Leigh, around 1900. Above stands a three-plank wagon of William and John Turner, the colliery owners. The first Wigan Junction shafts were sunk from 5 June 1876, meeting enormous quantities of water, so much so that they had to be abandoned and two new shafts sunk nearby to 526 and 483 yards. The colliery operated as Wigan Junction Colliery Company until 1930. From 1907, the company formed part of the Pearson & Knowles Coal & Iron Co. Ltd. From 1930, it came under Wigan Coal Corporation Ltd, then the NCB in 1947. The colliery closed in May 1962.

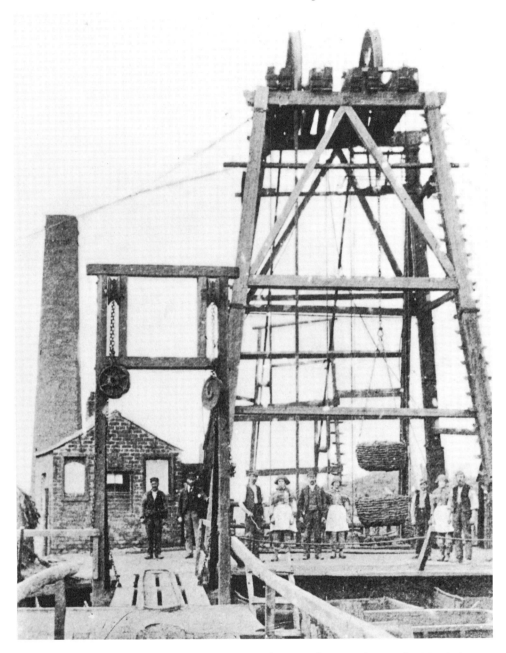

Without doubt the rarest photograph in existence relating to the Lancashire coal-mining industry is this one of basket winding at Winstanley Colliery No. 5 Pit (south of Wigan) around 1880. The pit was situated approximately a mile east of Pemberton Road (A571) and a few hundred yards north of the M6 near Glead Wood. Winding of baskets or 'corves' dated back at least to the thirteenth century. The use in shafts of guide rods and cages carrying tubs starts to come in after the late 1830s after T. Y. Hall patented their use. At the smaller or more remote collieries the old practices carried on. The baskets seen at Winstanley seem too large to have been mounted on skids and dragged through the workings, more likely smaller baskets had been unloaded into the ones seen in the photograph and sent to the pit bottom mounted on 'rolleys' or wheeled frameworks. Note also the flat pulley wheels on the headgear, used with flat rope winding. What we are looking at in this photograph could easily have been a scene of the late eighteenth century.

Bolton, Bury & Radcliffe

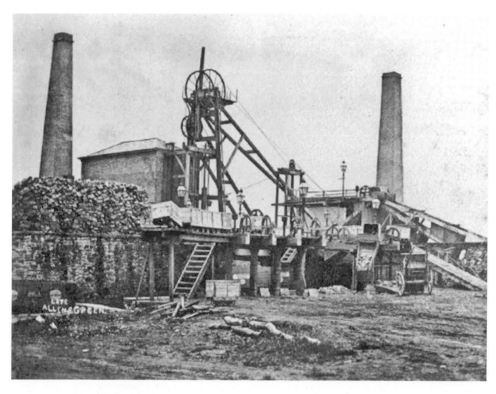

The early collieries around Bury and Radcliffe tended to be fairly small concerns compared to the central and Wigan area. This photograph of around 1895-96 shows Allens Green Colliery, north of Sion St, Radcliffe, after closure. Although poor in quality, it is worth including due to the surface layout and fittings visible, similar to collieries two hundred years earlier, namely, the raised pit bank, slender construction of the pit headgear, tub tipplers with shutes for waiting carts, a landsale colliery. Probably sunk around 1853 by Knowles and Hall and operated after 1873 by Andrew Knowles & Sons Ltd. The colliery had worked out the Six Feet and Nine Feet seams by 1881 and the Cannel and Trencherbone by 1895.

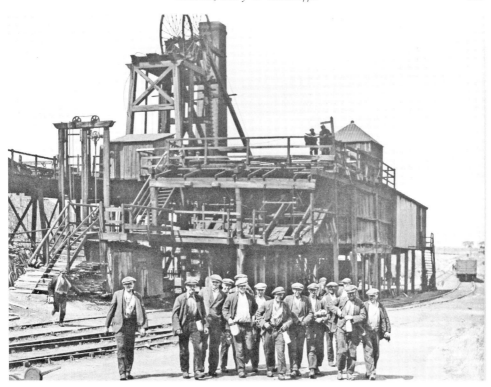

Miners leave the antiquated and compact wooden 'heapstead' and screens of Scot Lane Colliery Co. Ltd's No. 4 Pit. The caption reads, 'Scot Lane Colliery No. 4 Pit, 23rd July 1931. May shortly close unless pumping arrangements can be made with Wigan Coal and Iron Co. Ltd.' Scot Lane Colliery was situated east of Scot Lane, north of Haigh, Wigan, and was sunk around 1857 by William Wood & Sons. Wigan Coal & Iron Co. Ltd ceased pumping at their nearby Aspull Pumping Pit on 11 August 1932 without any real concern for the impact on other companies' collieries close by and to the north and east. Aspull Pumping Pit had been raising immense amounts of water, in the year 1883 amounting to 517,654,799 gallons! Cessation of pumping led to the gradual flooding of workings around Blackrod and specifically Scot Lane Colliery (closed 1932), and Stotts Pit, Westhoughton, which closed in January 1937. My grandfather became unemployed as a result.

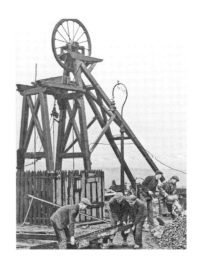

The old Dewhurst, Hoyle, and Smethurst's Anderton Hall Colliery (otherwise later known as Blackrod Brow Colliery) was situated on the north-east of Blackrod village. The colliery was sunk in around 1863. By 1892, the colliery was up for sale but without any takers. In 1931, it was reopened with a small workforce by the Blackrod Brow Colliery Co. Ltd. By June 1935, it had closed once more, abandoned by September 1936. In this photograph of 23 April 1937 men are preparing for reopening. Note the old single-pulley wooden pit headgear and ornamental gas lamp. The fence around the shaft is also a survivor of an earlier era of pit-top layout. On showing this photo to Fred Dibnah around 2002, he decided (after a few pints) to replicate it in his backyard! Over the next couple of years, a group of us helped and also sank his shaft, Fred bricking it.

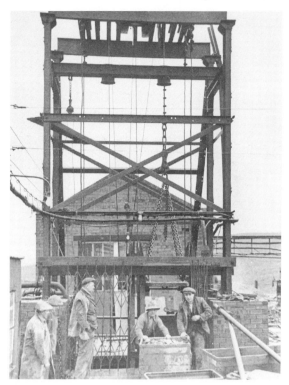

Blackrod Brow Colliery, Chorley Road, Blackrod, 7 November 1938. Around thirteen miners and ten surface workers were employed at the time. The photograph caption states that Westhoughton Coal & Cannel Co. Ltd were opening this 'new' pit, the previous image showed the earlier very short-lived attempt to reopen the pit by Blackrod Brow Colliery Co. A new steel girder headgear seems to have been erected with two pulley wheels. An old miner told me the pit had large amounts of water to deal with (Wigan Coal & Iron Co. Ltd had ceased pumping at Aspull Pumping Pit on 11 August 1932).

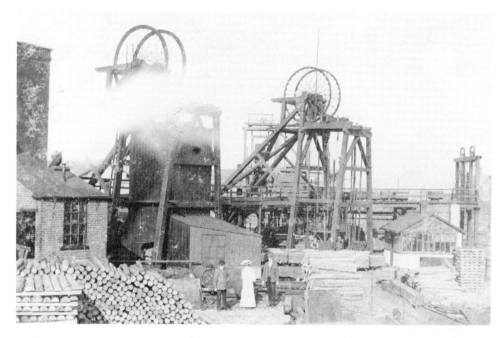

Stotts Pit, Westhoughton, No. 2 upcast and No. 1 downcast shaft around 1910, owned by Westhoughton Coal & Cannel Co. Ltd, founded in June 1872. Westhoughton New Colliery, as it was first known, was close to and west of the railway station (L&YR). Sunk around 1874 to the Arley seam. Note the large stack of pit props on the surface where space for materials was definitely in short supply. Tub hoists can be seen either side of No. 1 Pit.

Right: Stotts Pit No. 1 downcast pithead with tubs of around 5 hundredweight (20 hundredweight = 1 ton) clustered around the shaft. The pit worked the Arley, Half Yard, Yard, Three Quarters, Mountain and Ravine seams. The figures in the photograph may include on the left the Colliery Agent and Manager H. O. Dixon, prominent mining engineer and member of Manchester Geological Society. The young boys alongside them are waiting to go down the pit, holding miners' oil lamps.

Below: Stotts Pit at the time of its flooding, the L&YR railway line just out of view to the right. Wigan Coal & Iron Co. Ltd had ceased pumping at Aspull Pumping Pit on 11 August 1932. Through seam connections with Scot Lane Colliery, Blackrod, to the west in the Bone seam, water eventually (exactly one year later) made its way to Stotts Pit. Attempts to dam the connection below ground failed, and the company resorted to winding water out of the shaft sump in pit tubs at 10,000 gallons an hour. Stotts Pit was finally abandoned in May 1937, 576 miners and 187 surface workers losing their jobs.

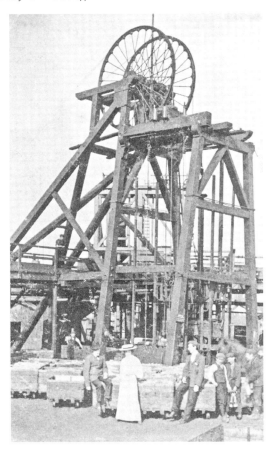

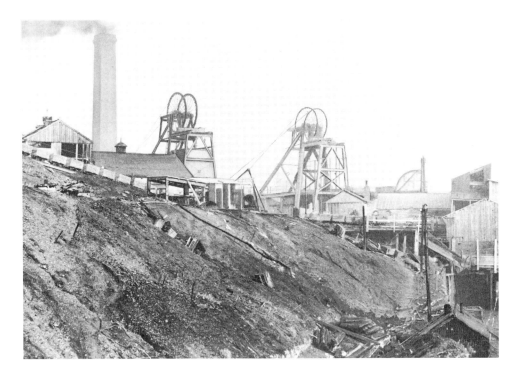

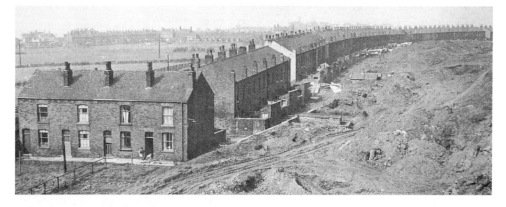

Miners' housing at Brancker Street, Chequerbent, near Westhoughton, seen in 1961. The pit waste covered ground to the right is the site of the demolished colliery. Not exactly the pinnacle of design as regards workers' housing, this long terrace was built in the late 1880s by the Hulton Colliery Co. Ltd for employees at Nos 1 and 2 Chequerbent Colliery, which was alongside. The houses were sandwiched between the diverted LNWR (former Bolton to Leigh) railway line to the rear and colliery at the front. Many houses in the row suffered as a result of the Pretoria Colliery explosion of 21 December 1910 when 344 men and boys died. The pit was a few hundred yards to the east and belonged to the same company. Chequerbent Colliery closed in November 1927, the houses surviving until 1974.

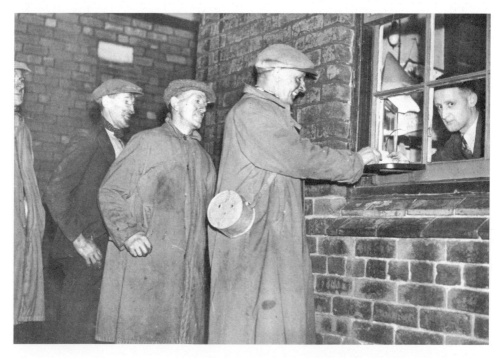

Friday 22 December 1939. It's the Christmas pay packet and a long weekend for these Second World War reserved occupation miners at Manchester Collieries Ltd, Brackley Colliery, Little Hulton. No pithead baths on site until September 1952, so these men had to catch the bus home 'in the black', a wash of the face giving a bit of dignity. An old lady told me she dreaded miners getting on the bus in case they sat next to her and dirtied her coat, conductresses also had to wipe down the seats after miners had left the bus.

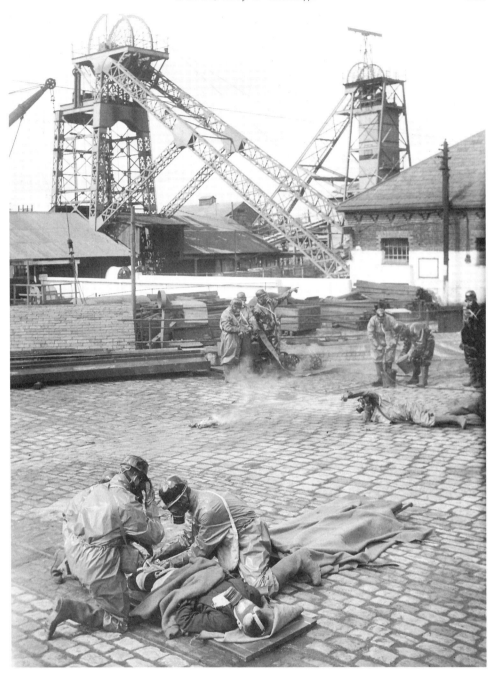

Thursday 4 July 1940. An Air Raid Precautions fire-fighting and rescue exercise is taking place at Brackley Colliery. First aid is being given to the man in the foreground by two men wearing smoke respirators, while in the background, fire-fighting is in progress, a hand pump supplying water from a bucket. Manchester Collieries organised ARP teams at their collieries from early 1940. In the background is, from the left, No. 1 downcast shaft of 394 yards (sunk c. 1858) and No. 2 upcast of 310 yards to the Arley seam. In 1939, 673 miners and 219 surface workers were employed at the pit. The colliery was linked to the Worsley underground canal system via a drift, the brick arch of which can be seen behind and to the left of the men at the back.

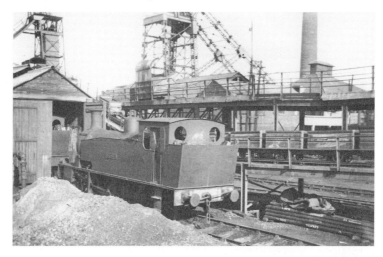

Brackley Colliery in 1943 with loco *Bridgewater* in view, a Hunslet, six-coupled, side tank. A similar loco, *Joseph*, is just visible in the shed. Behind is the raised gantry for pit tubs heading to and from No. 2 Pit on the left to the washery and screens. *Bridgewater* was sent to Astley Green Colliery in May 1957, later working at various local locations until leaving Astley Green in approximately early 1968 to be scrapped at Walkden Yard in October 1968. Loco *Joseph* stayed at Brackley Colliery until leaving for Walkden Yard in November 1959, being dismantled a few months later and scrapped by March 1963.

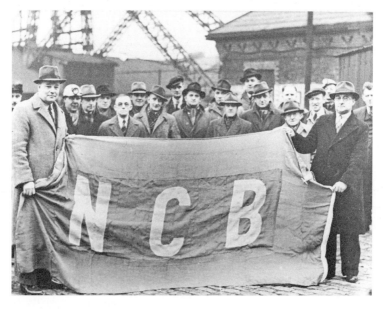

Vesting Day, 1 January 1947, the day when coal mine nationalisation came into force. Management and officials display their National Coal Board flag. The oldest and youngest employee normally hoisted the flag up the pit headgear flagpole. Many men found little was to change after nationalisation with their old coal owners securing the top jobs in the new organisation after receiving huge amounts of compensation for unworked coal. In 1947, ninety-four collieries remained in the Lancashire coalfield with an annual output of 11.35 million tons. In the first ten years after nationalisation, fifteen collieries closed and twelve were either opened or reopened. Twenty small mainly drift mines were allowed to operate under licence.

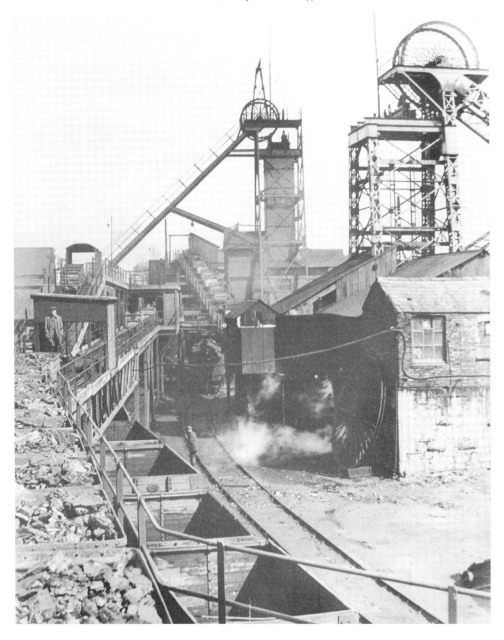

Brackley Colliery on 21 April 1951. Photographed for an article about mechanisation at the pit, where around 750 tons of coal a day was being screened, washed and loaded, and eventually fed into the boilers at Kearsley Power Station without being man-handled. This was unique in the coalfield. To the left, the pit tub gantry taking tubs to the washery and screen from No. 2 Pit left distance. Below are mainline wagons which accessed the LMSR. A line from Brackley led north-east to Dixon Green landsale yard, to the south beneath the A6, it led to the giant waste tip at Cutacre, being opencasted and landscaped at the time of writing. The colliery closed in May 1964. On Tuesday 16 April 1968, three young schoolgirls died when they entered the old drift tunnel at Brackley and were overcome by blackdamp (CO_2 and other gases), a fireman also died as he entered the tunnel. The site of Brackley Colliery and the area to the west was opencasted from November 1984. Unrecorded workings heading close to the outcrop of the Trencherbone seam were uncovered.

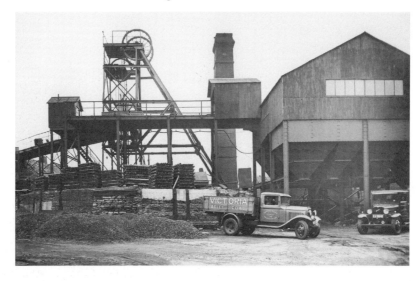

Deane Coal Co. Ltd, Victoria Colliery, Deane, west of Bolton, around the 1920s. Otherwise known as Deane Colliery or Three Pigeons Pit. Operated by Thomas Brocklehurst & Co. from around 1910 to the mid-1940s. The company was then operated by Deane Moor Collieries Co. Ltd of Barnard Castle. The number of miners averaged sixty-five for many years. The shaft in view was the main winding point, No. 1 Pit, sunk in 1868 to 75 yards. The upcast shaft of 1884 was a few hundred yards to the north and only 25 yards deep. The pit was very lucky in that it only had access to the 4-foot 2-inch-thick Arley seam, the finest coal in the Lancashire coalfield. The colliery closed due to exhaustion of reserves beneath Deane and Daubhill on 14 October 1960, 134 miners losing their jobs. The site is now a garden centre, its café designed on a mining theme.

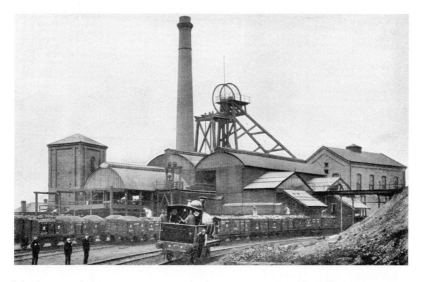

The well-laid-out surface arrangements in the late 1920s at Eatock Colliery No. 2 Pit, Westhoughton. Sunk approximately 400 yards to the Arley seam in 1884 by Wigan Coal & Iron Co. Ltd, winding began in 1890. At the time of the photograph, the colliery was producing around 2,400 tons per week from a heavily faulted area of coal. Coal headed off to the L&YR and LNWR via the maze of colliery lines in the area. Part of Wigan Coal Corporation by 1930, the colliery survived until February 1936.

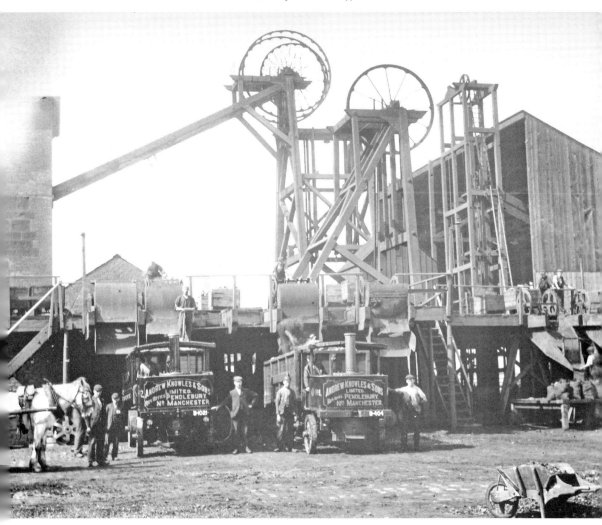

A fine record photograph of an early small colliery, Foggs Pit, Hall Lane, Darcy Lever, Bolton. Four shafts were on site, the colliery dating back to at least the early 1820s, eventually reaching the Cannel seam at 1,142 feet. Seen here around 1905-10, the Leyland steam wagons belonging to colliery owners Andrew Knowles & Sons Ltd are being loaded at tub tipplers (seven are visible) right next to the shafts. At the other side of this view was the Manchester Bolton & Bury Canal, barges being loaded directly. On 4 October 1907, a shaft accident in No. 1 downcast pit (at the back, sunk c. 1867) claimed ten lives, the ascending two-deck cage colliding with the descending one. The colliery closed in May 1912.

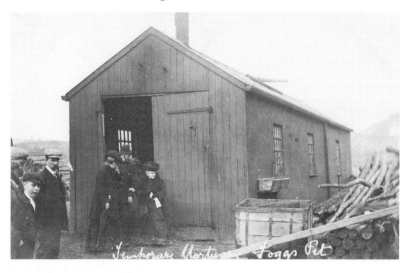

The harsh reality of life in a mining community. A postcard view of the temporary mortuary at Foggs Pit after the shaft accident of 4 October 1907; two ladies have just been in to identify the bodies. A father and son were amongst the dead. The Workmen's Compensation Act of 1897 meant owners Andrew Knowles & Sons were liable. They had a terrible reputation for meanness, opposed trade unions and treated their staff harshly. No doubt they would be none too happy to find themselves paying up to £300 to a widow who had lost her husband in the accident.

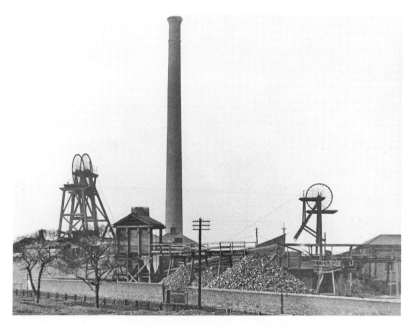

Few today will know that very close to the former Bolton Wanderers football ground at Burnden Park was Great Lever Colliery, off Manchester Road, and the later site of the Bolton Greyhound Track. Sunk by the 2nd Earl of Bradford (pre-1815 the Bridgeman family), a major Bolton landowner around 1840, the shaft reached the Cannel seam at 1,390 feet. The shaft also intersected the Doe seam, with 9 feet 10 inches of variable-quality coal as well as other lesser-rank coals. The colliery closed in March 1922, probably when this photograph was taken.

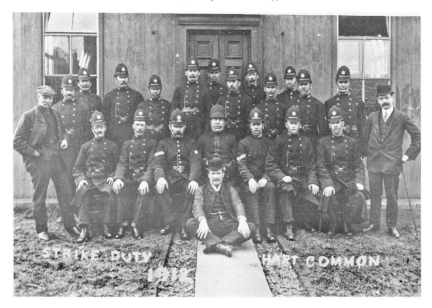

Strike duty for the police at Wigan Coal & Iron Co. Ltd's Hewlett Pit, Hart Common, Westhoughton, in 1912. The dispute, which had started on 26 February (ending on 15 April) was over claims for a minimum wage where the men would not have to be reliant on good working conditions or geology, and although the men went back to work with what nationally was considered a victory, a few militants opposed the return to work, causing trouble, even minor riots, around Leigh and Atherton. The miners' housing, once an isolated community, still survives at the colliery site.

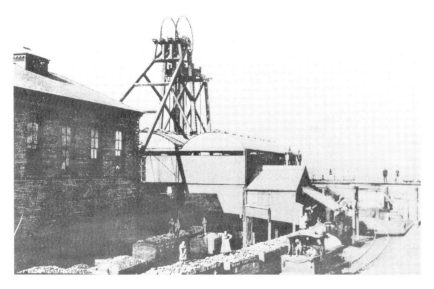

Very few photographs have survived of Hewlett Pits, Westhoughton. Owned by Wigan Coal & Iron Co. Ltd the shafts were sunk in 1865 to the Arley seam, No. 1 reaching this at 1,354 feet. This view shows No. 2 Pit, which worked the Yard and Arley seams and was linked to Eatock Colliery near Daisy Hill. Women brow workers are trimming the main line WC&I Co. wagons. The shafts were sunk 400 yards apart on either side of a geological fault. The colliery closed in January 1931.

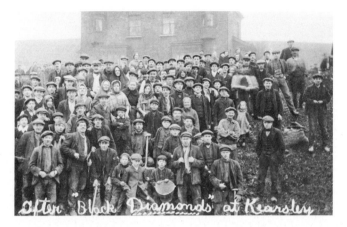

'After Black Diamonds at Kearsley' is written on the negative of this postcard. Kearsley near Farnworth had some very old collieries in operation in 1921 which dated back to the very early years of the nineteenth century, Unity Brook being an example. Here, mining families are out coal picking during the 1921 strike. By 1920, foreign coal was undercutting British in terms of price. Mine owners tried to cut miners wages in 1921, a strike was called on 31 March. Coal rationing came in on 3 April. The strike lasted eighty-nine days. Coal picking was partly for the pickers' own use and partly to sell.

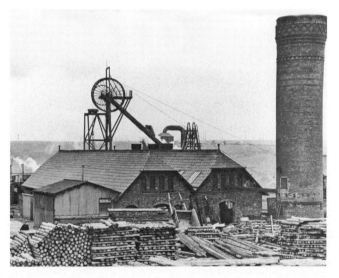

Ladyshore Colliery, Little Lever, Bolton, on 15 July 1948. From the left is the Owl Hole Pit downcast shaft behind the colliery workshops with their distinctive architecture. Pit props are stacked in front. In the distance on the other side of the Manchester, Bolton & Bury Canal is the headgear of the Victoria Pit downcast shaft, and right foreground the squat chimney above the furnace ventilation shaft (without an associated headgear). The shafts were sunk by Thomas Fletcher around 1830-35. Ladyshore Coal Co. Ltd was formed in 1906-07, later reorganised into Ladyshore Colliery Co. (1930) Ltd. Nationalisation came on 1 January 1947, but the colliery was not to survive long, closing in June 1949. Pit ponies had been used all through the colliery's life, and those in the final days were the last ever used in a Lancashire colliery. A large amount of the colliery's pre-1947 records were found in the roof of the old colliery offices and are now at Bolton Archives. An example of one of the colliery's barges complete with box containers can be seen at Ellesmere Port Boat Museum.

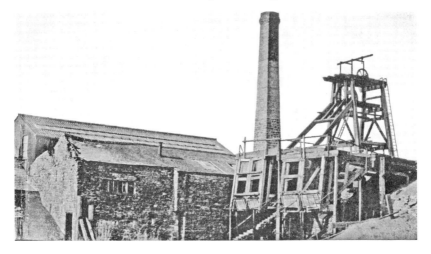

The ramshackle wooden screens and No. 1 Pit headgear at Montcliffe Colliery, Georges Lane, Horwich, near Bolton, around the late 1940s. The mines inspector actually condemned the structure as unfit for use around the late 1950s. No. 1 was sunk around 1820 to 400 yards; No. 2 upcast was sunk around 1860 to 365 yards. Owned by the Mason family for generations, it closed in 1862, reopening in 1882. The *Colliery Year Book* for 1943 states that the pit wound 3,500 tons of coal and 3,500 tons of fireclay. Montcliffe was locally known as Pottery Coalpit, as much of the coal and fireclay it mined went to local brick, tile, sanitary ware and ceramic works. The pit closed in 1966, twenty-four miners and ten surface workmen losing their jobs.

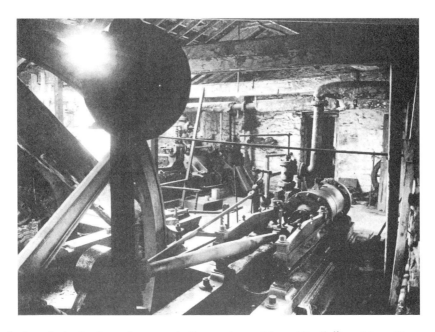

The single-cylinder horizontal steam winding engine at Montcliffe Colliery No. 1 Pit, photographed in about the 1950s. The photographer, George Watkins, an expert on steam engines and one of the first people to systematically document industrial archaeology, could not identify the maker, probably one of the numerous Wigan or Bolton engineering companies. It may have dated back to the colliery reopening of 1882. Sadly, it did not survive the colliery demolition after closure in 1966.

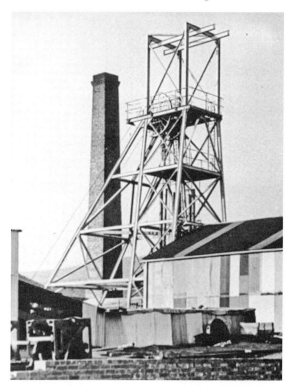

Montcliffe Colliery No. 2 Pit, the new steel-girder headframe of the early 1960s. No. 2 Pit was to the west of No. 1 alongside the road towards the present-day TV mast and served as the main winding shaft for the Sandrock seam after the inspector condemned winding arrangements at No. 1 in the late 1950s.

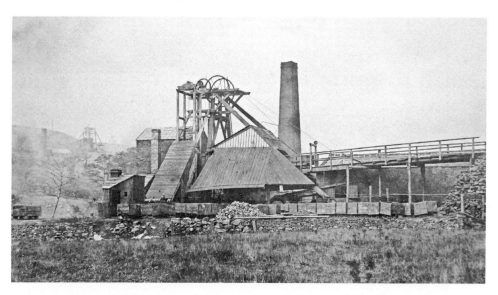

Outwood Colliery was situated south-west of Radcliffe, a quarter of a mile south of the River Irwell, here seen around the early 1880s. The structure alongside the pit headgear is the tub hoist raising tubs to the level of the tramroad gantry. Tubs headed off to the brickworks and coal yard off Outwood Lane just over half a mile to the north-east. Sunk around the 1830s, the colliery was originally named Clough Side Colliery, becoming Outwood Colliery in 1865. Operated by Brownbill & Bromilow until 1858, later Thomas Fletcher, until Outwood Collieries Ltd was formed in 1909. The pit on the hillside in the distance may be the disused Whitefield Colliery, closed in 1879.

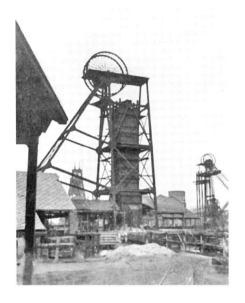

Outwood Colliery, Radcliffe, seen on closure in 1931. The old colliery structures are long gone. No. 5 upcast shaft is in the foreground, No. 4 is on the left behind, and No. 1 to the right. Hidden behind No. 1 is No. 2, sunk 311 yards to the Five Quarters seam. The pit became part of Manchester Collieries Ltd in 1929 but only survived a few years being abandoned in late 1931. The washery was left intact and used from 1947 to 1955 by the National Coal Board. The site was stabilised in 1998 and subjected to the horror of 'public art' with standing stones from Spain erected on site at huge expense. The old stone winding engine beds were on site at the time.

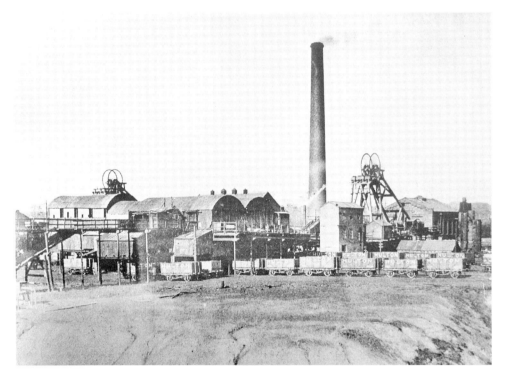

Mining had taken place within the Hulton estate, north of Atherton, for many centuries before William Hulton came to control the property in 1808. The Hultons came to Bolton from Wales as far back as 1167. The family also owned land in Harpurhey and Denton, an area also rich in coal-seams. William was a partner in the Bolton & Leigh Railway scheme (in operation by 1828), which would provide transport for his coal. By the 1830s and 1840s, collieries were dotted all across the estate. William formed the Hulton Colliery Company in 1859. After his death in 1864, the next William Hulton decided to further expand mining activity to the west and south of the estate. William died in 1879 followed by yet another

William who in 1886 preferred to allow a company to operate the pits, the Hulton Colliery Company Ltd. From 1892, new pits were sunk starting with Chequerbent Colliery to the west in 1892. Bank Pit 1 and 2 followed after 1897 with finally in 1900-01 Bank Nos 3 and 4 Pits. No. 4 intersected the Trencherbone, Plodder, Three Quarters and Yard seams, finally sumping 23 feet past the Arley at about 1,326 feet.

Bank Pits No. 3 and 4 Pits were later known as Hulton Colliery Nos 3 and 4 Pits and even later as Pretoria Colliery. This view from the south-east is thought to date to late 1934 after the colliery closed. No. 3 upcast shaft is to the left, No. 4 downcast to the right, Hulton wagons lined up at the screens. The colliery will always be remembered for one event, the disaster of 7.50 a.m. on 21 December 1910 when an explosion followed by a coal-dust blast killed 344 men and boys. Two survived. This goes on record as the greatest mining disaster in the Lancashire coalfield and the third greatest in British mining history.

High gas levels and defective miners' oil lamps in use in the Plodder seam workings down No. 3 Pit are thought to have ignited the gas. The poor level of managerial supervision was commented on at the enquiry. A further 545 men were at work in No. 4 Pit, some of whom were affected by gas, the majority though unaffected by the blast and suffocating gases produced. Some feel the 545 should be classed as survivors, as No. 4 pit was damaged by the blast, leaving only one cage operable.

In an amazingly insensitive move twenty days later, the company had colliers back at work again in the No. 4 Pit (Trencherbone and Arley seams being worked) a month before the last body was recovered from No. 3 Pit. Work recommenced in the explosion districts of the Plodder and Yards seams at No. 3 Pit by March 1911. What an eerie feeling that must have been to be underground, never mind working where 344 had died, and many of those 344 would have been known to those back at work. My grandfather worked at Westhoughton Colliery (Stotts Pit) and was seconded to Pretoria to help with clearing up operations.

Compensation for families in the form of lump sums and annuities came from the Wigan & District Permanent Relief Society, the Lancashire & Cheshire Miners' Permanent Relief Society based at Wigan, the Hulton Colliery Explosion (1910) Relief Fund, and as a result of the Workmen's Compensation Act of 1906. The Hulton Colliery Explosion (1910) Relief Fund was set up by the Mayor of Bolton to accept charitable donations and make regular payments to victims' families, making its final payments in 1975.

The colliery which had opened as a model mine with electricity below ground and other technological innovations closed in April 1934 after only twenty-four years operation. As I write, it is the centenary year of the disaster, and a number of publications and events plus a memorial are planned. The colliery site lies today amongst woodland, the shafts capped but not filled.

Salford & The Underground Canals

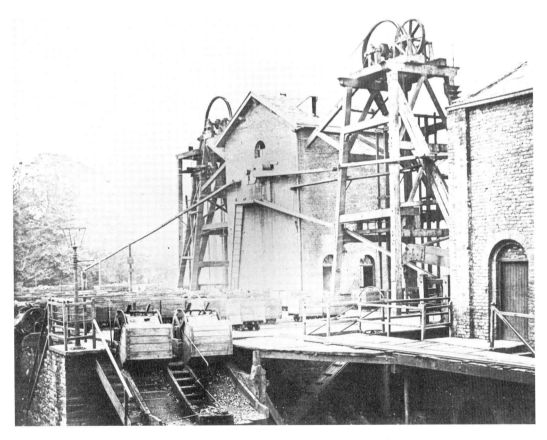

Andrew Knowles & Sons, Agecroft Colliery, Nos 1 and 2 pits around 1880. An important early colliery view with unusual winding arrangements. Sunk around 1844, the shafts were 9 feet 6 inches diameter and only 22 yards apart. They had ceased coal winding by approximately 1923. The central vertical winding house was a typical Knowles preference, winding both single-flat-rope shafts at the same time. Note the bar screens in use below the tub tipplers. The new Nos 3 and 4 shafts were sunk in 1894 to the Trencherbone seam at 700 yards, the colliery closing in 1932. Those shafts were to be reused when Agecroft was reopened and redeveloped from July 1953 onwards.

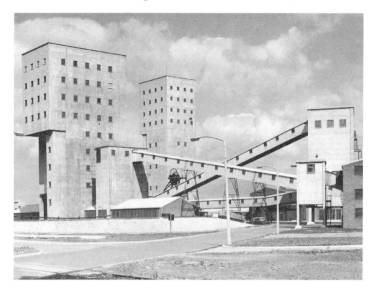

The clean lines of the newly redeveloped NCB Agecroft Colliery seen around early 1962. Overhead 'Koepe'-type friction winding towers and encased conveyors minimised surface dust creation. Boreholes carried out for the National Coal Board in 1951-53 proved coal reserves of 134 million tons, 80 million workable. The old Nos 3 (small traditional headgear) and 4 (in the distance) shafts were re-used and a new coal-winding shaft, No. 5 (left), was sunk, 24 feet in diameter to 668 yards.

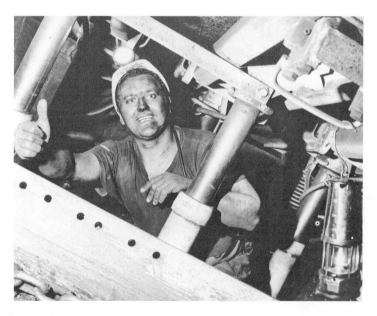

Some seams at Agecroft Colliery had inclinations of 1 in 2, meaning specially designed safe methods of working had to be adopted due to the dangers of airborne and rolling coal. This photograph was taken from the coal side of the face conveyor in the Worsley Four Feet seam. The face worker is within a bank of multi-leg hydraulic Dowty roof supports. Occasionally, supports at the bottom end of the coalface would have to be removed as sliding gradually occurred to be slotted on again at the top end. The GR6 safety oil lamp giving an idea of true vertical is by local company Protector Lamp & Lighting of Eccles.

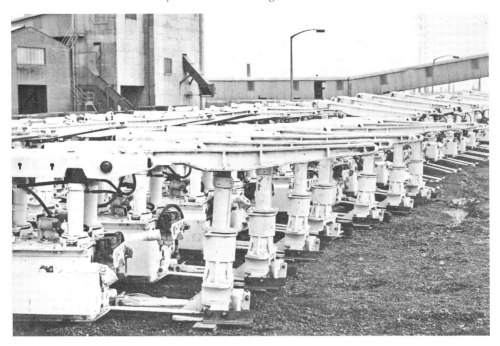

A line of Gullick (of Wigan) hydraulic roof supports ready for use on the coalface at Agecroft Colliery in the 1960s. Facelines could be as wide as 200 yards, advancing over twenty yards a week. Having four legs at the rear supporting the main canopy and one larger diameter leg at the front supporting the extension arm, these could be individually moved forward after the coal cutter had passed, pushing the face conveyor nearer the faceline. Men travelled between the front and rear legs. Behind the line of supports, the roof was allowed to totally collapse, leading to eventual subsidence on the surface.

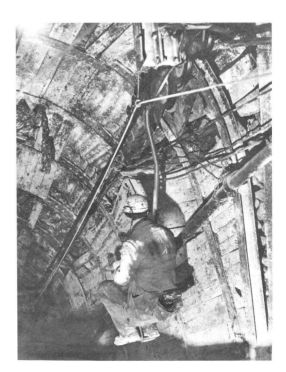

A miner at Agecroft Colliery, probably in the mid 1960s uses a 'ski-lift' system to travel a steeply inclined roadway. Men could not be expected to travel such steep roads, especially the prospect of facing an uphill slog up a hot return roadway after a shift on the coalface.

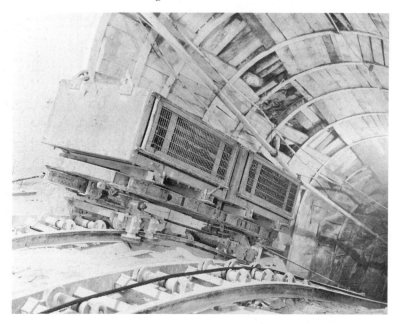

The 1980s era caption reads, 'Agecroft [Colliery] haulage carrier, return brow No. 2 & 3's face, Worsley Four Feet seam, materials only road 13ft x 12ft x 10ft [section].' Serious concern for safety can be seen here in this supplies road compared to an average colliery with less steep roadways and normal rail haulage. The National Coal Board and later British Coal were always keen to trial new technology, especially safer systems of working. Every colliery had a safety engineer 'on the books', our mines becoming the safest in Europe for many years.

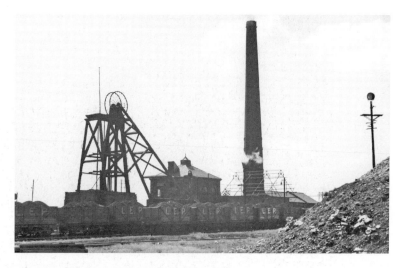

A rare view of No. 2 Pit, Ashton's Field Colliery, Cleggs Lane, Farnworth, around 1938-39. Sunk around 1852 to 515 yards and the Arley seam, later filled to 365 yards at the Haigh Yard seam level. A line of loaded Lancashire Electric Power wagons can just be made out. A typical Bridgewater Collieries square plan winding engine house with ventilator on the roof is in use. Ashton's Field was linked to the main underground canal driven from Worsley Delph. The pit closed in November 1929, 800 men losing their jobs. Brackley Colliery to the south took over its coal reserves.

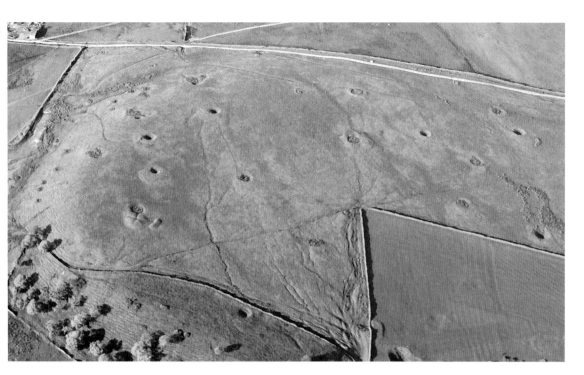

1. Outcrop working and closely spaced shallow 'bell pits' (named as such due to their cross-sectional shape) were the most ancient methods of coal mining in Lancashire. Here at Moleside Moor, east of Accrington close to the A56 are superb examples of early bell pits, possibly fifteenth century. The pits accessed the Arley seam, between 4 and 5 feet thick. Shafts were sunk and worked outwards until the roof needed support. The pit was then abandoned and another sunk nearby. (Photo and pilot Alan Davies, 2009)

2. The earliest known graphical illustration of coal-mining activity in Lancashire and Cheshire I am aware of appears in the Scarisbrick records (Burtonhead, St Helens estate plan DDSC 32/1) held by the Lancashire Record Office. The enormous mining historical importance of this seems to have passed by general historians. The plan is thought to date to around 1580, yet mining is known to have been taking place close by at Sutton at a 'mine of coals' in 1556. The 1992-94 opencast site at St Helens uncovered a cluster of early shafts, which may well be the 'bell pits' depicted on the plan, shown as 'Pembtons cole myne' (see also the Opencast section at the end of the book).

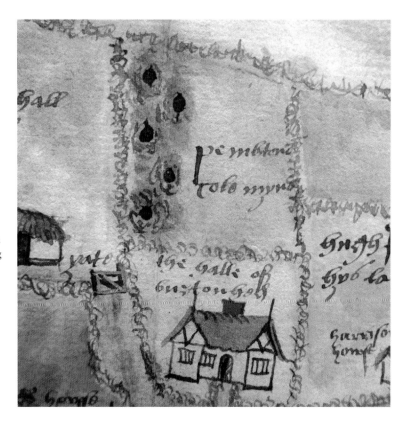

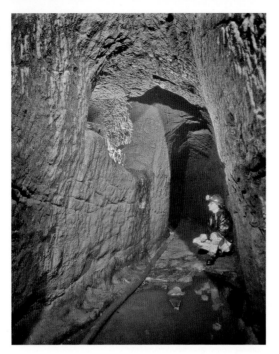

3. Wet Earth Colliery, Clifton, near Swinton, was a later name for one of many shafts in the area accessing the Doe Seam which outcropped on site. The pit was linked in 1800 with the Manchester, Bolton & Bury Canal via Clifton Aqueduct and a branch canal which came alongside the shaft at the pit. Water raised up the pit shaft, sections of the canal loading basin and the dry dock all drained into a system of 'sough' tunnels which also connected with earlier mine soughs of around the 1740s. In this photograph of around 1995, the hand-picked nature of the tunnel can be seen, with a canal overflow tunnel cut higher up opposite the girl. The author and a team of volunteers he brought together spent ten years excavating and documenting for the first time this tunnel and others, later showing hundreds of enthralled visitors of all ages the safer areas with the full backing of the City of Salford Health & Safety Manager. Council officials opposed to industrial archaeology (the reason interest in the 'park' started in the first place!) had the tunnels sealed off in 1999. Only in Britain it seems can such an archaeological disaster still occur. (Alan Davies, 1995)

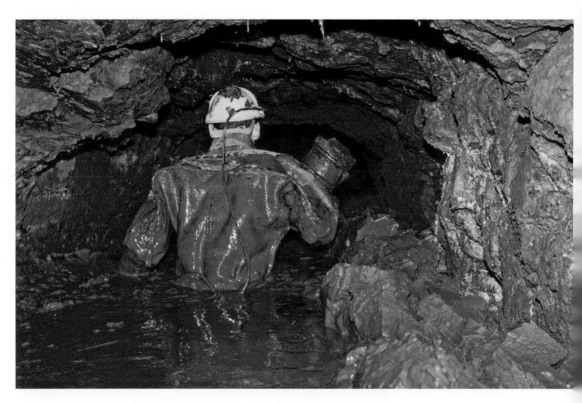

4. Water passing through coal measures strata, particularly iron-bearing sandstone leaches out iron. Ochre is essentially a clay stained with colouring minerals. Hydrous iron oxide imparts yellow colour and the anhydrous form red colour. The amount of iron oxide (Fe_2O_3) in ochre may be as low as about 20 per cent going up to 70 per cent. During excavations and explorations of the drainage tunnels at Wet Earth Colliery from 1989 to 1999, some tunnels were virtually fully silted with ochre sludge. Here, in 1991, explorer Mark Wright forges ahead in a mine 'sough' drainage tunnel of the 1740s never before photographed. The author meanwhile struggles behind to keep his equipment clean! (Alan Davies, 1991)

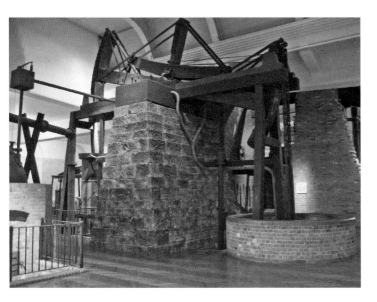 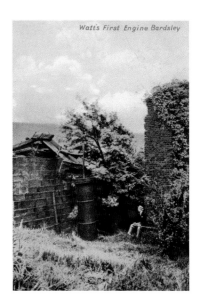

Above left: 5. Fairbottom Bobs engine in place at the Henry Ford Museum, Dearborn, USA. The pump shaft is to the right, the open-top cast-iron cylinder to the left. Water raised up the shaft was reused for steam generation and cylinder injection to create the vacuum and also sent to top up the Fairbottom Branch Canal 200 yards away. The University of Manchester Archaeological Unit excavated the site in 2000, the remains of which can be seen today as part of Park Bridge Country Park and Heritage Centre. Photographed in 2007. (Prof. Marc Csele, Canada)

Above right: 6. 'Fairbottom Bobs' was the local nickname for an early atmospheric steam pumping engine of around 1760 used at Bardsley Colliery, Park Bridge, near Ashton Under Lyne, until 1834. The name came from the up and down bobbing motion of the wooden cross beam. One end was linked via a chain to the piston in the open atmospheric cylinder, the other was connected to pump rods in the 200-foot-deep Cannel coal pit shaft. The site became well known enough for a postcard to be produced around 1910; by then the supposition that the engine was James Watt's first attempt at such a design had stuck and found its way onto the card. The rescue by the Henry Ford Museum, Dearborn, USA, of the engine in 1929 was probably for the best, as no one had shown any interest in preservation up to that time.

7. An NCB study in the mid-1950s suggested that, within a 3-mile radius of Wigan town centre, approximately 1,013 mine shafts were known to exist. With mining taking place in the area at least back to the late thirteenth century, the actual number of shafts and other mine entries is probably a multiple of the figure! Many were filled, others capped, occasionally the stone shaft surround was left in place as here west of Shevington Lane, Shevington, visible from the M6 when driving north. This shaft was one of at least six in the field accessing the Cannel and King seams back in the early 1800s. (Photo 2009, Stewart Parr, pilot Alan Davies)

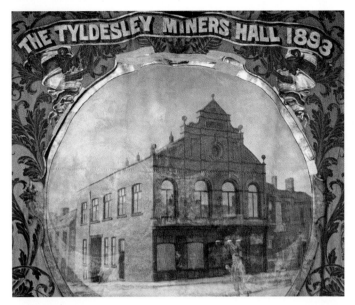

8. Rear view of the c. 1894 Tyldesley Miners' Association (est. 1862) banner depicting the newly built Miners Hall, Elliot Street, Tyldesley. The building could hold meetings with an attendance of 750 and still stands today. Ballroom dancing tuition is now carried on where national miners' leaders once spoke. Most association and trade union banners were made by George Tutill of City Road, London, hand painted on silk. The company is now based at Chesham, Bucks.

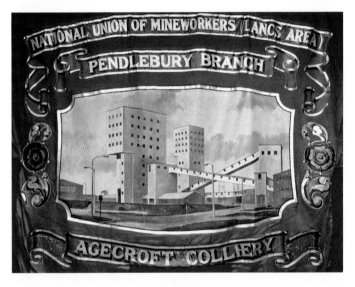

9. Agecroft Colliery, north-east of Pendlebury, was sunk in 1844 and closed by 1932, the shafts not filled. Boring between 1951 and 1953 proved reserves of 134 million tons, 80 million workable. Reorganisation started in July 1953, mostly completed by July 1960. Pendlebury Miners' Welfare Institute was opened the same year and this banner may date to about 1961. The banner shows the neat, modern layout of the colliery with its new overhead winding 'Koepe' towers, demolished on 7 January 1991.

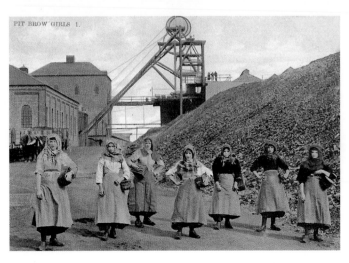

10. From around 1902, 'divided back' (to allow a separate message and address) colour tinted postcards start to appear in huge quantities on all possible subjects, even coal mining. The well-known pit brow women of the Wigan area had been featured on photographs and Cartes De Visite from the 1860s. Here at the impressive Wigan Junction Colliery near Abram, west of Wigan, pit brow women have been coloured in as two distinct designs of dress, probably artistic license. The colliery was sunk by William and John Turner in 1875 and closed under the NCB in 1962.

Right: 11. In certain towns in Lancashire, coal mining had been one of the major employers of the male population for generations. Leigh was such a case, when, in 1908, this stained glass window (along with others depicting engineering and textiles) was commissioned for the new Town Hall Council Chamber. The artist was Liverpool-based H. Gustave Hiller (1865-1946), trained at Manchester School of Art. His work can be found across the North West, along with North Wales and Cumbria. (Alan Davies, 2005, access courtesy Wigan Council)

Below: 12. The Lancashire & Cheshire Coal Owners Association opened Howe Bridge Mines Rescue Station, Atherton, in April 1908 to serve a wide radius of collieries. Rescuemen's certificates began to be issued shortly after the station opened. The artist was Gordon Forsyth, an eminent designer and ceramic illustrator at Pilkington's Royal Lancastrian Pottery, Clifton, Manchester. The Pilkington family owned collieries in the Swinton area.

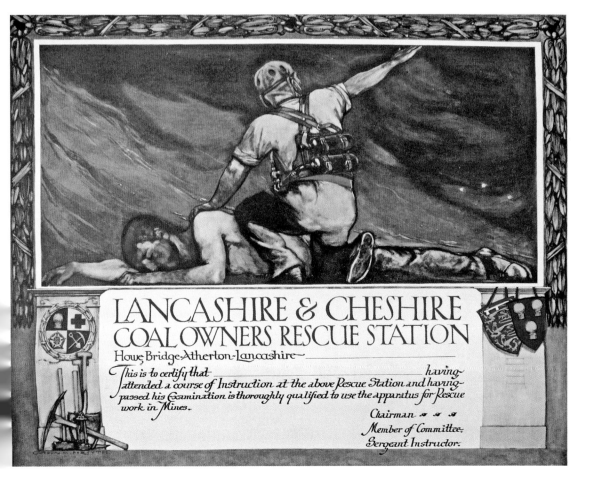

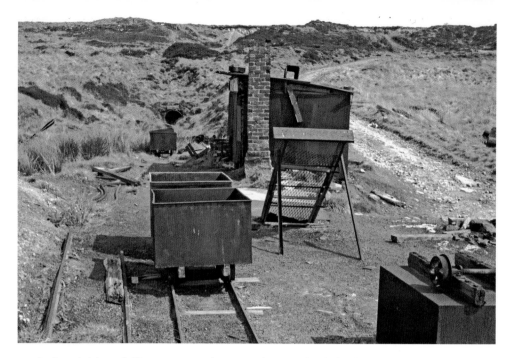

13. Ludworth Moor Colliery near Marple, 28 April 1971. The drift mine worked the Cheshire extension of the Lancashire coalfield. Worked for many years single handedly by Alf Gee. The drift entry is in the distance behind the tubs. The angled screen is where coal was thrown to be graded, a technique used 300 years earlier. (R. Bradbury)

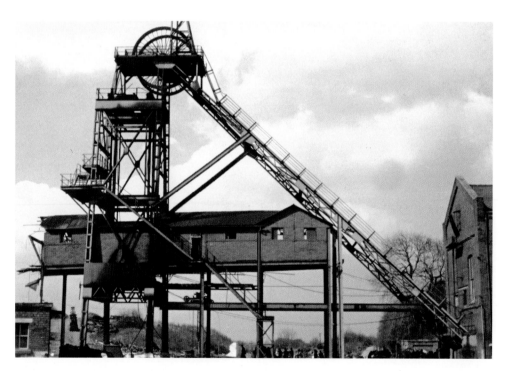

14. Wood Pit No. 3, Vista Road, Haydock, after closure in June 1971. Formerly known as Newton Colliery, it was sunk in 1866 to 490 yards by Richard Evans & Co. The pit suffered an explosion on 7 June 1878 which claimed the lives of 189 men and boys. Fifteen victims were not included in the Mines Inspector's report but appeared in the Coroner's Inquest and in some cases in burial registers. The final death toll should therefore have been 204. (R. Bradbury)

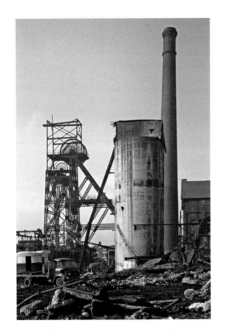
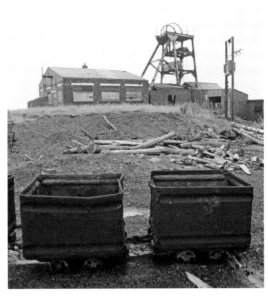

Above left: 15. Astley Green Colliery closed officially in August 1970, yet the site had not been fully demolished in early 1971 when this photograph was taken. No. 1 downcast shaft (which survives today on the museum site) is dwarfed by the 156-foot-high chimney. The tall concrete structure formed the pulverising section of the new coal preparation plant, installed by the end of 1962 and designed to process 300 tons an hour. (R. Bradbury)

Above right: 16. Windy Arbour Colliery, Wigan, adjacent to the M6 motorway near Winstanley. Seen here in 1980 after closure. Originally Winstanley No. 4 Pit sunk by Meyrick Bankes in 1837. Windy Arbour Colliery Co. Ltd worked the pit from the early 1920s. Licensed after nationalisation in 1947, it then employed 105 miners and thirty-eight surface workers, probably the largest licensed mine in Britain. (Alan Davies, 1980)

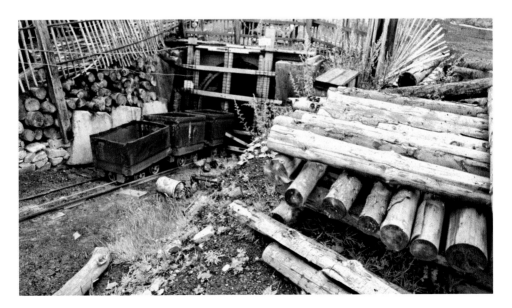

17. Tubs up against the gate of the Ravine seam drift at Windy Arbour Colliery after abandonment. Props and bars are stacked on the right. Great Row Colliery Co. worked this very dirty and gassy 6-foot-thick seam, also known as the Plodder in districts around Leigh, Atherton, Tyldesley, Bolton and Farnworth from 1977 to 1979. (Alan Davies, 1980)

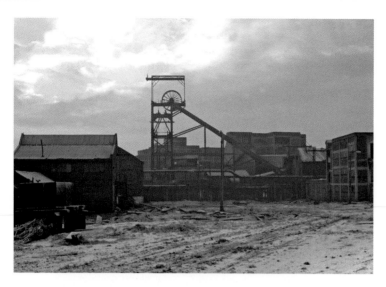 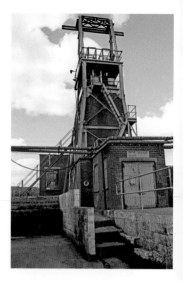

Above left: 18. A frosty morning around November 1967 at Bedford Colliery, Leigh, close to the southern edge of Lilford Woods. No. 3 Pit headgear, sunk to 880 yards, is in view. The colliery closed in October 1967. (Mr Sayles)

Above right: 19. A close view of the structure of an upcast shaft, here at Hapton Valley, Burnley, shortly before closure in April 1982. The headgear above the 12-foot-diameter 488-foot-deep No. 4 shaft is bricked internally, the cage able to rise into this section. Heavy-duty steel air-lock doors allow access to the pit top, a small regulator 'window' allowing the pressure to be reduced enough for one man to open the doors. The overall structure reduced leakage from the outside air to the fan drift part way down the shaft. Yorkshire miners picketed the entrance to the colliery during the 1984-85 strike unaware that the colliery had been demolished. The colliery site, a few hundred yards away, could not be seen from the road due to woodland. (Alan Davies, 1982)

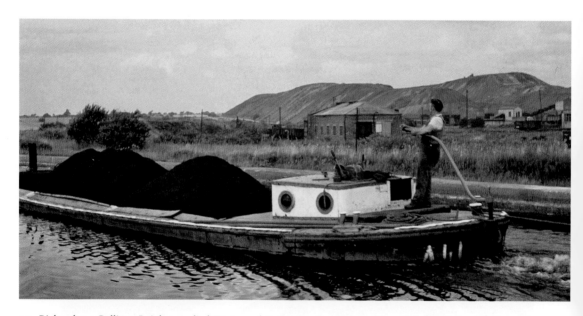

20. Bickershaw Colliery, Leigh, supplied Westwood Power Station, Wigan, (demolished 1989) partly by coal barge along the Leeds & Liverpool Canal Leigh Branch until 11 August 1972. The barge featured, A41, is a 62-foot-long 'Short Boat' originally built for Ranks the millers carrying grain to Blackburn until the 1950s. It then worked carrying coal to Blackburn and Wigan (Westwood) power stations. By 1971/72, it was being worked by the British Fuel Co. ('Hargreaves Lancashire'). The load of coal for each trip would be about 50 tons. This photograph was taken to the west of the colliery, behind are the enormous waste tips now (2010) being landscaped, part of a major redevelopment of the area for housing, business and leisure use.

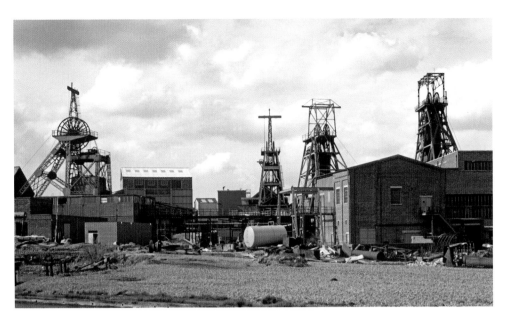

21. The impressive skyline at Bickershaw Colliery, seen from the south in 1979. From the left No. 1 Pit, No. 3 Pit, No. 2 Pit and No. 4 Pit. No. 5 Pit was demolished in 1952 and would have featured to the right of No. 4. No. 1 Pit headgear came from Abram Colliery after its closure in 1934. After nationalisation, the pit regularly raised over 600,000 tons per year, hitting 930,913 tons in 1951 with 2,680 men on the books. By 1967, Nos 1 and 2 pits were mainly used for ventilation. Subsidence due to the colliery working led to Leigh 'Flash' being created from around 1900. By 1948, a feature article in the NCB's *Coal Magazine* described how the Flash had become a haven for birdwatchers; it continues to be so today. (Alan Davies)

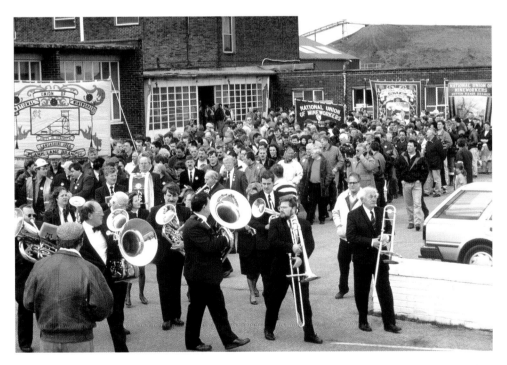

22. The miners march sets off from the canteen at Bickershaw, band to the fore. The banner to the front is the Plank Lane (Bickershaw) National Union of Mineworkers branch and right at the back is the old Sutton Manor Colliery, St Helens branch banner. Sutton Manor had closed in 1991. (Alan Davies, 1992)

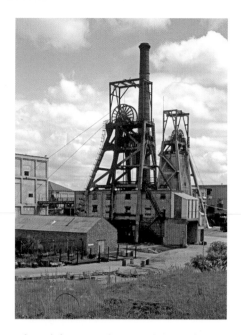 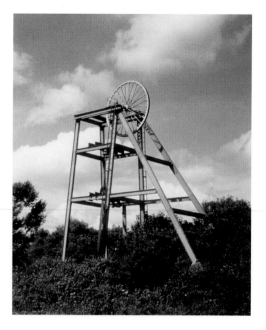

Above left: 23. A close-up of the 86-foot-high No. 2 downcast and No. 1 upcast pit headgears at Parsonage Colliery. In the early days of shaft sinking, an enormous feeder of water of 50,000 gallons per hour was met. Wigan Coal & Iron Co. Ltd was one of the first companies in Britain to choose the steel-reinforced-concrete design, using this also on associated surface buildings, resulting in a clean, 'modern' layout . The pulley wheels were 18 feet in diameter, weighing 6 tons. In 1923, a few years after opening, No. 2 was steam winding the 1,008-yard shaft in 60 seconds, the load on the winding rope being 25 tons. (Alan Davies, 1979)

Above right: 24. Small emergency and maintenance headgear above one of the old Collins Green Colliery Co. Ltd shafts north of Bold Colliery, St Helens, in 1981. Four shafts were sunk on site in the 1870s, huge volumes of water being encountered, so much so that two of the shafts were used solely for pumping. From 1878, St Helens Corporation utilised water out of the shaft at Collins Green for public use. This was still taking place in 1990. (Alan Davies)

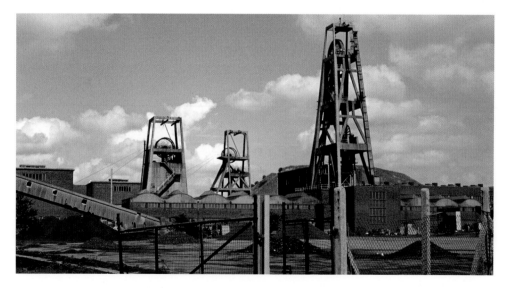

25. Bold Colliery, St Helens. Nos 3, 2 and 1 pits photographed after closure in 1985, the remains of its once giant waste tip behind. The reorganisation of 1948-56 (which proved coal reserves of at least 60 million tons) resulted in an increase in coal output from 186,000 tons in 1947 to 746,000 tons in 1957. (Alan Davies)

26. Sutton Manor Colliery, Sutton Manor, St Helens, seen from the north-east around 1984. No. 1 downcast shaft on the right is scaffolded up for repainting. It was reclad (for want of a better term) with a new outer headgear in 1986 and converted to electric winding, the engine house sited 180 degrees to the old one. The pit closed on 24 May 1991 with around forty years of coal in reserve.

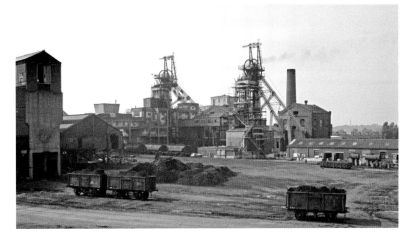

27. Parkside Colliery seen around 1981, pithead baths on the left and canteen to the right. Many similarities in overall design and layout to the reorganised Agecroft Colliery, Swinton.

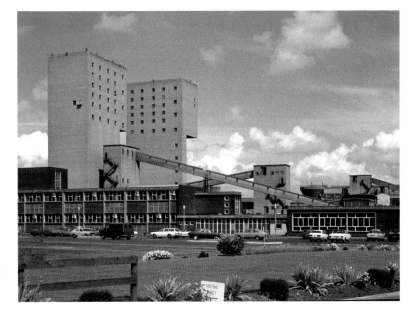

28. Parkside Colliery during shaft filling in late 1993. The recently reinforced 204-foot-high No. 2 upcast shaft 'Koepe' winding tower is reflected in a pool of water in the stockyard, pit prop timber strewn around. No. 2 was the coal-winding shaft with two four-rope DC 2,500-hp overhead winders. (Alan Davies)

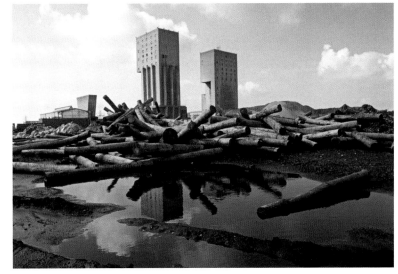

29. The huge pile of Derbyshire limestone delivered to Parkside Colliery in October 1993 for shaft filling. On Friday 28 May 1993, miners' union NUM leader Arthur Scargill's wife Anne and some friends staged a protest at the top of No. 1 winding tower. The British Coal area director ordered that the colliery electricity supply be cut off. This shut the fans down and gas began to build up. The winding enginemen could not move the cages and the fans could not start up again as gas levels were now within the 5-15 per cent explosive range of methane. It was decided to start filling the shafts, the skips still in place in No. 2 pit. A senior former British Coal official has told me that Parkside could be recommissioned relatively easily, especially as the colliery 'made' very little water and is not connected to nearby older pits. (Alan Davies)

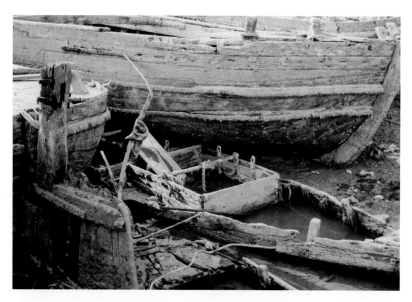

30. May 1991, Boothstown Canal Basin near Worsley, on the Bridgewater Canal Leigh Branch. The canal basin dated back to about 1862, linking collieries to the north via tram roads. This had been drained as part of a housing and marina development. Exposed were two layers of sunken barges, twenty-four narrow and wide barges, some dating back to around 1900 and very well preserved. Just visible here is a 1930s Manchester Collieries narrow boat with its coal container still in place. The cross bar, chain and ratchet, which released the doors on the bottom of the container, also the suspension attachment eyes can be seen. Containerisation reduced large coal breakage. One example was saved and is now at Astley Green Colliery Museum. Greater Manchester Archaeological Unit carried out a full survey of all the barges revealed. (Alan Davies)

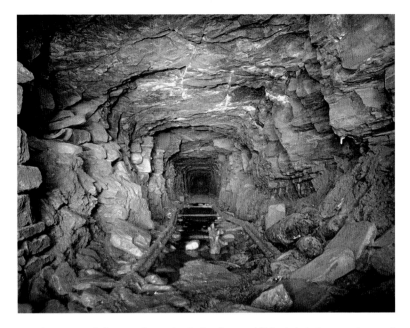

31. The Lancashire & Yorkshire Railway Co. Ltd, who established their locomotive works at Horwich in 1886, funded the driving of exploratory tunnels and sank shallow shafts in the 1890s north-west of Horwich, close to Georges Lane. They must have been made aware of the coal deposits by landowners or lessees of coal and decided to access coal that was left amongst old workings plus virgin coal areas. This tunnel was driven in 1894 through workings of the 1830s to 1860s period, the iron 'bridge' rails still in place when photographed a few years ago. (Alan Davies)

32. Wilderswood Colliery, Horwich, near Bolton, was worked over a large area by various concerns from the late eighteenth century through to 16 August 1960. A large number of shallow shafts and adits accessed two seams, the Little Mine and Great Mine. Occasionally these shallow tunnels subside allowing temporary access. Only experienced mine explorers with safety equipment and gas alarms should even consider entry. Here, in one of the main haulage levels driven around 1894, the manager Rowland Adamson (RA) has chalked up the date of his inspections on a stone pack wall. Dates ranged from 1924 to 1944. Rowland was a qualified colliery manager who took charge of Wilderswood around 1914 and signed its abandonment plan on closure. (Alan Davies)

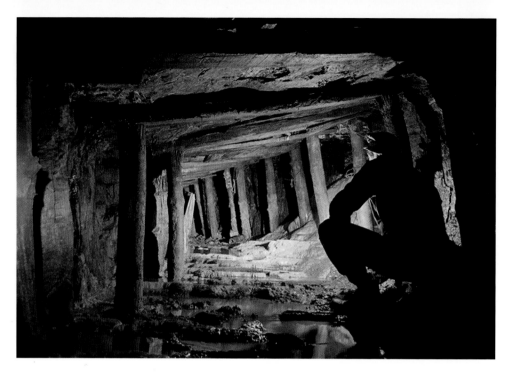

33. Oxidation of coal and mine timbers in old workings leads to ochre (Hydrated Iron Oxide) formation through the staining of mine waters and clays. Here, at the small licensed Hilltop Colliery near Bacup, workings less than ten years old soon have the appearance of great age, ochre oozing in through the props. The author gives the scene scale. (Stewart Parr, 2009)

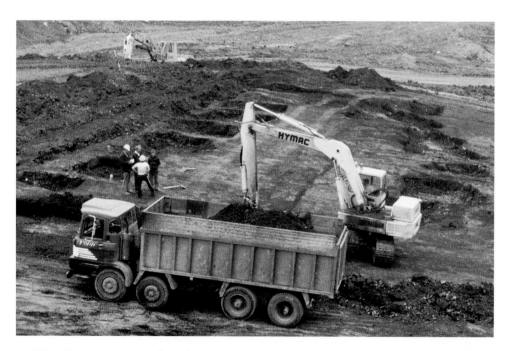

34. The older opencast sites allowed coal wagons right up to the working area. Here at the Tan Pit Slip site, Winstanley, south of Wigan, adjacent to the M6, on 14 September 1978, loading takes place next to a cluster of centuries old 'bell pits' (on the right of the loader). More ordered and later room and pillar workings can be seen to the left. This opencast extracted coal left by Winstanley Colliery No. 5 Pit. The colliery was still winding coal in 'corves' or baskets in the 1880s.

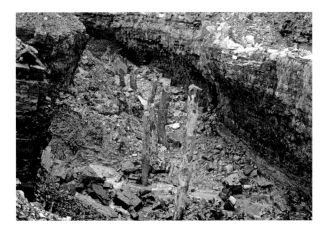

35. A possibly unique feature in the ancient (probably late sixteenth to early seventeenth century) Potato Delph workings at the Timberyard site, St Helens, in 1993, were the roadways arched in solid coal with centre-set silver birch props. Centre setting of props probably means the roadway was retained for drainage rather than being packed to the roof with riddled (graded) small coal as were roads nearby. Arching of the roadway points to great age, the support method adapted from architectural practice. The props still had their bark on. (Alan Davies)

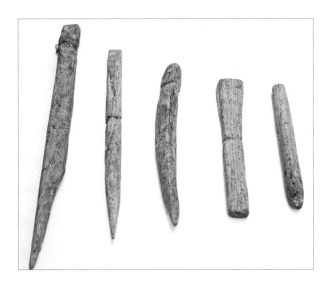

36. The rarest items (probably unique in Britain) ever found in a Lancashire opencast site were these wooden miners' tally sticks or pins. These were discovered in the mid-eighteenth-century workings of the Wigan Four Feet seam at the St Helens Timberyard site in 1993. Colliers attached these to their baskets of loaded coal, the surface banksman recognising the distinct shape each had. He would then be able to 'keep a tally' of the man's output of coal. The tally shapes were given names, those names in use in many coalfields:

 Picket-top, sharp at one end.
 Double-picket-top, sharp at both ends.
 Chisel top, chiselled and shaped at one end.
 Double chisel top, chiselled and shaped at both ends.
 Picket-chisel-top, sharp at one end and chiselled shaped at the other.
 Pig's foot, chiselled shaped, with a notch cut in the centre of the chisel end to form two fingers.
 Half-ass, a 'pig's foot' with one of the fingers cut off.
 Double half-ass, a double 'pig's foot' with a finger cut off each end.

The range of pins could be increased by adding extra notches. A pin with a notch cut in the middle was a 'one-notch'. A pin with notches cut on opposite sides was called a 'twist notch', and a pin notched all around was known as a 'ring dagger'. That the site engineer Fred Lowell spotted these spread amongst the site rubble and mud was nothing short of amazing. (Alan Davies, 1994)

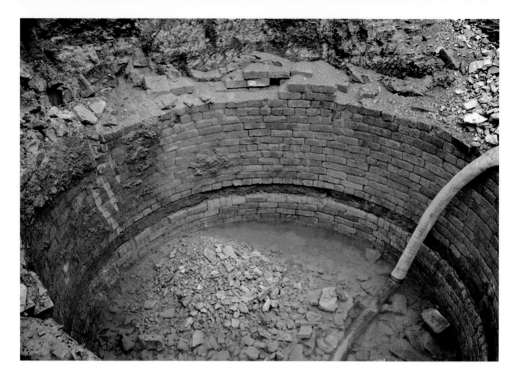

37. One of the three Wharton Hall Colliery shafts exposed at the Cutacre opencast site in 2009. Approximately 12 feet in diameter, double brick lined. Water was forcing its way up through the shaft infill. Waterlogged old workings in the shallow underground canal system and in various seams to the north were responsible for the enormous head of pressure. (Stewart Parr, 2009)

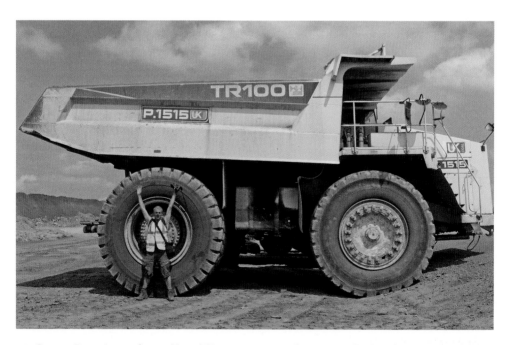

38. Stewart Parr gives scale to a Terex TR100 100-ton coal wagon at the Cutacre opencast site, Little Hulton, in June 2010. General Motors introduced Terex products as a way to continue manufacturing earthmoving products, having acquired Euclid in 1953. The tyres on this example were made in Belarus, costing £4,000 each. The Terex Titan of 1974 held the record for a rock wagon for many years with a capacity of 350 tons, powered by a 3,300-hp GM engine. In 1998, the Caterpillar 797 broke the record by a mere 10 tons. (Alan Davies, 2010)

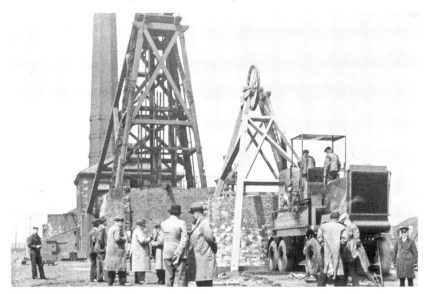

Ashton's Field Colliery *c.* 1942. Manchester Collieries engineers view an exercise at the old ten-foot-diameter 365-yard-deep No. 1 Pit shaft. The mobile emergency winding engine from nearby Boothstown Mines Rescue Station has been set up (delivered in late 1940). No. 2 pit wooden headgear is in the background. After closure in 1929, Ashton's Field was kept open as a pumping station and also to allow access and ventilation to the Worsley underground canal system. The derelict colliery site was only landscaped in 2008-09.

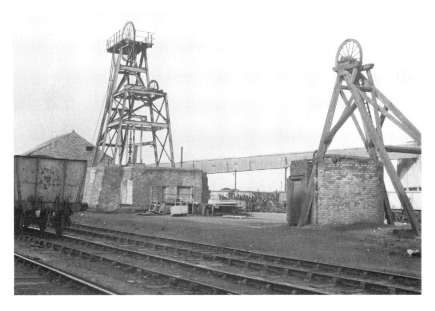

Ashton's Field Colliery site in the early 1960s. The old wooden No. 2 Pit headgear has been replaced with a rolled steel-girder construction. This survived until 1964. The Ashton's Field blending plant (set up in 1937) conveyor structure is in the background. Coal from Astley Green Colliery (closed 1970), Mosley Common Colliery (closed 1968) and Brackley Colliery (closed 1964) was blended and despatched to Lancashire Electric Power's Kearsley Power Station. Lifting of the railway track at Ashton's Field meant it was well and truly closed by August 1971.

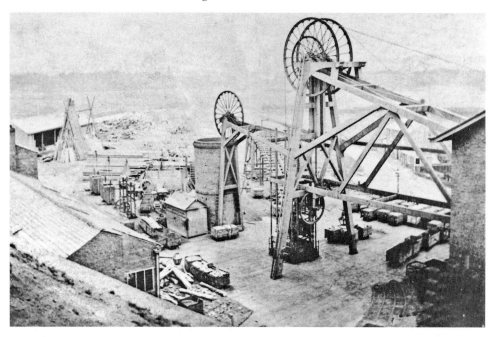

A superb early Lancashire colliery view. Andrew Knowles Clifton Hall Colliery, Lumn's Lane seen around 1880. No. 3 furnace ventilation shaft is to the left, No. 1 downcast shaft to the right. The pit was to the west of Agecroft Colliery. Sunk in 1838, the two shafts were only 10 yards apart, one 10 feet diameter, the other 9 feet. Sunk 600 yards to the Cannel seam. Note the combined trestle-type headgear design and the mass of tubs on the brow.

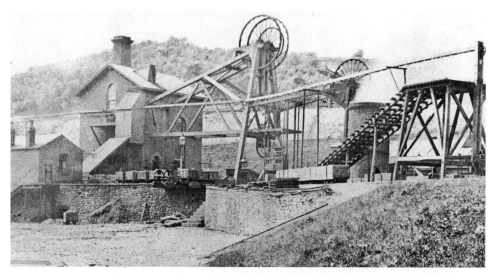

Another fine view of Clifton Hall Colliery from the north-east from the Lumn's Lane side. Taken c. 1880, No. 1 is to the left, No. 3 to the right. Here No. 3 furnace ventilation shaft can be seen to be in operation. At the base of the 600-yard-deep shaft was a blazing furnace drawing air out of the workings, imagine the draught a 600-yard chimney would create. The vertical engine house contained a Musgrave of Bolton 42-inch by 72-inch engine of 1858. The spiral drum ranged from 14 to 25 feet in diameter; note the long rope slots in the roof and engine house wall to allow for the varying rope entry.

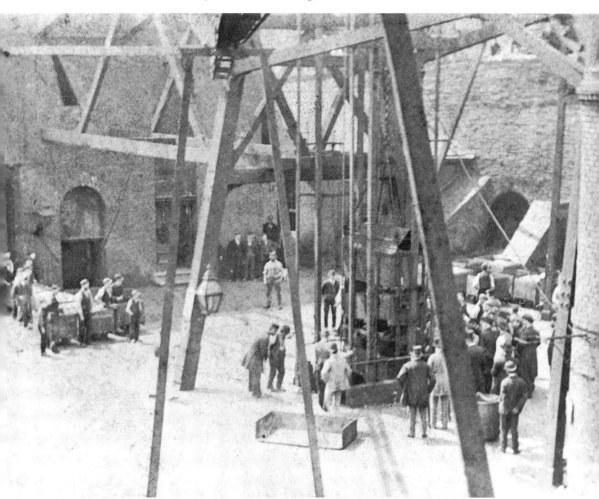

One of the earliest colliery explosion site photographs for the Lancashire coalfield, the Clifton Hall Colliery disaster of 18 June 1885. The explosion killed 178 men and boys, the youngest being thirteen. Here, officials and management await bodies being wound up the shaft, the long single-sided box acting as a makeshift coffin. Fifty-three men received illuminated addresses for their rescue efforts. Undermanager Thomas Worrall, Blacksmith George Hindley (aged sixteen) and fireman George Higson received Albert Medals for their immediate rescue efforts. Worrall received a first-class medal as well as a Hundred of Salford Humane Society Gold Medal. The Salford medal, Mines Rescue medals presented to R. Johnson and F. Burtonwood and a gold chain inscribed to George Hindley were all sadly stolen from the Salford (later the Lancashire) Mining Museum in Buile Hill Park, Eccles Old Road, Salford in the early 1980s.

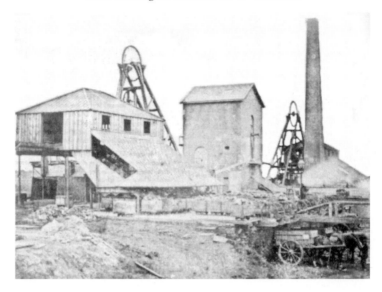

It is always exciting to see a photograph of a colliery when it is known to be unique, the only surviving visual image. Colliery layouts are always different so for the industrial historian surprises are always to be found. Also image quality often does not matter, as here with Clifton Moss Colliery in 1866, as we are so lucky to have such an early record. Sunk by Andrew Knowles & Sons around 1840 the central vertical engine house winding single-cage shafts are typical. Accessing the Trencherbone seam at 1,404 feet via 404-yard-deep shafts. Horse-drawn directly tippled coal was in place throughout the colliery's life, which came to an end in 1891. Attempts to partly reopen the pit to relieve the large Bridgewater Collieries' Sandhole Colliery (to the south-west, closed 1964) of its water burden came to an end *c*. 1922.

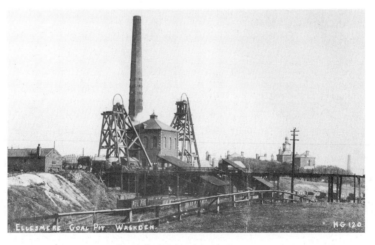

Postcard view to the south of Ellesmere Colliery, Walkden, *c*. 1905. Twin wooden headgears and single-cage winding in operation. The pit was situated in the town centre south of Manchester Road opposite today's (2010) giant Tesco. No. 2 (right) was sunk to 415 yards, No. 1 to 276 yards. Intersecting the main Worsley underground canal system, it ceased production in 1921. NCB (formerly Manchester Collieries) Walkden Yard workshops was for many years situated to the right, servicing colliery equipment and locomotives (now a housing development). In the distance with the clock tower stands the Bridgewater Collieries, later NCB Walkden offices.

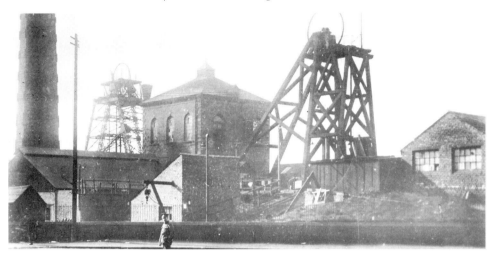

A combination of steel and wooden headgears at Bridgewater Collieries' Ellesmere Colliery, Walkden, seen here around 1924. Note the typical Bridgewater Collieries square plan, central ventilator, vertical engine house of c. 1866 which contained a Naysmith Wilson 30-inch x 54-inch winder. This was electrified in 1936.

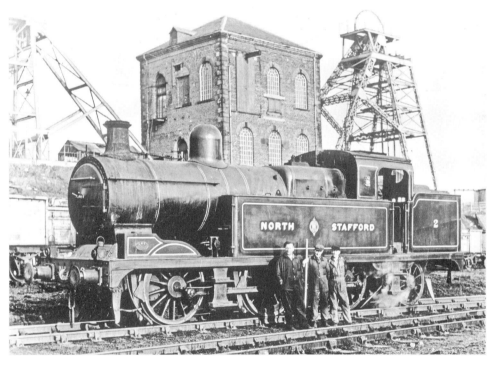

A fine view, c. 1965, of loco Princess (built 1923 at Stoke) with Ellesmere Colliery access and pumping station behind. Ex-LMSR 2271 the loco arrived at Manchester Collieries in October 1937, joining the NCB stock in January 1947, based at Ellesmere shed. Substantially repaired in the 1950s at the adjacent Walkden Yard Workshops, it was repainted in North Staffordshire Railway livery (although I am reliably informed it was never an NSR loco!) as NSR No. 2 in April 1960. Loaned shortly afterwards to Crewe for the NSR centenary. After further repairs in 1964, it was withdrawn in August 1965, then by 1967-68 headed off to Shugborough Museum.

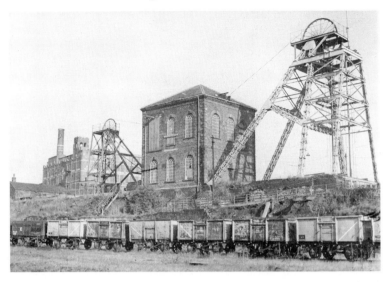

NCB Ellesmere Colliery (Pumping Station), Walkden, seen around 1962. The shafts were retained long after the colliery ceased coal production in 1921, functioning as an access point for materials for maintenance of the main Worsley underground canal. A nearby 12-foot-diameter 255-yard-deep shaft to the north of Manchester Road was used for ventilation. The site acted as a pumping station raising water to the level of the underground canal, easing the burden on Mosley Common Colliery to the west (closed February 1968). The site became disused after the closure of Mosley Common, attempts to preserve the engine house and headgears sadly failing.

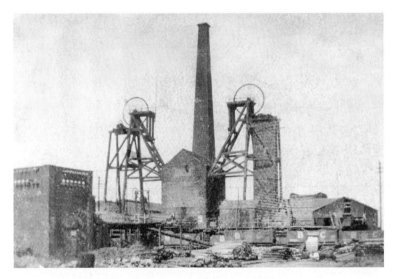

The only image in existence of Bridgewater Collieries' Linnyshaw Colliery c. 1921. The local name was Berry Field Colliery. The pit was situated east of Walkden, north of Manchester Road and off the end of Moss Lane. The tall headgears (No. 1 downcast to the left, No. 2 upcast on the right) allowed for multi-deck winding, the 12-foot plain drum wound by a Walker Brothers of Wigan vertical 48-inch x 60-inch engine. Note the Bridgewater Collieries BC wagons. Linnyshaw ceased coal production on 31 March 1921, being retained for pumping until 1937 when the site was demolished. Sandhole Colliery, a former Bridgewater Collieries pit a few hundred yards to the south, worked the reserves of coal left by Linnyshaw, becoming part of Manchester Collieries Ltd (1929-47), then the NCB in January 1947.

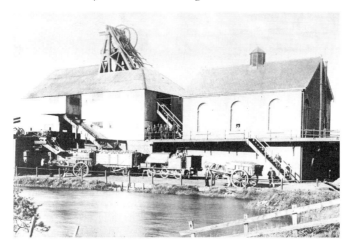

A fine, although faded image of James Roscoe & Sons' Peel Hall Colliery of around 1905. The pit was south of and close to the A6 at Little Hulton, east of Wharton Lane. Two shafts sunk around 1850 (No. 1 to the left) accessed the Arley seam at 1,301 feet, the shaft bottom being at 1,361 feet. Interesting features include the unusual encased trestle-type wooden headgear, the open screens shute for mainline wagons and the tub tippler shute for Roscoe's own coal carts taking away 'run of mine' coal. The 0-6-0 locomotive is *Lord Kenyon* (after the lord of the Manor living at Peel Hall close by to the east), built by the Hunslet Engine Co. of Leeds in 1884 and scrapped in 1909. The colliery closed in December 1931.

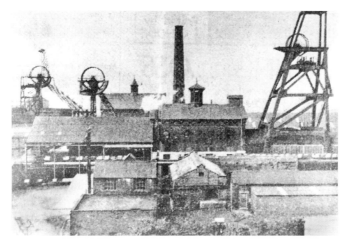

Sandhole or Bridgewater Colliery was one of the large number of collieries under the Trustees of the Duke of Bridgewater. Situated east of Walkden, south of Manchester Road and to the west of the M60. Two shafts, No. 1 (middle) and No. 2 (right, concrete construction of 1935), were initially sunk in 1865 to 573 yards and 562 yards, later No. 3 (on the left) and No. 4 were sunk to 554 and 427 yards. Problems with 'running sand', hence the pit's name, meant substantial piled foundations were needed to support major surface features. Construction of the washery removed 'two good holes' from the adjacent Ellesmere golf course! The deepening of No. 3 pit in 1943 included installation of the last newly constructed steam winding engine in the Lancashire coalfield. This was a twin-cylinder horizontal of 36-inch x 66-inch made by Worsley Mesnes Ironworks of Wigan. This poor-quality newscutting of 1962 is frustratingly one of few photographs of the colliery, surprising since coal production only ceased in September 1962 when 607 miners and 186 surface workers lost their jobs.

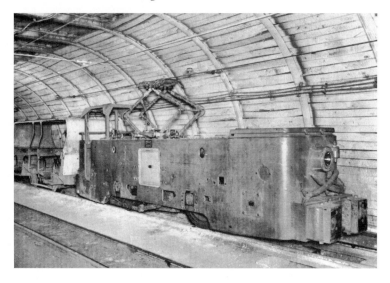

Sandhole Colliery came to national attention within the coal industry when approval was given by the NCB in November 1950 for an experimental bare-wire trolley loco installation, the first in the country. The obvious danger of open sparking down a coal mine needed special regulations to allow this. These had been in place since nationalisation in 1947. In this photo of around 1953, the loco is linked to manriding carriages. Four locos were ordered from Metropolitan Vickers of Trafford Park, Manchester, the cost amounting to £21,360. Few other installations were to be designed due to the very strict safety regulations associated.

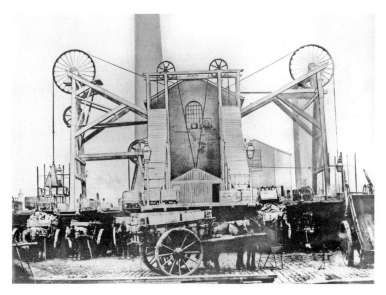

Andrew Knowles & Sons' Wheatsheaf Colliery c. 1880. The pit was off Bolton Road, Pendlebury, near Carrington Street and City Walk. A fascinating early retouched view of the pit, which was sunk from 1846. The two 10-foot-diameter single-cage shafts, 24 yards apart, were wound by a vertical steam winding engine by J. Musgrave of Bolton, still in use in 1944. Note the multi-deck cage tub hoisting arrangement and tub tipplers loading directly into coal carts. Edward Ormerod of Atherton had patented his winding-rope safety detaching hook in 1868, but the trestle headgear design and also the flat winding rope in use at Wheatsheaf has precluded its use, making travelling the shafts that bit more dangerous.

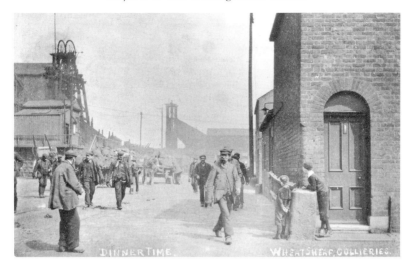

Two young lads wait for their dad or older brother to appear; an atmospheric postcard view of 1905 showing miners leaving Wheatsheaf Colliery, Pendlebury. Taken from Bolton Road, probably after the day shift finished around 1-2 p.m. The caption states 'Dinner Time', indicating the photographer possibly thought miners went home for dinner! In Britain in 1905, there were 673,800 miners at work producing 12,693,885 tons of coal. Lancashire's miners earned a few pence a shift less than the majority of coalfields. A recent discovery has been amongst the Mitchell & Kenyon film archive showing men leaving Wheatsheaf by this entrance heading left. The film can be viewed on the internet: search under Pendlebury Colliery.

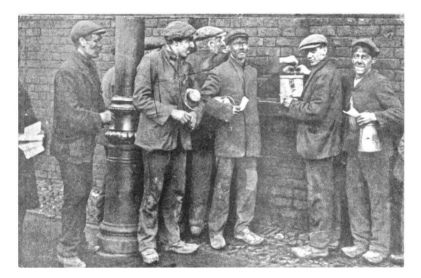

This postcard of the ballot taking place at Wheatsheaf Colliery during the 1912 minimum wage strike was sent to Doncaster, no doubt to coal-mining relatives. The strike was one of the first national actions led by the Miners' Federation of Great Britain, demanding a national minimum wage. Many miners received no strike pay during the dispute, which lasted from 26 February to 15 April. By March, there was a coal shortage, and any coal that was still available became expensive. An agreement on minimum wage levels was eventually secured for the one million mineworkers who had been on strike, although the more militant men, basking in their power acting nationally, stayed out for more concessions, with violence and minor riots occurring across the Lancashire coalfield.

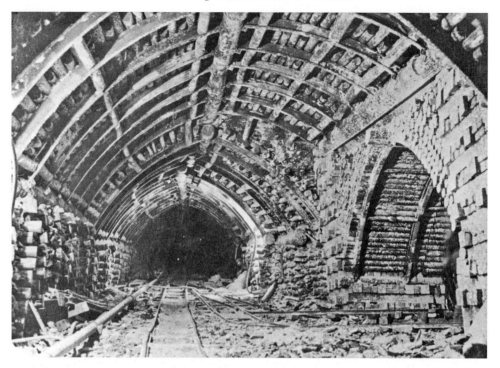

The main engine or haulage road at Wheatsheaf Colliery in 1938. Old railway lines have been used to create arch supports, the continental 'Moll' system. Packed behind the arches are pit props. The arches stand on hardwood timber chock stacks at the sides. Of 14 feet by 12 feet dimensions, this system of support was ideal for long-service main roads. The white coating on the surfaces is stone dust, which would tamp down a coal-dust explosion if disturbed.

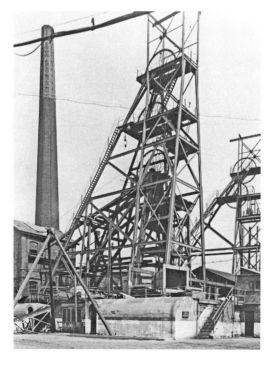

The old No. 1 Pit wooden headgear at Wheatsheaf was replaced in 1950 by this tall offset pulley wheel steel-girder design. The old headgear was left in place, as the new one was constructed around it, quite a feat of engineering and accurate surveying. These types of jobs were planned in minute detail so as not to affect coal production, often carried out during the summer holidays. Note the wartime air-raid shelters for surface workers close to the shaft.

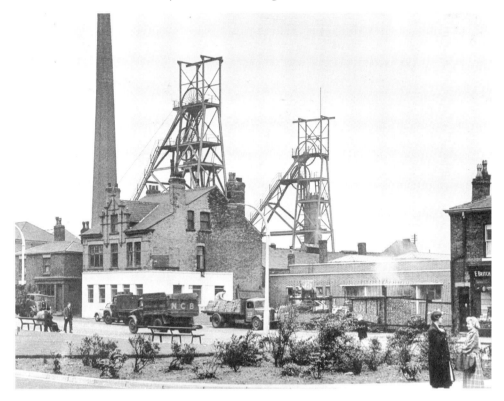

A classic Lancashire coal-mining town scene. It's Friday 23 May 1953; the photograph is entitled 'A typical morning scene in Pendlebury'. The new steel headgears at Wheatsheaf Colliery tower above the pub on Bolton Road, an NCB coal wagon passes by, two women have a chat, not giving the scene behind them a second glance. Hundreds of colliery headgears were an integral part of the Lancashire landscape for centuries and now only one survives at Astley Green Colliery museum.

The white bollard at the entrance to Wheatsheaf Colliery seen in this photograph of 14 July 1959 is the one the young boy is leaning on in the 1905 postcard, the terraced house next to it by now demolished. Behind the lady is the old weighbridge house seen in the Mitchell & Kenyon film mentioned earlier. The board on the side of the office building states that 'In 1957 this colliery produced 231,000 tons of coal for industry and household use'. In 1957, 657 miners and 253 surface workers had produced this coal from the Crombouke and Windmill seams.

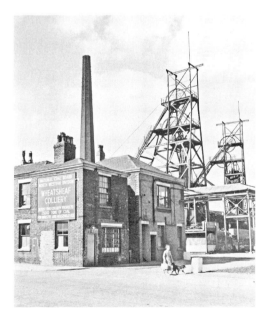

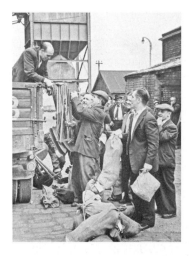

The men's picks and shovels on their tool rods are being loaded into the NCB wagon at Wheatsheaf Colliery after coal production ceased on 16 June 1961. Some men would be heading off to start work at the recently redeveloped nearby Agecroft Colliery; others would be given work at Mosley Common Colliery, Tyldesley (closed 1968), and Astley Green Colliery, Astley (closed 1970). Men were used to the idea of some day having to move to another colliery, many changing pits four or five times during their working lives.

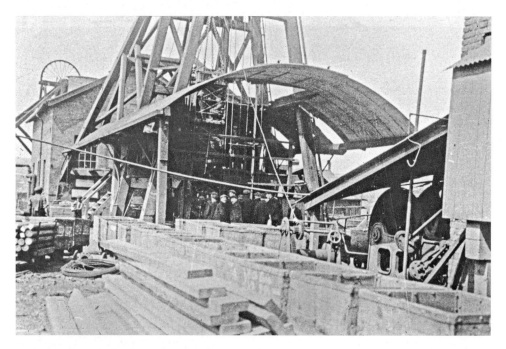

Mining in the Irwell Valley around Kearsley, Clifton and Swinton is recorded in archives back to the mid-sixteenth century and probably, on a small scale, had a far longer history. One of the more interesting sites was Wet Earth Colliery, Clifton (Clifton Country Park, off the A666, Clifton House Road). Known to have been active around the 1740s, the pit was one of many shafts accessing the wide expanse of the outcropping 1 in 3.5 inclined Doe seam, 9 feet 7 inches thick. James Brindley (1716-72), the famous canal engineer, devised around 1752 a water-powered pumping scheme on site using a weir, tunnel and siphon arrangement to supply water to a waterwheel. As the colliery closed in 1928-29, very few photos exist; this is one taken around 1920 of men waiting to go down the downcast shaft, perhaps on the afternoon shift. A three-deck cage is in use, men crouched in the top deck. In the distance is the chimney-surrounded upcast shaft reminding of its former furnace-ventilation days. Note the empty tubs ready for the shift to load, also on the right a surface haulage winch used for shaft maintenance. The manager George Jones was killed when being lowered down the shaft in a kibble (iron bucket) on 20 December 1918 due to the brake of this engine failing.

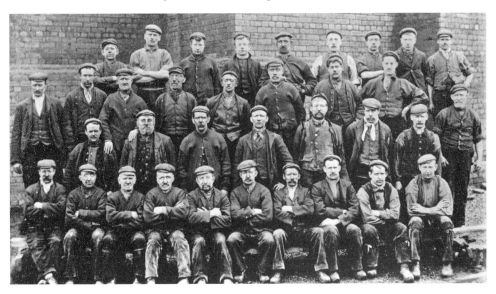

A group photograph of surface workers is quite a rarity; here, thirty-five of the surface workforce of around 120 at Wet Earth Colliery suffer the photographer around 1900, behind them are the substantial stepped walls of the gas-production building. The colliery mined the 4-foot 7-inch-thick Cannel seam, famed for the large amount of gas trapped within it and ideal for gas production. The colliery even had its own gasometer on site. Many of these men would be involved in keeping the train of coal tubs on the move, around 2,800 7 hundredweight (20 hundredweight = 1 ton) tubs a day being circulated up and down the shaft. Roughly half of the coal produced was loaded directly into Clifton & Kersley Coal Co. Ltd's barges. These could get within fifty yards of the shaft, the company owning around two hundred. Travelling the company's Fletchers Canal east and parallel to the River Irwell, the barges linked up to the Manchester, Bolton & Bury Canal via Clifton Aqueduct.

The only other image surviving of Wet Earth Colliery is one taken during demolition in early 1929. Roughly the same viewpoint as the 1920 shot, we can see the wooden downcast shaft (285 yards deep) headgear and engine house, with the upcast shaft (207 yards) behind. The upcast shaft used furnace ventilation until 1898, when a Walkers of Wigan Indestructible fan was installed. In the foreground on the left and covered over to the right are two of the Lancashire boilers in the boiler house, at a lower level than the surface. A trail exists today around the colliery site and many features can be made out, albeit overgrown and most of the information panels have sadly been vandalised. At the entrance to Clifton Country Park a visitor centre has information on the colliery's history and an interpretation board about the site.

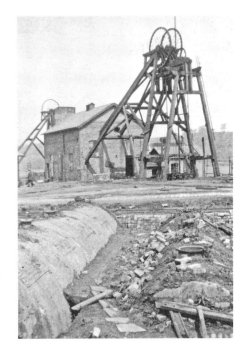

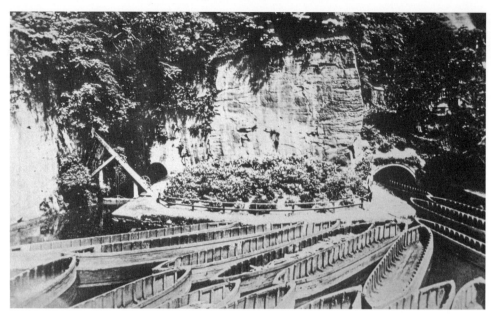

Worsley Delph, Salford, and the entrances to the Duke of Bridgewater's underground canals, seen in 1872 when coal transport along the tunnels had greatly declined. The canal 'basin' is full of empty 'starvationer' boats, so named due to their ribbed structure. These could be up to 53 feet long by 6 feet wide, carrying around 30 tons of coal. Initially, the idea was that the eastern (right) tunnel, driven from 1759 to intersect the many seams of coal to the north, was basically a mining 'sough', the water draining out of the workings topping up the newly constructed Bridgewater Canal. Through the insight of John Gilbert, the 3rd Duke of Bridgewater's Chief Agent at Worsley, the tunnel would be of a size to allow boats access to load coal, the flow of water assisting the loaded boats on their outward journey. The tunnel intersected the Worsley Four Feet after 270 yards, a branch canal heading west along the strike of the seam. It is thought in total that over fifty-one miles of canals were driven in total. The use of the navigable level for coal haulage declined in the 1870s and finally ended in 1889, the collieries mostly by then linked up to the railway network and possessing powerful winding engines for raising large amounts of coal on site. After this time, the level acted mainly as a drain for the collieries, only ceasing to serve that purpose when the last of the former Bridgewater collieries, Mosley Common, Tyldesley, closed in 1968. The system was last inspected in the early 1970s and is now inaccessible; water, though, is still flowing out after 250 years.

Worsley Delph. By the use of 'clows' or sluice gates, water levels in sections of the canal levels could be allowed to rise then be released, the pent-up volume of water helping boats flow outwards. Here, in the 1920s, a boat has emerged out of the western arm of the main navigable level into the Delph. The boatman is operating the chain control on the exit clow. This tunnel was driven from 1771 to ease congestion at the Delph. The two tunnels met after 500 yards at a point known as Waters Meeting, the main level then continuing as a single tunnel beyond and to the north.

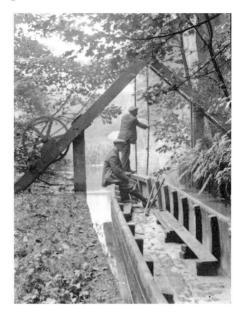

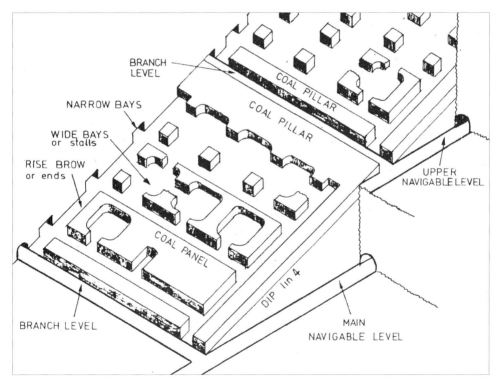

Explaining how the Worsley underground canal system was laid out is very difficult. This diagram gives an insight into John Gilbert's amazing three-dimensional grasp of the layout of the coalfield north and north-west of Worsley, the inclination of the seams, the dual use of the water levels for haulage and drainage. Gilbert had arrived at the theory and practice of 'horizon' mining over a century and a half before European and later British mines adopted the technique. The upper navigable level was linked to the main level via an inclined plane, another insight into the genius of Gilbert.

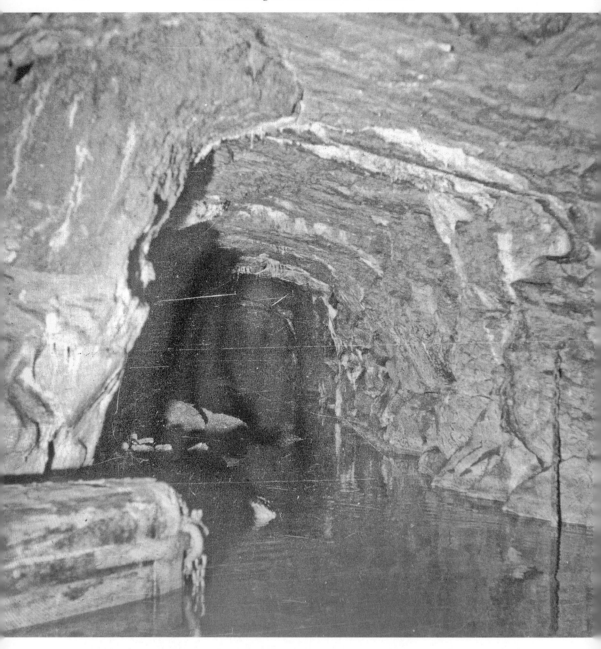

An example of a branch canal off the main level. This branch is heading along the strike of the First Three Quarters seam and is below roughly halfway between Worsley Delph and Walkden town centre. The seam was so named because geological faulting led to certain seams being encountered a number of times. Driven in solid rock probably using gunpowder and trimmed by hand pick. The author was part of a project comprising the Mines Inspectorate, the Coal Authority and Mines Rescue teams from Selby and Mansfield in August 1998 to inspect the two entrance tunnels up to their meeting point 500 yards inbye. The potential for reopening to the public was being driven by Royston Futter, Director of City of Salford Arts & Leisure. The tunnels were in perfect condition, especially sections in solid rock. Sadly, nothing progressed after the investigation, the mines inspector never too pleased at the prospect of public entry.

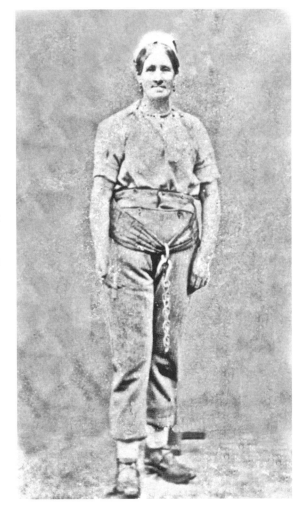

Mrs Whittaker was photographed around 1870 in her old mineworker's clothes. She had worked down Edge Fold Colliery, close to and north of the East Lancashire Road north of Worsley, part of the vast network of mines linked by the underground canals entered at Worsley. She toiled below ground dragging baskets of coal to be loaded into boats using her waist harness and chain. In her right hand she holds a candle, her sole source of light when working. The Children's Employment Commission had gathered evidence from the coalfields in 1841, its findings shocking both the public and politicians alike. The subsequent Coal Mines Act of 1842 ended Mrs Whittaker's working life in the mines, as women, girls, and boys younger than ten were barred from working in mines. Women at Worsley and other mining sites within the Bridgewater complex were lucky to be offered work immediately on the surface and within the estates compared to women at other collieries in Lancashire coalfield.

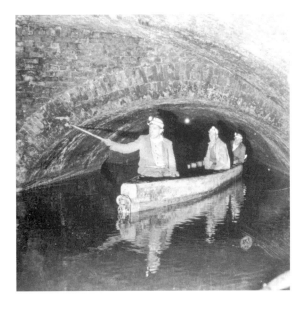

An inspection team in the early 1960s pass through brick arched tunnels of the late eighteenth century in a section known as the Deborah Pillar under Magnalls Fold (a few hundred yards north of the Tesco store), Walkden. Vast numbers of bricks were needed in the construction of the canal levels, lime for the mortar being mined at Bedford, east of Leigh and Middlewood, south of the canal, south-west of Worsley. The 1998 inspection showed the lime mortar in the main level to be as hard as rock with virtually no signs of deterioration.

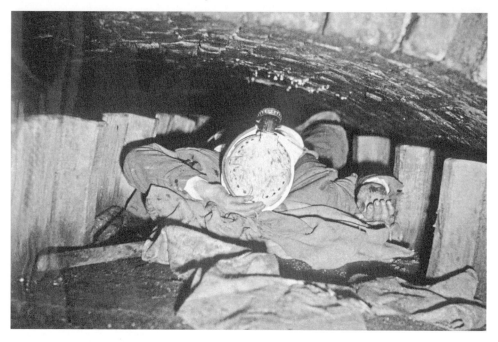

The NCB film unit produced a short film about the underground canals in March 1955 entitled *Deep Waters* as part of one of their Mining Review short films. This is the only footage apart from the 1998 inspection in existence. Sections of the film show men lying on their backs 'legging' the boat along the main canal level. The man in this photograph is beneath an area known as Moss Pillar between Walkden and Farnworth. Speaking to an old man in the 1990s who had worked most of his life maintaining the canal levels, the farthest disused reaches of the canal levels beyond Farnworth and to the north-west were beginning to subside and collapse in the late 1930s and have probably by now closed up. There is still a vast underground water 'pond' building up over a wide area of old workings. Experts feel this will create many problems at some time in the future as the water reaches the water table and gas is pushed through the strata to the surface.

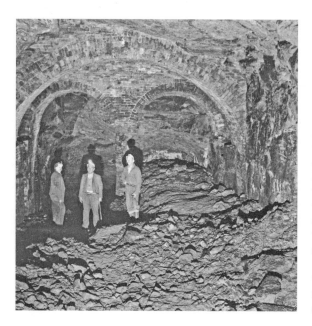

A feature designed by John Gilbert (1724-95) but which he did not live to see completed was the inclined plane. This linked the upper canal (topped up by surface reservoirs) to the main navigable level and also allowed barges on wheeled carriages to be brought to surface at Walkden for repair at Boatshed Reservoir (close to today's Tesco petrol station). Here, seen during an inspection around 1962, is the southern end of the vast chamber which housed the mechanism; the caption adds 'dry since 1830'.

The Burnley Area

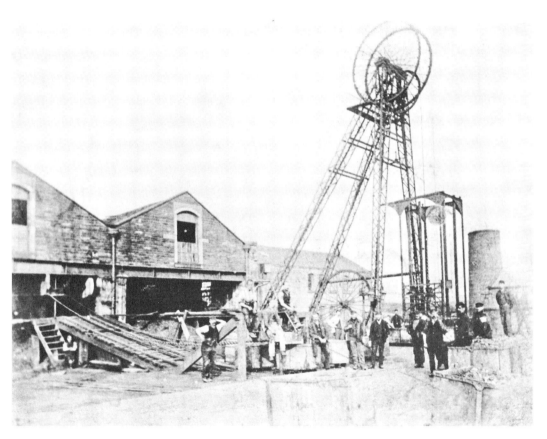

December 1903, Bank Hall Colliery No. 2 Pit, Burnley. Operated by Hargreaves Collieries Ltd. Officials and surface workmen pose alongside one of the most precariously top-heavy headgears the Lancashire coalfield has ever seen! Why such large-diameter pulley wheels were chosen is a puzzle to say the least. This could be because it was an early example of steel-lattice design. The design did not allow for the use of a safety detaching hook (patented by Ormerod in 1868) if the cage was overwound. Behind is the 'cupola' furnace ventilation chimney above the upcast shaft.

A close-up view of the No. 2 Arley headgear at Bank Hall Colliery above a 12-foot-diameter shaft, sunk in the early 1860s. Behind is the cupola ventilation chimney upcast shaft and in the distance is No. 3 Dandy Pit, sunk in 1900 540 feet to the Upper Arley seam. The Dandy seam consisted of 2 feet 1 inch of coal with a 5-foot dirt band. Beneath the seam was 5 feet 9 inches of fireclay. Coal-seams varied in name from district to district, even from colliery to colliery; at Bank Hall were to be found the 1-foot 8-inch China and 1-foot 5-inch Crackers seams. No. 2 was not used for coal winding after 1939.

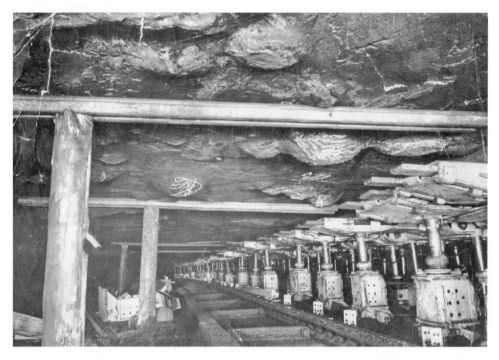

A problem for collieries in the Burnley, Accrington and Bacup areas was the inclusion in the seam of coal balls, locally known as 'bobbers', varying from an inch in diameter to two feet across. No definitive explanation for the presence of these has been arrived at. In general, it is thought that decaying organic matter such as snails, large insects and bivalves produced chemicals which affected the clays and muds surrounding them in a way which made a roughly concentric area around them solidify harder than the material beyond. In this 1960s photograph on the 4-foot-thick Lower Mountain seam coalface at Bank Hall Colliery the bobbers in the roof have been highlighted with chalk. Coal cutter shearer discs hitting these created sparks of a high enough energy to ignite gas, one of the main reasons Bank Hall closed in March 1971.

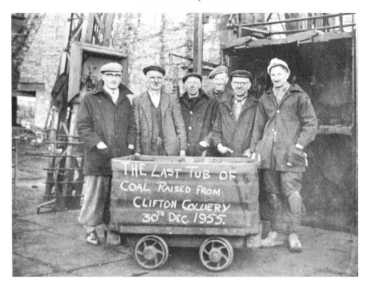

Clifton Colliery was sunk in 1876 by the Executors of John Hargreaves (Collieries Ltd). Of three shafts, the downcast was 310 yards deep, 14 feet in diameter, used for pumping. The water raised was for many years approximately 560,000 gallons per day. Another downcast was 260 yards deep, 11½ feet in diameter, for coal winding, men and materials. The third, the upcast shaft was 9½ feet in diameter and 260 yards in depth. From the left: colliery manager H. Tomlinson, banksman T. Bordley, surface foreman D. Robinson, storekeeper H. Fort and pit overman H. Smith.

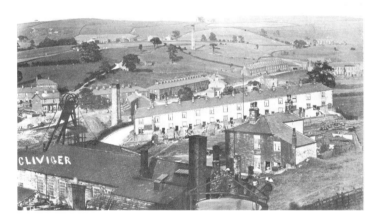

Mining for coal around the Cliviger district south-east of Burnley really was ancient, possibly back to the mid-thirteenth century. Coal from the area is mentioned in documents of 1295 (see introductory text), the earliest record of coal mining in the Lancashire Coalfield. The working of lead and ironstone in the area probably goes back long even before that. Around 1853, the Union Pit was sunk to 150 yards by the Cliviger Colliery Company to access the Arley seam. This view from around 1904 is fascinating due to the rural setting and the layout of the pit. Other pits in the Cliviger valley included Copy, Railway, and Cliviger Drift. Arley coal from Burnley and Cliviger is reputed to have been sent to Buckingham Palace. A colliery-supplied gasometer fuelled lighting for the shaft bottom, the miners housing in the village at Lower Damfield, as well as the surface buildings at the colliery. Union Pit closed in 1943.

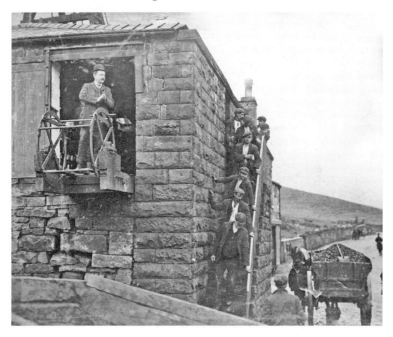

The Jobling family for generations owned and managed the Cliviger collieries from around 1800, originating from Brampton in Cumberland. In this superbly atmospheric photograph at Union Pit around 1910, colliery manager John Jobling (who also managed Copy and Railway Pits) stands alongside the tub tippler rubbing his hands after another productive shift, the miners coming down the steps alongside the road. In 1911, the pit came under Cliviger Coal & Coke Company, employing ten miners and nineteen surface workers.

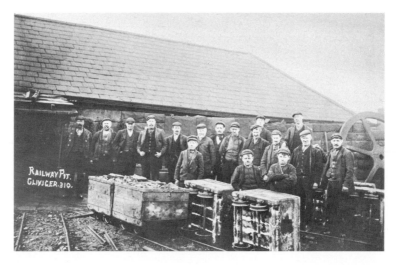

Railway Pit, Cliviger, near Burnley, came under Cliviger Colliery Company. Here, around 1904, surface workers appear reluctant to do their duty alongside what look to be about 5-hundredweight tubs. A large engine flywheel, possibly off a winding engine, leans against the shed behind. The pit accessed the Arley seam via two rising drifts of 450-500 yards length avoiding the need to carry out pumping. A furnace in the return airway provided ventilation. Up until closure around 1938, candles were in use below ground. It is said two were needed per shift; watches were not required!

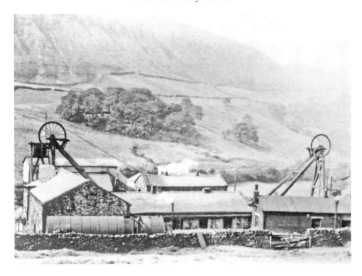

Copy Pit, Holme-in-Cliviger, with Thieveley Pike in the background, seen in 1948. Set in the magnificent Cliviger Valley, it was probably sunk in the late 1850s. This interesting small colliery had an unusual winding system where the engine house was central, winding two single-cage shafts at once, the cages carrying four men at a time. The shafts were shallow at 96 yards, of which 85 was through glacial sand and gravel deposits. A Cornish beam engine was installed around 1860 to pump the heavily watered strata. Furnace ventilation was in use at the pit, firstly at the base of the upcast shaft and later by a new 'cupola' chimney shaft on the nearby hillside. The pit closed in March 1964.

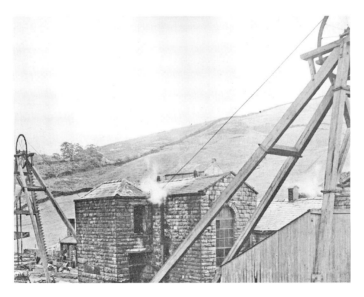

A closer view of the winding arrangement at Copy Pit. The abundant stone quarries nearby meant a fine and strong engine house could be constructed. Due to stretching of the winding rope after replacement to regain the exact length where one cage was at the pit bank and the other at the pit bottom landing, timber lagging boards were placed on the drum, slightly increasing the circumference. I am sure this became a fine art for the surface fitter. On nationalisation in 1947, the colliery had fifty-two miners below ground and seventeen on the surface; the seam listed being worked was the Dandy.

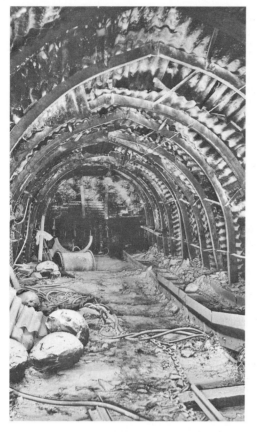

As mentioned earlier in relation to Bank Hall Colliery, Burnley coal balls or 'bobbers' could vary from an inch across to ones of the size in this photograph at Deerplay Colliery, around 18 inches to 2 feet across. The two colliery drifts were driven around 1860, situated north of Bacup close to Thieveley Pike. The 3-foot 9-inch Union seam was being worked on 80-yard-wide longwall undercutter faces roughly 100 metres below the surface at the time of this photograph in No. 9's district. Centrally pivoted Stewarts & Lloyds steel arches support the roadway. The colliery closed in April 1968 with 179 miners and nineteen surface workers losing their jobs.

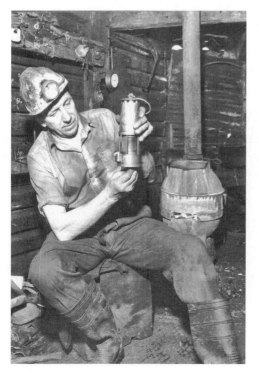

Grimebridge Colliery, Lumb-in-Rossendale, was situated north-west of Bacup close to Small Shaw Height. Sunk around 1851, the shaft was only 32 yards deep yet had a small, traditional headgear and three-man cage. Surface drifts at around 1 in 5 accessed the Upper and Lower Mountain seams. The colliery closed initially in November 1963. Billy Clayton had worked at Deerplay Colliery, Associated Tunnel Co. of Lowton, then Cliviger Coal Co., who worked the Arley near Long Causeway east of Burnley. In 1978, he obtained a licence with Rod Mitchall to reopen Grimebridge, driving a new drift. This photo shows Billy adjusting the flame height on his safety oil lamp. By 1990, the coal price he could obtain had plummeted nearly 50 per cent to £28 per ton, the colliery closing on 31 May. After a one-year return as coal shot up to £52 per ton the price again went down and the colliery was abandoned on 4 July 1996. Billy's sons Jimmy and Billy now part-own nearby Hilltop Colliery, Lancashire's last colliery at the time of writing.

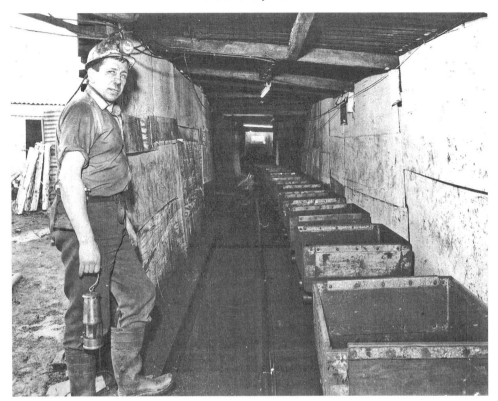

Above: A line of roughly 5-hundredweight tubs at Grimebridge Colliery around 1978, mine owner Billy Clayton alongside. The tubs had the simple solid 'disc' wheels peculiar to this area and centuries old in design, a type still in use today (2010) at Hilltop Colliery nearby.

Right: Like an album cover for an American rock group, this photograph of miners taken at Grimebridge Colliery around 1978 includes, from the left, George Clayton, Rod Mitchall, Terry Atkin, Bob Clayton and Billy Clayton. This type of mining has a character of its own, genuine mining you might say as compared to UK Coal's vastly overpaid button pushers!

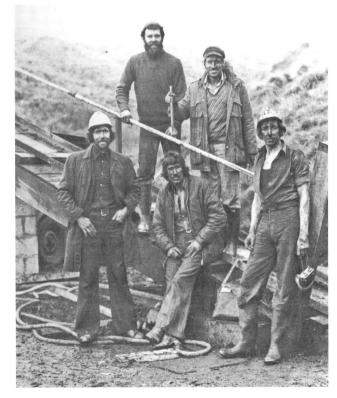

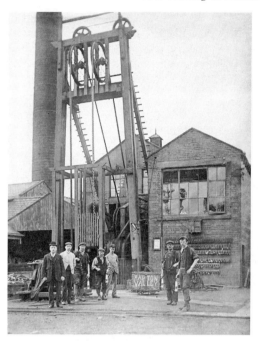

Technically, this is a rare and important record of around late 1901 of the flat-rope winding system in use at the 90-yard-deep No. 2 Pit, Hapton Valley Colliery, Spa Pit. The pit was situated at Hapton, a mile west of Burnley. Flat wire ropes came into coal mining around the late 1830s, their advantage over coiled ropes being that they would not twist. Never becoming widespread in use, they were disappearing by the 1920s apart from at isolated collieries in remote areas. No. 1 and 2 Pits at Hapton Valley were sunk around 1850, so we are probably looking at a winding arrangement of that period. Note the thinly spoked headgear pulley wheels and the miner's tub tally racks on the wall of the building to the right.

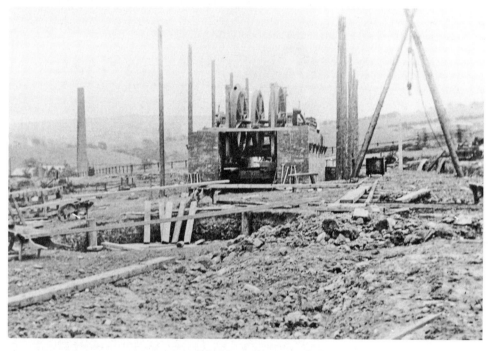

A very small and poor image but an important one, as this shows the very early stages of the sinking of a new shaft, No. 3 downcast to 171 yards, and the construction of its future engine house at Hapton Valley Colliery in 1910. The colliery was owned by the Executors of Colonel Hargreaves, who employed nearly 4,000 men at the time. The large diameter wheels were for the flat winding ropes to coil around lap on lap rather than using a shared drum and the rope spreading across it. The 18-foot-diameter shaft, large for the period, can be seen in the foreground. The chimney in the background is at Hapton Spa Pit.

A very rare type of winding installation in use in the Burnley coalfield (and Howe Bridge, Atherton) was the endless chain system, here photographed on 9 May 1908 for the Transactions of the National Association of Colliery Managers. A party of colliery managers visited Hapton Valley Colliery and saw the Spa No. 2 Pit system in use. Two chains had cross bars linking them every few feet, the chains passing over pulley wheels at the top and bottom of the 90-yard shaft. Tubs were suspended from the cross bars by spreader chains. The empty tub in the photograph is waiting to be taken upwards and back down the shaft, the system being stopped for the photograph.

A poor but important view of the Hapton Valley Colliery Spa Pit endless-chain system in 1908. Here we can see the cross bar linking the chains. Operating slowly and continuously, 500 to 600 tons of Mountain Mine was raised per day in 6½ hundredweight (112 lb), the rate being approximately nineteen tubs in 5 minutes. A vertical non-condensing 30-hp steam engine installed in around 1891 powered the system. A potential worry might be thought to have been a chain breakage, but this would only be confined to one section between cross bars, the overall structure keeping intact. A limiting factor as regards shaft depth and loading was the total weight of the chains and bars.

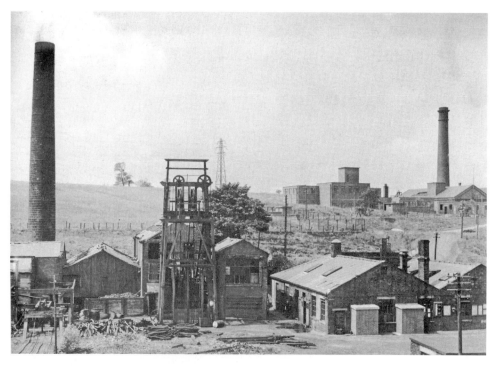

Hapton Valley Colliery, the old Spa No. 2 Pit in the late 1950s to early 1960s, the old flat-wire-rope winding system headgear in view. The shaft was sunk around 1850 to 90 yards and in use for pumping and as a secondary access point until 1956. When this shaft was winding coal, screening (grading by size) of the coal was unusually carried out near the pit bottom. On top of the hill, right distance, are some of the main Hapton Valley Colliery buildings.

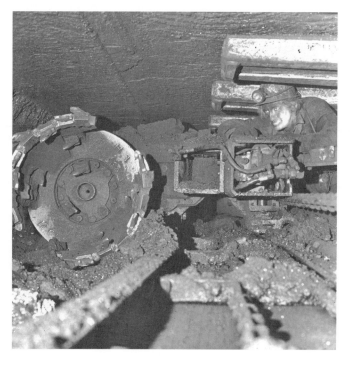

Hapton Valley Colliery, late 1970s. An armoured-face conveyor-mounted trepanner coal cutter is in use. This type of cutter was used for a while in the late 1970s in the Lower Union seam, producing a good proportion of large coal. The cutterman covered in fine coal dust gives an indication of the downside to the set-up. In 1961, at Hapton Valley, a 1,200-yard 1 in 4.16 inclined drift from the surface was driven, 16 feet 9 inches wide by 11 feet 6 inches high. The belt drive was a powerful 300-hp Consortium unit with a speed of 500 feet/minute.

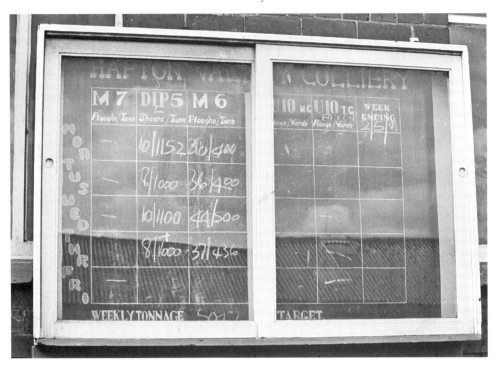

The colliery output performance board at Hapton Valley Colliery after announcement of forthcoming closure by the NCB in February 1981, the colliery actually ceasing production on 17 July 1982. The board states 'week ending 2nd of May 1981'. The output from a coal shearer face and a coal plough face is shown. Men both on the surface and below ground would keep an eye on boards such as this at collieries and hopefully be inspired to work harder if output fell, everyone's bonus potentially being under threat! (Alan Davies, 1981)

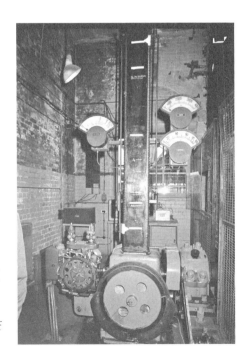

Lily overspeed device with centrifugal controls (lower left), winding speed indicator dial (left), ammeter and voltmeter (right) in the No. 4 upcast winding engine house at Hapton Valley Colliery. The central pillar is the cage shaft-position indicator. Colliery reorganisation began in 1951. In 1954, the steam winder had been replaced with a British Thomson Houston 200-hp, 3,300-volt direct coupled system. After the driving of the new drift in 1961, the upcast winder was replaced in 1968 with an M. & B. Wild winding engine driven by a BTH motor of only 45 hp. (Alan Davies, 1981)

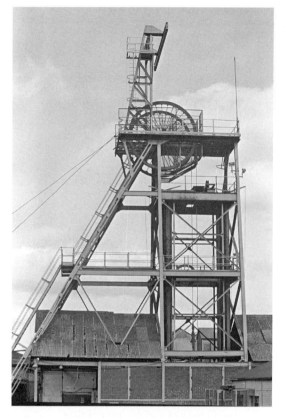

Hapton Valley No. 3 downcast shaft headgear. By the time of this photograph, the shaft was used for pumping/electrical services and access. The 18-foot-diameter 171-yard-deep shaft still had wooden guides for the cages. In 1968, the shaft winding engine was replaced with a 220-hp Beckett & Anderson ground-mounted manually controlled electrical set-up. The headgear was demolished in the week beginning 17 January 1983. The colliery entrance was picketed by Yorkshire miners in 1984 who did not know it had been demolished! (Alan Davies, 1981)

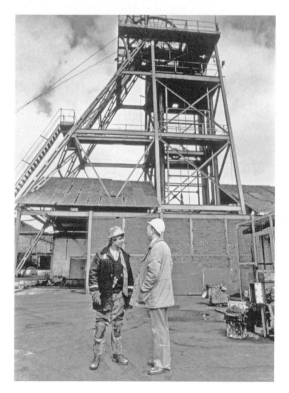

Hapton Valley Colliery after the announcement of closure. A colliery managerial official on the right chats to a miner who has just come up the pit. An explosion occurred at the pit on 22 March 1962. The Inspector of Mines in his report thought the methane explosion was caused either by shotfiring in the coalface return road or from a high-energy spark created through friction on metal foil. Sixteen miners died, three more later, and thirteen were seriously injured. (Alan Davies, 1981)

A managerial official at Hapton Valley Colliery holds a 'Burnley Bobber' or coal ball in his hand. The current most probable theory of their origin (amongst a few) is that a small amount of rotting organic material such as a dead snail produced putrifaction molecules that affected the surrounding mud or clay in a way that made it become harder than normal. This process carried on concentrically outwards to a certain distance, limiting the eventual size of the coal ball. They are termed coal balls because they are found within the coal-seam or in the roof above it. The actual material tends to be siltstone or mudstone. (Alan Davies, 1981)

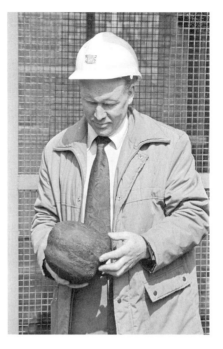

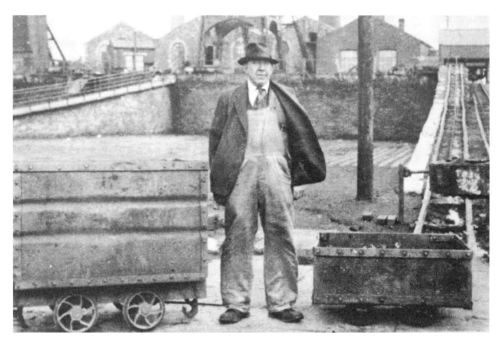

A poor-quality but interesting photograph from the March 1948 issue of the NCB magazine *Coal*. This photograph (taken at Huncoat Colliery north-east of Accrington) shows the wide variation in size of pit tubs in use in the Burnley Coalfield. In view is a tub of 10-hundredweight (1 hundredweight = 112 lb) size and one of 4½-hundredweight capacity used at Huncoat. About four other sizes were also in use at the widely differing types of mines in the area. After nationalisation in 1947, the NCB was keen to standardise tub size as much as possible, making manufacture and maintenance more efficient as well as increasing output at the pits where the smallest tubs were in use.

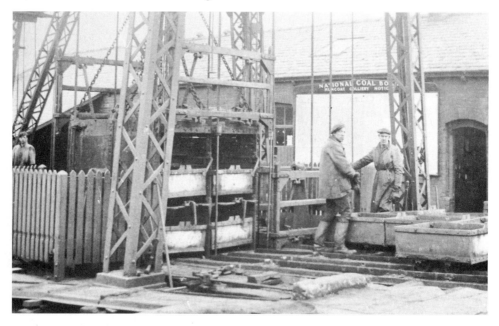

Huncoat Colliery pit bank seen in July 1950 before reorganisation. The old 4½-hundredweight tubs are in use. Note the slotted steel plates on the tubs. This is where the endless chain used on the haulage system below ground slotted in, a system of haulage common around Accrington and Burnley both below and above ground. On nationalisation in 1947, the pit produced only 82,077 tons; ten years later, this had shot up to 241,729 tons.

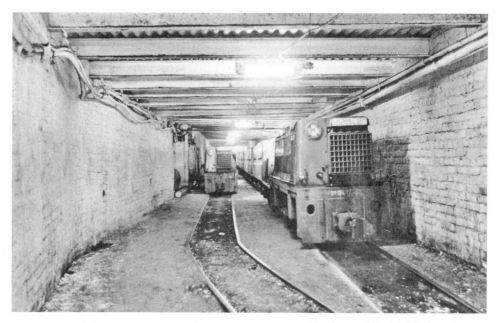

The mine car (large tubs of 3-ton capacity) marshalling area near to the pit bottom at Huncoat Colliery, Accrington, around the early 1960s. Two Hunslet of Leeds 65-hp diesel locomotives are in view. These were specially adapted with flame traps on the exhaust system to stop potential ignitions of gas. A new pit bottom had been constructed at Huncoat in 1950 at a depth of 219 yards.

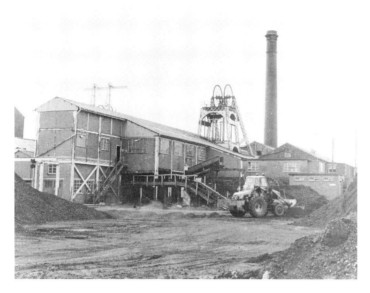

Huncoat Colliery, Accrington, on 17 May 1968. Nos 1 and 2 pits were sunk in 1885 to 222 yards and 228 yards respectively. At the time of ceasing production due to exhaustion on 14 February 1968, three coalfaces were in production in the Upper Mountain seam. Two worked to the dip of the seam and another to the rise. 150,000 tons were mined in the colliery's last year. The headgear in view had been locally designed and built on site by the engineers; during the 1950 reorganisation, the pulley wheels had to be separated to allow for larger cages.

Where coal-seams outcrop the very basics are all that is needed to work the coal, namely a surface drift following the seam down, a compressed air winch, tubs, props, angle iron rails, compressed air picks and shovels, occasionally compressed air pumps. Here at the small (three miners and one surface worker in 1980) Merrills Head Colliery, near Cliviger, Burnley, in 1984, pit props for the Arley seam workings are piled up near the opening for loading and sending down the pit. Farmer and former mineworker John Simpson Little started the first of his five drifts around 1962. (Alan Davies, 1984)

An empty tub of about 5-hundredweight capacity goes hurtling down the steep drift past the materials-loading opening at Merrills Head Colliery, Burnley. These were of wooden construction with solid 'disc' wheels running on angle iron rails. The pit worked the Arley seam: the finest coal in the Lancashire Coalfield, high in carbon and with no dirt bands. Full tubs were wound back up the inclined track to be tippled into the hopper below, men being paid by the tub. Merrills Head had the luxury (for a small drift) of an exhausting fan at the end of a 1 in 1.5 fan drift tunnel. (Alan Davies, 1984)

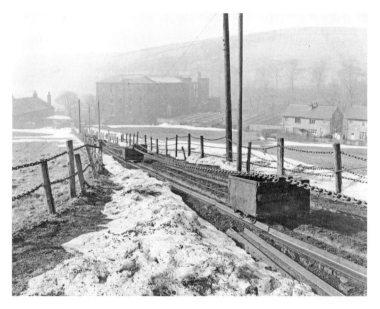

The use of endless-chain haulages in the Burnley and Accrington Coalfields goes back a long way, probably to the early nineteenth century. Here, in late 1968, the double track 'ginney' road, as it was locally known, takes coal away from Old Meadows Colliery, Bacup, (closed March 1969) south-west towards the coal yard tippler near Burnley Road. The heavy chain slotted into a plate on top of the tub, which is carrying about 6 or 7 hundredweight of coal. Note the simple angle iron rails and 'disc' wheels. When snow fell in these higher areas of Lancashire, the whole system could be brought to a halt. (Frank Grimshaw)

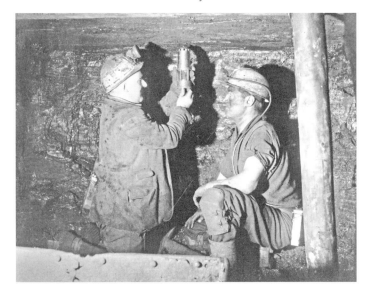

This photograph looks to have been taken around the 1930s or 1940s, yet it was taken by Frank Grimshaw, the NCB area photographer, in 1968 after the closure announcement of NCB Old Meadows Colliery, Bacup. The drifts were driven in 1860. Mining here was on the pillar-and-stall method, roadways being driven at right angles to each other. Compressed-air picks (introduced in September 1959) and hand picks were used to bring the coal down, loading by hand shovel into the tub. Here the deputy/shotfirer is lowering the flame on his oil safety lamp to test for methane gas, which accumulates near the roof, being lighter than air. (Frank Grimshaw)

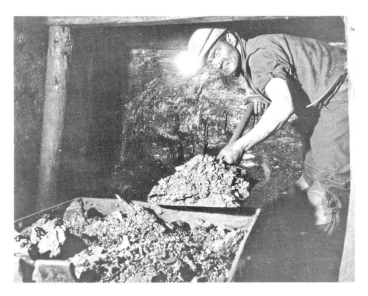

Loading Union seam coal at the coalface, Old Meadows Colliery, in 1968. The seam was inclined at 1 in 12 and consisted of the Upper Mountain at 1 foot 10 inches and the Lower Mountain at 4 feet thick. An awkward height for shovelling if you are tall, the alternative being to kneel on the floor. Old Meadows had been owned by the Executors of Colonel Hargreaves, later Hargreaves Collieries Ltd, before nationalisation in 1947. Even in the 1960s, men at Old Meadows had pay scales based on carrying out specific tasks, such as filling a tub, 'drawing' or pushing a tub to the main haulage road, and cutting 'bords' or side roads. (Frank Grimshaw)

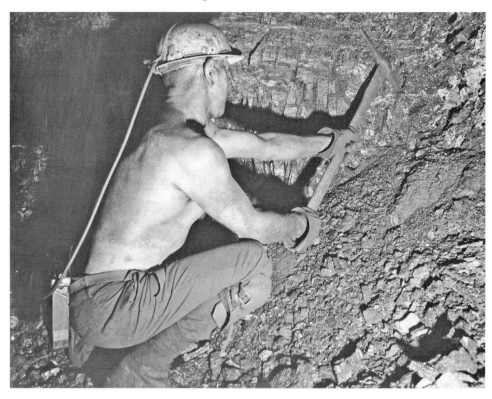

For many years, approximately thirty miners worked down Old Meadows Colliery. Here, in 1968, the face worker is picking the coal, dragging it down so he can shovel it into the tub. In my experience at Hill Top Colliery north-east of Bacup in 2010, the Union seam varies in hardness, normally too hard to use a hand pick on, at other times flaky and easy to work; alternatively, compressed-air picks create large amounts of dust. In 1967, forty-one miners and twelve surface workers were employed at Old Meadows. (Frank Grimshaw)

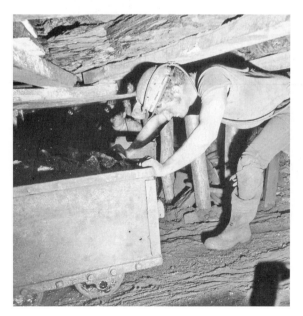

Not much headroom here at Old Meadows Colliery in 1968 for this 'drawer' pushing his tub. Back in the early years of the last century, drawers regularly scraped through the skin on their spinal column vertebrae. Drawers in 1968 received 9d (in old money, spending value equates to 39p) for drawing a tub 45 yards. The tub carried around 3½ hundredweight (177 kg) of coal. Note the solid disc wheels and the floor covered in coal dust, no protective stone dust in place. The mine was classed as gas free. (Frank Grimshaw)

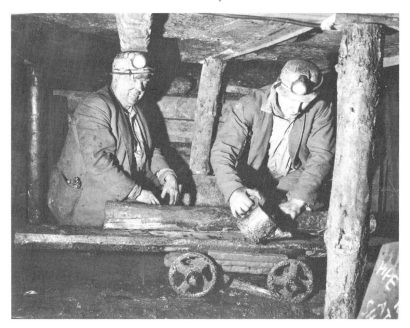

Old Meadows Colliery, 1968. Oiling the axles of a materials cart. These carts were also used by men and officials for travelling round the workings, it being too low to travel any distance. Wooden props are supporting corrugated strap bars in the roof. (Frank Grimshaw)

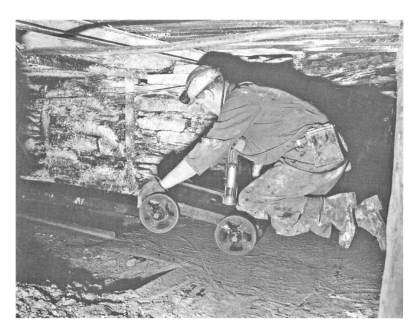

Old Meadows Colliery, 1968. A deputy travels his district on one of the materials and travelling carts. He would have to do this before and after the shift testing for gas, the condition of the roads and roof supports. The low roof height shows how vital these carts were. Over-adventurous speeds often led to a derailment and bruised ego if the wobbly wheels hit a bad joint in the angle iron rails! Many of these carts have survived at the time of writing (June 2010) and are in use at Hilltop Colliery, north-east of Bacup for carrying supplies. (Frank Grimshaw)

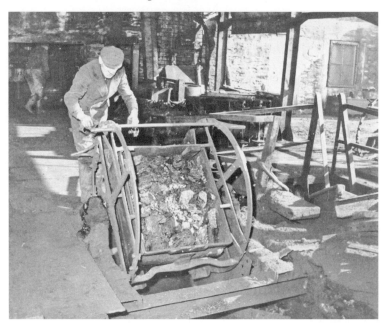

Kick tub tippler in use at the Old Meadows Colliery coal yard or 'staith' near Burnley Road in 1968. The coal dropped onto screens below, grading into large and small coal. This was a job for female surface workers in the Wigan area until mechanisation removed the need for them in the 1930s. (Frank Grimshaw)

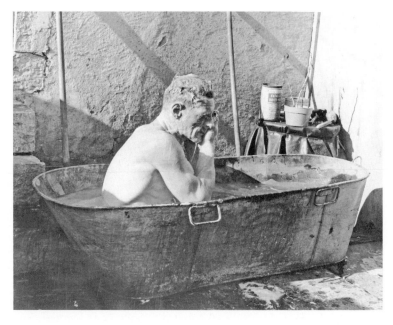

When Frank Grimshaw photographed Old Meadows Colliery miner Roy Sanderson in his back yard tin bath in 1968, he was actually capturing a scene never before or since recorded by photographers in the Lancashire Coalfield. It may be just a tin bath but where would you get one now and what has happened to all the old ones? It's hard to believe this really is 1968. (Frank Grimshaw)

Even though the Burnley Coalfield was fairly small in extent, a variety of mining techniques and technical innovations were tested over the years, especially after nationalisation in 1947. Here at Reedley Colliery (north of and close to Burnley adjacent to the LMSR line) on 7 October 1952, American systems of 'Room and Pillar' extraction had been in use since 1945. Gathering arm 'Joy' loaders designed for thin-seam working brought down the coal, loading it into shuttle cars. To work coal and leave such a wide expanse of roof unsupported could only be done when the geology was known in detail and could be relied on. Here, a combination of RSJs and roof bolts are in place.

Reedley Colliery, Burnley, 7 October 1952. In this roadway, only roof bolts hold the roof strata together. Many miners used to roof bars were uneasy to see such a wide unsupported area. Note the tyre marks made by the shuttle car coal transports. They took the coal off to the main trunk conveyor. The colliery was linked in 1956 to Bank Hall Colliery, Burnley, via a 558-yard-long drift giving direct access to the washery. 212 miners and thirty-seven surface workers were employed at Reedley in 1947. When closure was announced in May 1960, the workforce was only four greater. Roof bolting is used today at some of UK Coal's mines.

Around Oldham

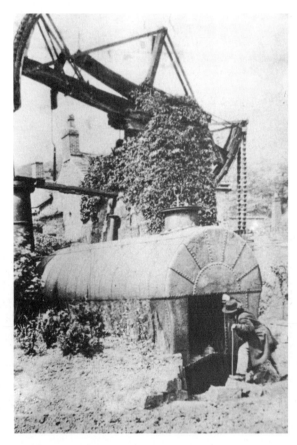

A curious walker around 1880 peers into the old boiler of one of the Lancashire Coalfields earliest steam atmospheric mine engines, Fairbottom Bobs, used at Bardsley Colliery, Park Bridge, near Ashton-under-Lyne from around 1760 until 1834. The local nickname originated from the up and down motion of the wooden cross beam. One end of the beam was linked via a chain to the piston in the open to atmosphere cylinder, the other to pump rods in the 200-foot-deep Cannel coal pit shaft. Rescued and restored by the Henry Ford Museum, Dearborn, USA, in 1929 (see the colour section).

Another view of Fairbottom Bobs, this time showing the cast-iron open-top cylinder with connecting rod and chain intact. The pit shaft can just be made out to the left, the chains linked to the pump rods visible. Two secondary wooden arcs still intact formerly linked by chain to pump rods raised water to the cistern above. The water spray was used to create the vacuum beneath the piston. The other arc operated the steam feed from the boiler to replenish the cylinder as it returned back upwards again.

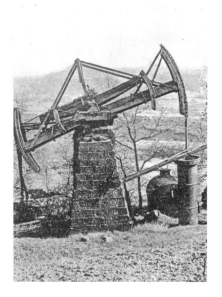

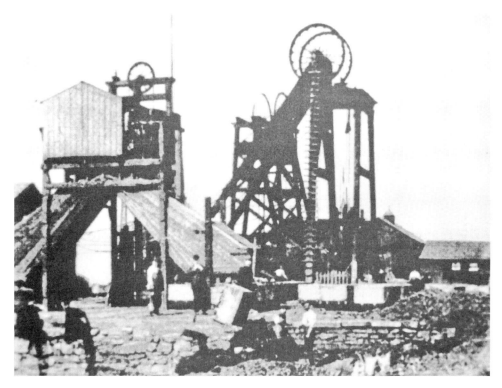

A poor but rare view of Bower Colliery, Chadderton, around 1913, the last colliery to operate in that area. To the left is the tub gantry with wooden shutes distributing the tippled and screened coal. Sinking, probably on the site of the earlier colliery, Birchen Bower, started around 1860, ending on 7 May 1863 to 256 yards. Operated in the early days by the Marlands, who had made their fortune in Australian gold mines. The colliery was linked up to the Rochdale Canal and later the rail network. Electricity was in use at the pit as early as 1903. The Marlands worked the mine until 1916, Bower Colliery Co. Ltd then being formed. It closed in 1922, ninety miners producing 22,000 tons in the final year.

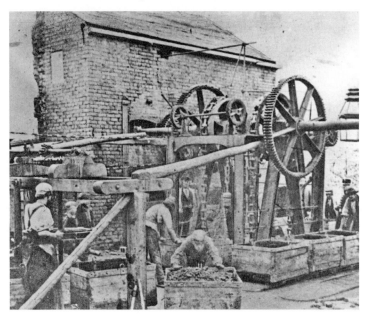

A rare view of steam-powered endless-chain winding at Bridge Pit, Bardsley Bridge, (alongside and east of Ashton Road, north of the canal) around 1868 to 1872. Tubs of around 5-hundredweight capacity were attached to cross bars which spanned the two loops of chain. The Bardsley collieries came under Jonah Harrop's control from around 1829 onwards. The 331-foot-deep shaft was sunk to the Cannel seam, also passing through the Stubbs seam (1 foot 6 inches), the Fairbottom seam (2 feet 2 inches), a 4-foot seam and a seam of 2 feet 3 inches.

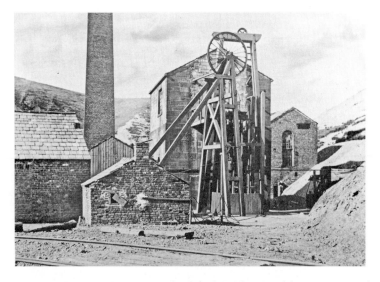

The Rocher Pit, a mining pumping site north of Park Bridge, Bardsley, seen around 1890 minus winding ropes. Operated by an Oldham company, the Rocher Colliery Company. The colliery had been abandoned by 1887 due to water problems exacerbated by ceasing pumping at nearby collieries. The photograph shows the 'engine' or pumping pit powered by a steam beam engine. The tall wooden structure (known as shear legs) with the small pulley wheel allowed maintenance of the pump rods in the shaft. Single cage or kibble winding took place within the shaft using the small traditional pit headgear.

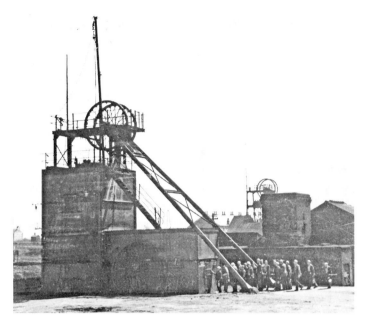

Afternoon shift miners at Woodpark Colliery, Bardsley, around 1952 head to the airlock doors of the upcast shaft. The pit was sunk by the Fairbottom Colliery Co. from 1836 onwards, situated alongside Ashton Road off Coal Pit Lane. The Deep Pit was sunk in approximately 1840 to 1,163 feet reaching the 4-foot-thick Black Mine. The colliery was operated by the Chamber Colliery Company from about 1873.

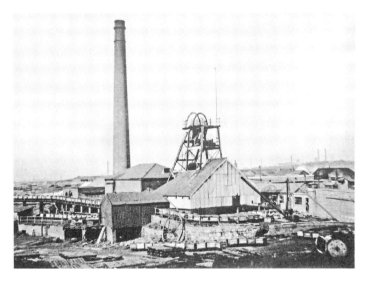

Woodpark Colliery, Oak Colliery and Ashton Moss Colliery were linked in the Roger seam in 1936 to aid ventilation. In practice, this led to an infestation of mice and many men contracting septic boils! Pithead baths were installed in 1938 to the design of Sir Robert Burrows (formerly of Fletcher, Burrows & Co., Atherton Collieries). In 1951, 314 miners produced 91,986 tons of coal, but a few years later, the NCB decided to access Woodpark coal from the extensive and more modern Ashton Moss Colliery. The pit ceased production in August 1955 approximately when this photograph was taken. The shafts were filled with dirt from Bradford Colliery, east Manchester.

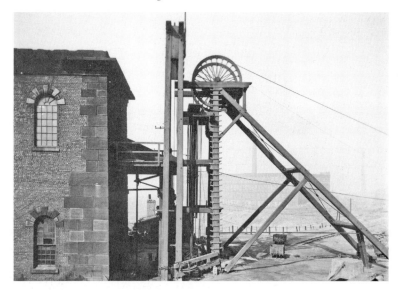

A fine record taken in 1921 of the 1846 Duke Pit engine house, shear legs and pit headgear at Oak Colliery, Hollinwood, south-west of Oldham. Note the massively strengthened outer wall of the engine house to give support to the huge weight of the cast-iron beam and engine within. Part of the beam can be seen between the shear legs and engine-house wall. The engine was designed by the famous Manchester-based Scottish engineer William Fairbairn (1789-1874).

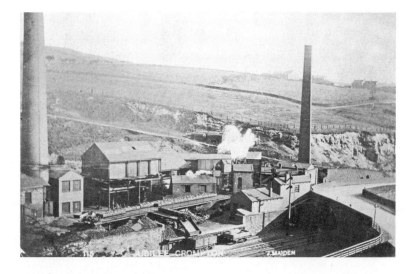

A postcard view to the south-east of Jubilee Pit, Crompton, about 1910. The pit was sunk by Edge Lane and Dryclough Colliery Company in 1845 to the Lower Mountain seam at 325 feet. Platt Brothers of Oldham took over in 1883, the coal ideal for coke production, which was needed in their ironworks in Oldham. The colliery was situated east of the A663 (in the photo) between Shaw and Newhey adjacent to the LMSR. Sadly, the two pit headgears cannot be seen, the puff of steam emerging from the downcast shaft winding house. From the left are boiler house, chimney, joiners shop, coal crushing and washing plant, blacksmith's shop, downcast shaft winding-engine house. Adjacent to the railway bridge are, from the left, the lamproom and offices. The pit closed in 1932. A nature reserve and trail is now on site, the old pit buildings visible amongst the vegetation.

Rhodes Bank Colliery, Oldham, was sunk around 1845. This photograph dates back to around the late 1860s, showing how the colliery was set right amongst the town's streets, houses and mills with obviously no consideration for subsidence damage. The colliery stood to the south of Gas Street, now Rhodes Bank. By 1854, Holebottom Colliery Company operated the pit, their other pit being Holebottom Colliery on Bradshaw Street. By 1880, Rhodes Bank was owned by the Chamber Colliery Co., to be abandoned in about 1887.

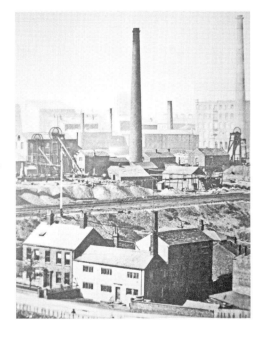

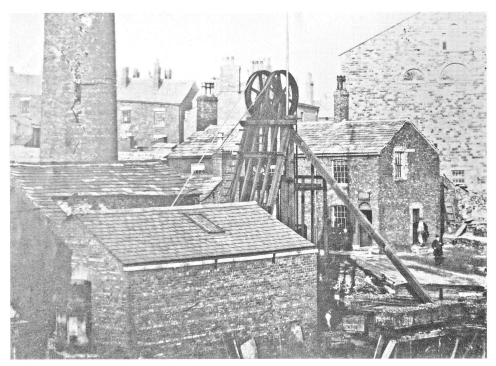

Holebottom Colliery, Bradshaw Street, Oldham, seen around 1880. Lees, Jones & Co. sank a colliery at Holebottom c. 1825-29. The colliery was situated to the east of Bradshaw Street. James Thomas, aged eleven, who pushed (drew) tubs below ground, was asked in 1841 his hours of work at the colliery. He replied that he went down at 6 in the morning and came up at 6 p.m. with only a short break for lunch at 12. The simple shear leg pit headgear is winding flat steel rope over broadly spoked pulley wheels similar to those in use in mills or manufactories. The colliery ceased production in about 1880.

Manchester, East Lancashire & Cheshire

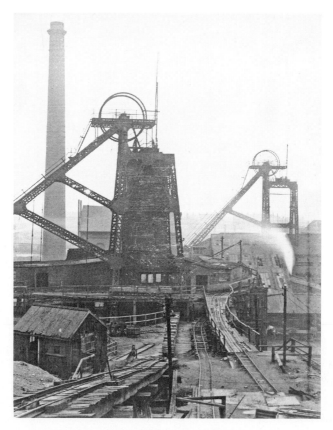

A dramatic view of around 1913 showing the powerfully built steel headgears at Ashton Moss Colliery, Audenshaw, Ashton-under-Lyne. No. 2 upcast shaft (954 yards deep) is to the left, wound by a Worsley Mesnes of Wigan steam winder. No. 1 downcast (934 yards deep) is to the right, wound by a Daglish of St Helens winding engine. The Ashton Moss Colliery Company had taken over the lease of seams worked by Lordsfield Colliery when it closed in 1875. They then sank the two deep 18-foot-diameter shafts, which were the deepest ever in Britain at the time, and by 1884, the second deepest in the world. The tub ways in the foreground are feeding the large dirt tips.

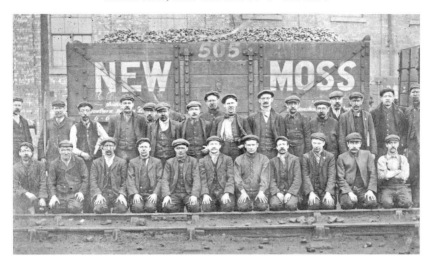

New Moss Colliery Company surface workmen pose alongside a 6-ton mainline wagon at Ashton Moss Colliery around 1913. The colliery was linked to the LMSR Ashton Branch Junction line and the LNER. The wagon number gives an idea of the company's fleet size. Some of the colliery's output left via the adjacent Manchester & Ashton-under-Lyne Canal. Coal from the pit was also shipped from Partington on the Manchester Ship Canal. In 1911, 1,560 miners and 496 surface workers were employed, the wages bill coming to nearly £3,000 per week, approximately 400,000 tons of coal being produced per year from the Roger, Great and Colonel seams.

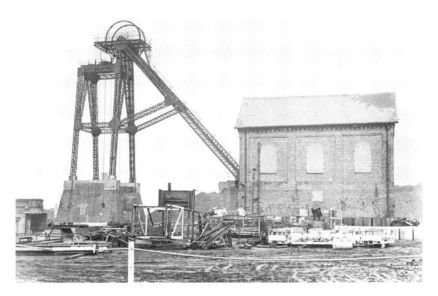

Ashton Moss Colliery ceased coal production on 11 September 1959, this photograph of No. 1 Pit taken shortly after that date. Manriding carriages (in white) have been brought to the surface, possibly for use at nearby Bradford Colliery. The engine-house windows have been bricked up, possibly to avoid vandalism and the elements getting at the winding engine. In 1957, 389 miners and ninety-five surface workers had been employed at the pit producing 149,843 tons of coal. Nine seams in total had been worked at Ashton Moss Colliery, 39 feet in total. Ashton Moss was linked to Bradford Colliery after the major 1950s reorganisations, Bradford colliery closing in 1968.

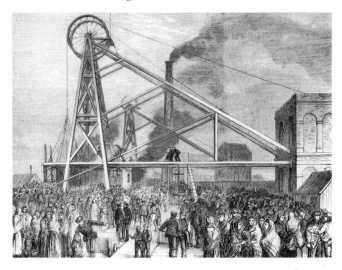

Astley Pit, Dukinfield, Cheshire. Named after F. D. Astley, who developed the early-nineteenth-century pits in the area. An engraving of 25 April 1874 from *Pictorial World* of the scene after the explosion of 14 April, smoke emerging from the furnace upcast shaft to the rear. Fifty-four men and boys died along with a rescueman after an extensive roof fall led to a large amount of gas being displaced. Managerial negligence and incompetence were revealed by the enquiry. The pit was sunk from the 1840s onwards reaching 686 yards by 1858, for a while the deepest workings in Britain. On 15 July 1855, four miners had been overwound over the headgear, five others being killed at the bottom of the shaft. The headgears were of an early simple trestle design with winding under full manual control of the engineman. They had to be adapted to allow the use of safety winding-rope detaching hooks, which arrived after 1868. The colliery closed in 1901.

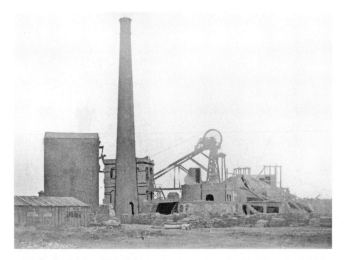

Astley Pit, Dukinfield, Cheshire, during demolition after closure in 1901. The upcast headgear has been demolished, the large mound of dirt and timber alongside for filling the shaft in. Many shafts were filled in at this time by throwing all manner of dirt, timber and scrap metal down in the hope of blocking it early. These are the shafts which today can suddenly collapse when voids close up. The downcast headgear seen close up in the disaster engraving has been adapted with rear legs to allow for the use of a detaching hook for the winding rope. Note the winding rope entering the vertical steam engine house through the roof.

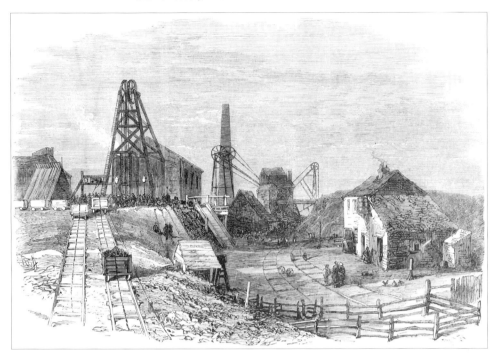

The Victoria or Lakes Colliery, Dukinfield, Cheshire, came under the control of F. D. Astley. It was situated between King Street and Birch Lane, near Tarbet Road. The upcast shaft was 500 yards deep, the downcast pumping shaft 540 yards deep. Six shafts were on site altogether accessing seven seams. On 14 June 1866, thirty-eight men and boys were killed after an explosion, two as young as thirteen years of age. The *Illustrated London News* sent a reporter and artist to the site. His engraving shows a crowd around the shaft top waiting for news, an endless-chain tub road for the 6-hundredweight tubs and what appears to be an inn close to the shafts.

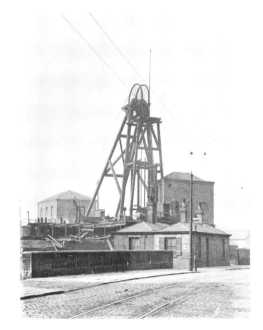

A vertical engine house winds the 295-yard-deep shaft at Lane Colliery, Hyde, Cheshire, around 1906. The pit was sunk possibly as early as 1800 being sited alongside the Peak Forest canal, which was constructed from 1794 onwards. On 18 January 1889, an explosion killed twenty-three men and boys. The owners of the pit at the time were Mr J. W. Sidebotham, MP for Hyde, and his brother J. Nasmyth Sidebotham. The parapet of Hyde Lane Change Bridge is in the foreground and the colliery offices are to the right of the parapet. Coal left the site by road, rail or canal, the nearby gas works consuming large amounts. The colliery was abandoned on 28 March 1906 after an inrush of water and near exhaustion of the coal reserves.

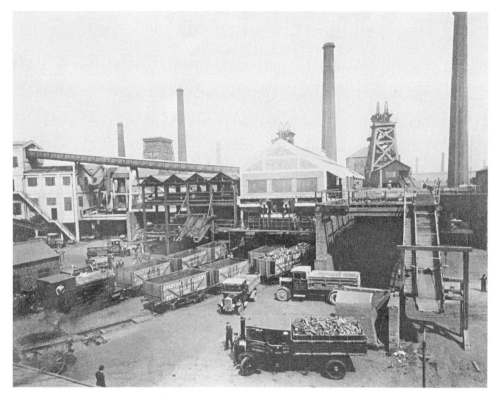

Bradford Colliery, Bradford, East Manchester, developed on a coal-mining site centuries old. Miner Francis Taylor was recorded as being killed by a roof fall at 'Bradford Coal Pitt' in 1622. Actual archive records of the colliery's operation begin in 1740 when a 200-year lease was granted to Sir Oswald Mosley of Ancoats Hall. The 'Deep' Pit was sunk from 1903 to 1906, reaching 924 yards, one of the deepest shafts in Europe at the time. When this photograph was taken in 1935, the colliery was moving from Bradford Colliery Company Ltd control to Manchester Collieries Ltd. In shot is the Avonside of Bristol 0-4-0 loco of 1928, which shunted wagons across Forge Lane to the sidings, and a Foden steam wagon.

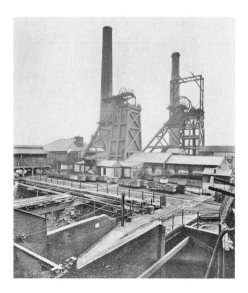

An NCB photograph of Bradford Colliery taken as the major reorganisation began in May 1947. Nationalisation was only four months old, and the huge potential of the colliery with its vast reserves (sixteen seams available and 275 million tons-plus workable) had been known to the directors of Manchester Collieries, now prominent within the NCB. No. 2 'Deep' pit and No. 1 shaft are in view. No. 2 shaft was deepened by 1948 to 960 yards. After nationalisation in 1947, the coal reserves of Ashton Moss and Moston collieries were accessed by Bradford.

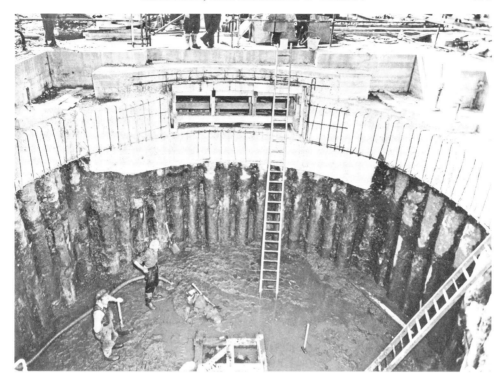

The top 100 feet of the 960-yard-deep, 18-foot-diameter No. 2 shaft at Bradford Colliery was relined with concrete in 1948. The 2 x 1,950-hp friction winder ('Koepe' type) and skip installation were commissioned in December 1954. The shaft was designed to wind 360 tons per hour of coal. Five shafts in total were on the cramped site at Bradford if the three early disused ones are allowed for.

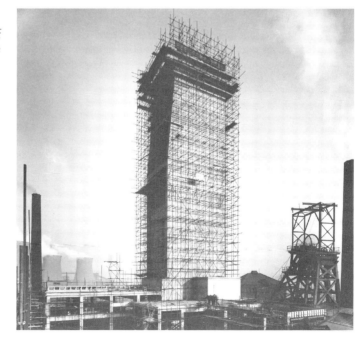

Bradford Colliery c. 1951. An amazing feat of scaffolding surrounds the futuristic new concrete encased headgear above No. 2 upcast coal-winding shaft. Towering 194 feet high, the structure was built by Monk of Warrington and completed by 1952. In the distance is Stuart Street power station linked to the colliery by a 460-yard tunnel driven between 1947 and 1954. A total of 200 tons per hour could be sent to the power station, which had a 1,100-ton bunker and 40,000 tons ground storage.

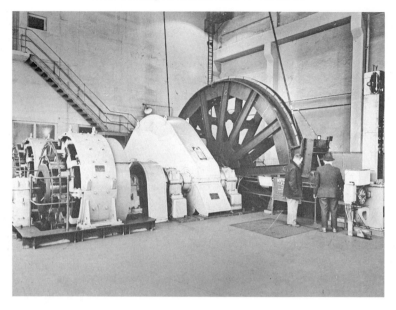

No. 2 shaft winding engine, Bradford Colliery. This was completed by 1952 and consisted of two 1,950-hp motors by Metropolitan Vickers of Trafford Park driving the 24-foot-diameter friction wheel, which the winding rope passed round. Fraser & Chalmers, one-time steam winding engine manufacturers made the mechanical parts of the arrangement. The rope was a 2 ¼-inch locked-coil type with a 278-ton breaking strain. This was the first large installation of its type in Britain.

The 460-yard circular section tunnel to Stuart Street power station passed below the Manchester & Ashton-under-Lyne Canal and a mineral railway linking with sidings on the Lancashire & Yorkshire Railway to the north. The conveyor belt from pit to power station was over 600 yards length in total. Here, soft clay-type material is being passed through, the men using spade-end compressed-air picks.

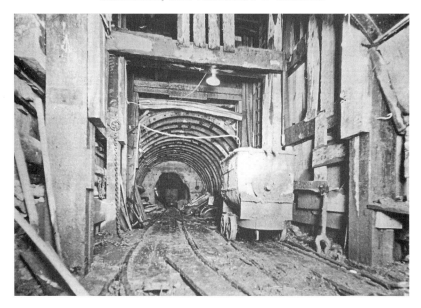

A National Coal Board photograph of the Bradford Colliery to Stuart Street power station tunnel, December 1948. This shows the site of the Gibbon Street access, materials and ventilation shaft. This was roughly half way along the 460-yard tunnel. The power station was built in 1900; by 1904, two massive 6,000-hp marine triple-expansion engines driving flywheel alternators had been installed. Bradford Colliery closed on 7 September 1968, the power station closed in 1975, the cooling towers were demolished in February 1978.

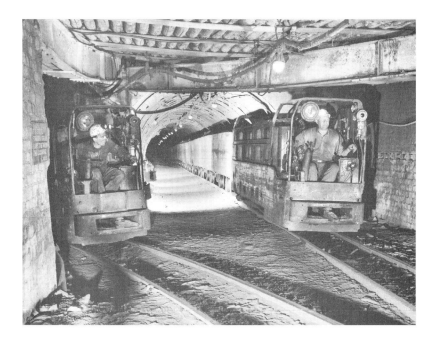

Bradford Colliery loco horizon junction around 1956. Taken by the NCB's top photographer, Hayward Smead, who contributed regularly to their *Coal Magazine*. Here two 10-ton 95-hp battery locos are hauling thirty-five 3-ton mine cars to the pit bottom skip pocket, picking up empties to take back.

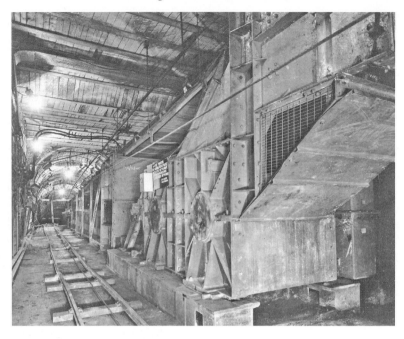

Bradford Colliery *c.* 1964 looking inbye towards a dip roadway. On the right is a very powerful heavy-duty drive head for the 1 in 4 conveyor beyond. The drive was made by long-established Sutcliffes of Wakefield. Installation of the drive and belts was a very skilled task.

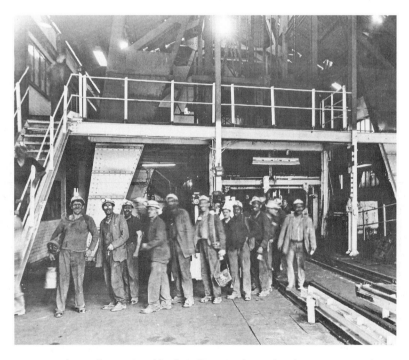

Miners arriving at the surface at Bradford Colliery in the mid to late 1960s. In the year before closure, 1967, 1,314 miners worked down Bradford with 242 surface workers. When the colliery closed on 7 September 1968, ninety men moved to Agecroft Colliery, others to North Wales, the Midlands and West Lancashire (the Leigh pits and Parkside Colliery for example).

The contrast in headgear styles at Bradford Colliery after closure in 1968. By 1967, Manchester Council was becoming very concerned about subsidence damage to property in the Collyhurst, Cheetham, Miles Platting and Ancoats areas. The corporation decided to control where the mining could be carried out in future, seriously affecting the NCB's long-term planning and workable reserves assessment. The high cost of dealing with the subsidence damage must also have been considered by the NCB, offsetting the profitability of the pit. The headgears were only demolished in 1973, a tricky job due to the adjacent streets and properties.

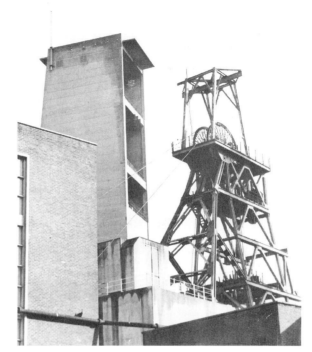

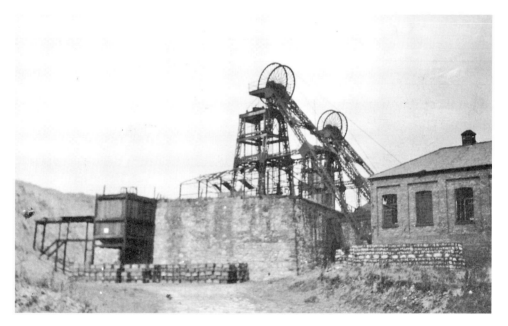

Bredbury Colliery, Lingard Lane Collieries, Cheshire, photographed by future Lancashire Inspector of Mines Jack Lane in 1947, ammunition boxes stacked up outside the shaft and engine house. Eyewitnesses said, during the Second World War, miners were seen walking from Bredbury Colliery to Denton, an intriguing story remains to be told! Mining at Bredbury in general dated back to at least 1598, mentioned in parish records. The two shafts here were sunk from 1889 to 1892, north of Lingard Lane and close to the Ashton Road junction. The colliery is said to have officially closed in 1936.

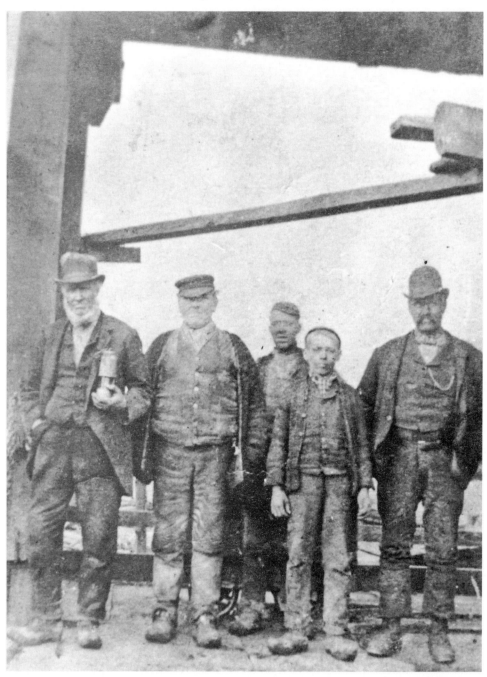

Some real characters in this early photograph taken at Broadoak Colliery No. 2 Pit, Hurst, Ashton-under-Lyne, *c.* 1891. From left to right: Tom Mills, colliery manager, Ralph Kenyon, William Holland, head banksman, Frank Lees and Matthew Ramsden, undermanager. A colliery had existed at Broadoak as early as the 1780s. Two disused Broadoak Collieries are shown on the 1922 geological survey plan 105NE. This particular Broadoak colliery was abandoned in 1904.

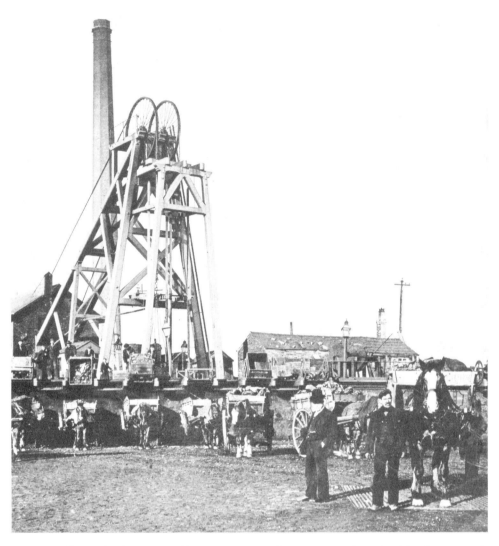

Denton Colliery, also known as Ellis Pit, seen around 1905, situated north of Stockport Road. A substantial flat-rope wound wooden headgear and very tall chimney with, no doubt, the pit manager stood in the foreground. At least five tub tipplers are in view on the pit bank ready to load waiting horse-drawn carts. The colliery has its origins around 1805 and involves a lease from landowner William Hulton of Hulton Park (north of Atherton) and John Fletcher, brother of Matthew Fletcher of Clifton near Swinton and an early developer of collieries in Atherton. In 1848, the shaft of Ellis Pit was deepened to the Roger Mine. In around 1867, the Denton pits were leased to a Peter Rothwell. In 1872, the Denton Colliery Company Ltd was formed.

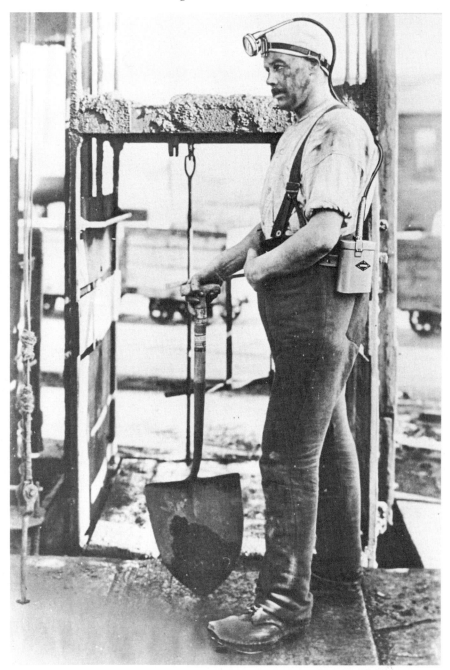

Denton Colliery pit bank around 1928-29. John Hopwood is modelling the first British miner's battery cap lamp by Oldhams of Denton, later to become the coal industry's main supplier after nationalisation in 1947 (Oldhams closed in 2002). The arrival of modern-type safety helmets coincided with the first use of cap lamps, as they were needed to mount it on! Not everyone was suddenly equipped with cap lamps. At the Atherton Collieries, they were termed 'Special Lamps' and only used by tunnellers and shaftsmen. Note the pit cage without any side gates or mesh curtains, also how easily something or someone might fall down the shaft during winding. The man is holding what became nicknamed as a No. 1 shovel, the large-size colliers' coalface shovel.

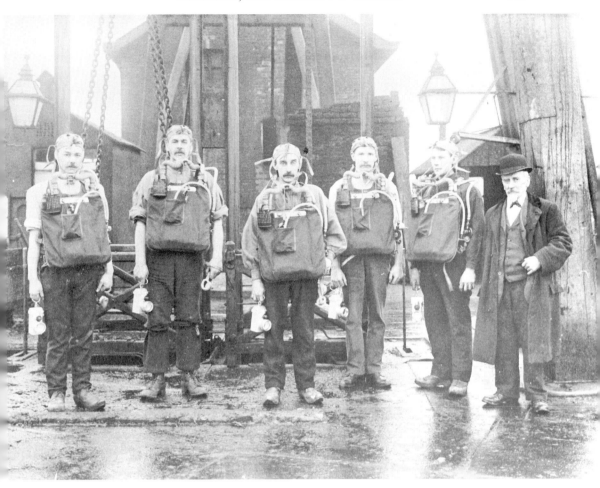

Howe Bridge, Atherton, was the first central rescue station in the Lancashire Coalfield serving a wide radius of mines. Opened in 1908, it trained, amongst others, miners from Denton Colliery. Here, the colliery's team pose with their Proto breathing apparatus around 1910. From the left: A. Hopwood, John Hopwood, Phillip Lloyd (behind Philip's left shoulder the flat winding rope can be seen), Albert Wildgoose, the colliery manager Mr Ollerenshaw. The 1926 strike led to rising water levels and damage at the colliery, and the decision was taken to close in 1929. The pit headgear was demolished in 1932, the shaft filled and capped in 1974.

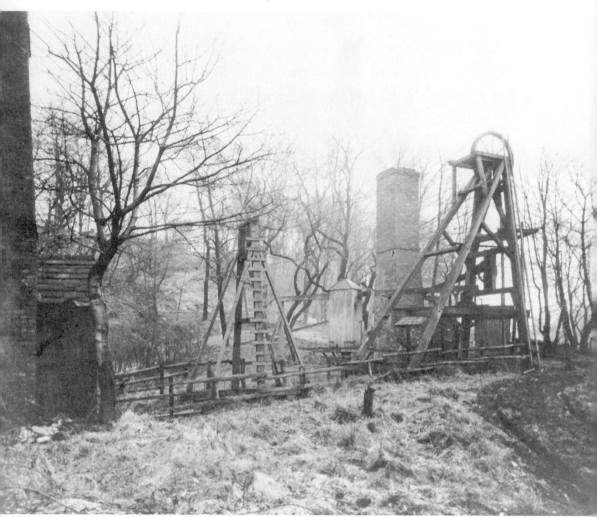

A fascinating view of Hulme's Pit, Denton, c. 1929. The colliery (in later days also a pumping station) was situated in Hulmes Wood at the foot of Beat Bank by the river Tame, sunk around 1730. Alongside the trestle-type pit headgear stands the furnace ventilation chimney, linked to the shaft via a cross drift tunnel. Hemp winding rope is in use with a rope guide half way to the headgear to stop the rope coming off the headgear pulley, a very antiquated feature. A Newcomen atmospheric beam engine was in use, adapted by Musgrave and Co. Ltd of Bolton in the 1830s. The engine had a beam 10 feet 6 inches long supported at its centre by four pillars. From floor to the centre of the beam was 9 feet 8 inches. It pumped water from a depth of 120 yards, the boiler pressure only 5 lb per square inch. In 1931, the engine was said to be in good order, pumping eight gallons of water per stroke, at six strokes per minute. It worked 4 ½ hours a day, seven days a week, coal consumption being 3 tons a week. It closed around the early 1930s. If ever a site deserved preservation, this did – an amazing glimpse into early mining technology.

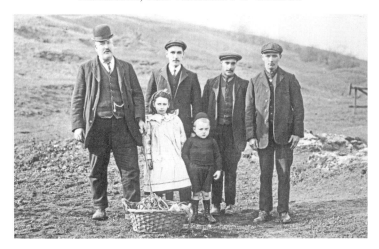

On 28 February 1910, Sarah Leech, aged eight, and Jack Bowler, aged five, were playing in a field at Glasshouse Fold, Denton, and fell down an overgrown part-filled old colliery shaft. They were down the shaft for 16 ½ hours. They were overheard by two men, who hauled them out in the basket seen in the photograph. The main search party had moved away from the area and had nearly given up hope of finding the children. One can only wonder how many bodies lie today at the bottom of the hundreds of thousands of old shafts in Britain considering the age of the industry.

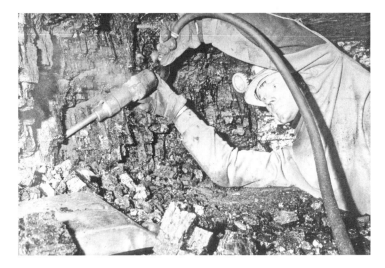

Geoffrey Du Feu works his compressed-air pick on the Compstall Two Feet seam (actually 1 foot 8 inches) at Ludworth Moor Colliery near Marple, Cheshire, in 1981. In 1938, the colliery was operated by Ludworth Moor Fireclay & Coal Co., Clough End, Marple, two miners below ground and one surface worker. In 1947, Ebor Mullineux operated the pit with two miners at work and no surface workers. For many years after this time, this small, licensed pit had been worked by just one man, Alf Gee. Alf used to go down, break the coal down, fill a tub, then push it out to the surface. Locals knew roughly when he would come out and would buy coal off him. Geoff Du Feu worked the mine with Rod Thackray in 1981, filling a shallow tub of about 1- to 2-hundredweight capacity, which was then wound out. Owners at various times of Ludworth Moor and adjacent panels of coal include A. Wozencroft 1927-32, F. Massey 1932-45, Ebor Mullineux 1940-50, J. Grogan 1950-53, Alf Gee 1953-69, Alf Gee 1972-77, Geoff Du Feu 1978-81. (Alan Davies, 1981)

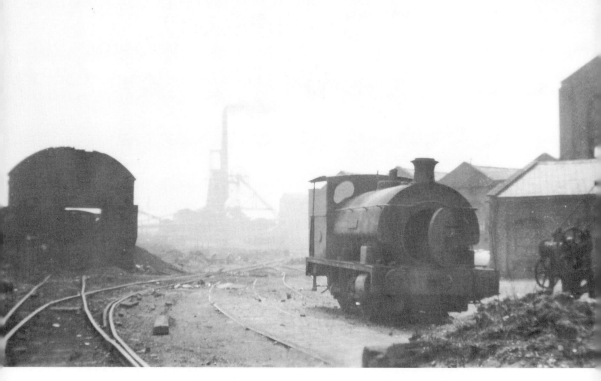

A distant view of Moston Colliery No. 4 upcast and No. 3 downcast, Moston, north-east Manchester, in May 1948. Sadly for such a large colliery, good close-up photographs are rare. The pit was situated alongside the Manchester to Middleton line near Nuthurst Road and Woodstock Road. Mining around the area of Moston dated back to around 1595 when disputes begin to arise (the Theyle Moor case). The serious sinking of deep shafts on site dates back to the 1820s. Heavily watered strata created major problems for these early shaft sinkers. On completion of a third shaft in 1850, the first was abandoned. The Oldham firm of Platt Brothers (1821) were in total control of the pit by 1877. Just to the right of this photo was the old Moston No. 1 Pit abandoned in 1884 after a major inundation of water. Two new shafts were sunk in 1887. By 1943, 639 miners and 165 surface workers were employed. On nationalisation in 1947, the colliery employed 537 miners and 204 surface workmen, the seams worked being the Big, Colonel and Foxholes. Loco *Westwood* is in for a spring repair to the right. Built for the colliery by Hudswell, Clarke & Co., Leeds, No. 1036, in 1913. After 1947, the loco worked at a number of collieries in the area before finally being moved to Ravenhead Colliery, St Helens, in 1967. Ravenhead closed on 18 October 1968 and the locomotive was scrapped on site the following month. One nameplate and a maker's plate off this loco were sold in 2008 for £800. Moston colliery closed in June 1950, raising 121,776 tons in its final year.

A highly ornamental letterhead for Sowerbutts Ltd Coal Merchants of Stockport dated 30 September 1940. The colliery depicted is probably stylised. The term high class probably relates to the prized Roger seam (the Arley in the west of the coalfield). The company had an office at the Manchester Coal Exchange. The Fuel and Lighting (Coal) Order 1941 came into force in January 1942 to offset the impact on coal output of skilled miners heading off to the forces. Coal output from Lancashire, Cheshire and North Wales dropped from 16,985,900 tons in 1939 to 12,354,100 tons in 1945. British coal output dropped from 231,337,900 in 1939 to 174,657,900 tons in 1945. The making of 'coal bricks' and 'coal eggs', or briquettes from coal dust was increased. Central heating was prohibited in the summer months, i.e., 29 July to 29 August. Domestic coal was rationed to 15 hundredweight a year (1 cwt = 112lbs, 20 cwt = 1 ton) for those in London and the south of England; 20 hundredweight for the rest due to the colder climate. Some kinds of coal, such as anthracite, were strangely not rationed, and even in coal-mining areas were eagerly sought after as in the First World War era. Coal rationing lasted until 1958.

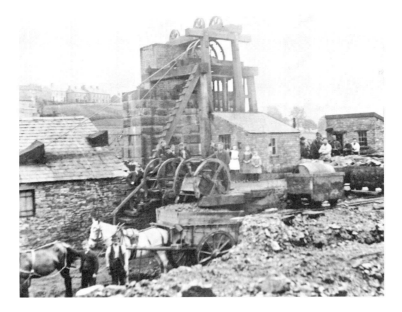

Wharf Pit, Whaley Bridge, Cheshire. A fascinating view of an early 'home-made' type of colliery layout. Substantial timbers supporting the pulley sheaves, flat wire ropes passing over them emerging from the side of the engine house roof. Two tub tipplers loading directly into waiting carts. Wharf Colliery was north of the River Goyt and west of the LNWR line. Sunk around 1850 and owned for many years by L. & E. Hall, it was working in 1935 but is not shown in directories in 1936.

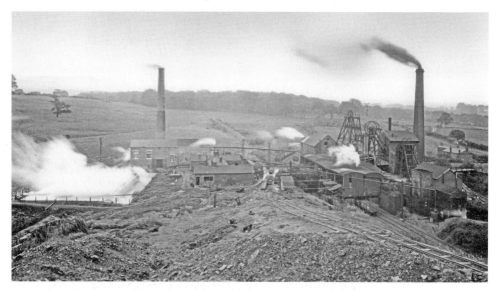

Park Pits, Poynton, Cheshire, in 1926. Not an area where you might expect a substantial colliery to have existed when passing through today's beautiful countryside. The industry is thought long established as a lease dated 28 February 1589 includes mention of a 'Coal pit at Wourthe [Worth] lately occupied by George Finche'. By 1847, eighteen new pits were either being sunk or winding coal in the area. Bagshaw's 1850 directory shows the Lord of the Manor as being firmly in control of the exploitation of the coal reserves; 'The Poynton and Worth Coal Mines, the property of, and worked by the Right Hon. George Warren Lord Vernon'.

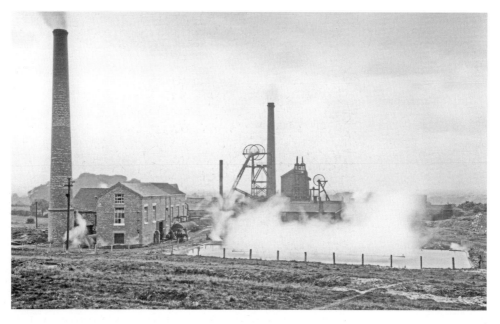

Park Pits, Poynton, Cheshire, in 1926. The two Park pits were initially very shallow, only 20 yards to work the 10-foot mine, 4-foot and 5-foot seams, although it was known that the 10-foot seam at 55 yards and the 5-foot at 170 yards existed. A new shaft was sunk from 1884. Pumping costs were the main reason for the Poynton area collieries closing, and on Friday 30 August 1935, 250 men working for the company were made redundant.

Opencast Mining

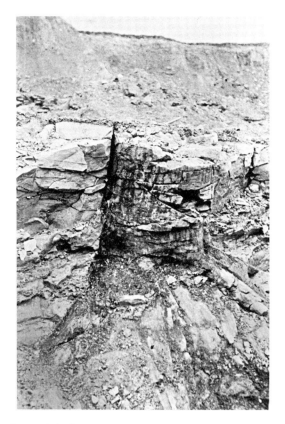

Even though the working of shallow or outcrop coal is ancient, opencast mining really developed in Lancashire and Britain in general during the Second World War as a boost to coal production. These workings were usually very shallow, often only 30 to 50 feet deep, gaining rapid access to the coal. Sadly, these early sites were not well documented photographically, often uncovering early, even ancient unrecorded workings. Interest in industrial archaeology was not as well developed as today. In the late 1920s, Mr Smith, the owner of the Swan Island quarry, opencast coal and brickworks, Atherton, at least took the trouble to record fossils he uncovered including this *Sigillaria* tree base with *Stigmarian* roots, 300 million years old.

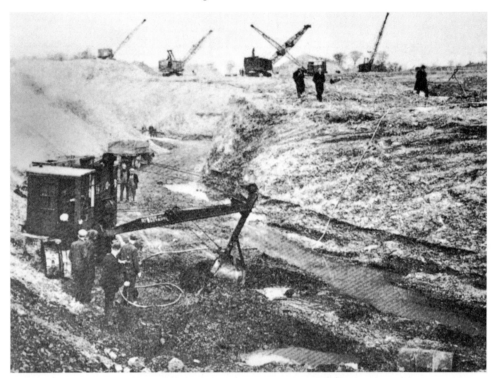

The Standish, near Wigan, opencast sites of 1943-45 were examples of the early 'strip'-type sites, shallow and often accessing outcrop coal. Here, a number of Ruston Bucyrus bucket-scraper cranes are at work. Around 200,000 tons of coal was extracted over the site's life from phased small extraction areas close to the eastern edge of Elnup Wood, Shevington.

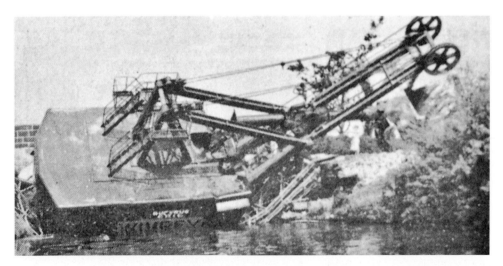

One of contractor Wimpey's huge (for the time) Ruston Bucyrus opencast excavators at 190 tonnes proves too much for Pendlebury Bridge, Haigh, near Red Rock, blocking the Leeds & Liverpool Canal. The area was opencasted on and off from 1945 to 1959. The quality of post-working landscaping was very poor, not an exact science at the time, the evidence is there for all to see today. With late-fourteenth-century workings within the Haigh estate, one can only imagine what ancient workings may have been uncovered and never recorded.

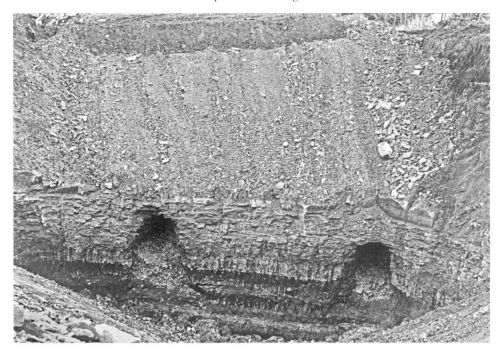

Over the years, an area of land may have been opencast mined a number of times. Early wartime sites were very shallow, sites being revisited and worked to greater depths, especially in the 1950s. The Windy Arbour Colliery site, south-east of Winstanley, Wigan (adjacent to the M6), has been worked and reworked in 1946, 1948, 1950-52, 1983 and 1999. In October 1983, old roadways, possibly of the 1950s in the King seam, were exposed, cratering upwards through the strata above. (Alan Davies, 1983)

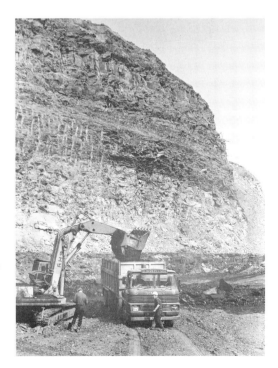

The 'hanging wall' at the 1982-84 Atherton, Millers Lane, opencast site was not far off 200 feet high at its greatest. The depth an opencast site works to is based on a number of aspects: the coal-seams available and their thickness, the quality of and price obtainable of the specific seams, the nature of the overburden (strata above the seams) of coal, the extent of expected old workings, the presence of major utilities passing through the site and many others. Here, the Bin seam coal is being loaded into one of Bradley's wagons. Today, coal is loaded after screening near the site offices, thus avoiding ordinary wagons potentially getting bogged down. (Alan Davies, 1984)

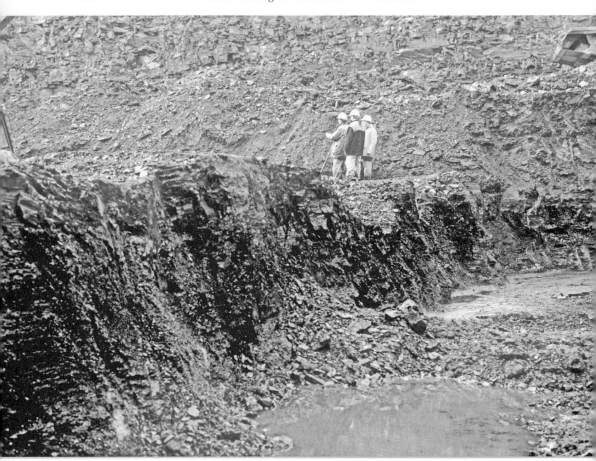

The site of the former Brackley Colliery, Little Hulton (closed May 1964) was opencasted in 1984-85 revealing unrecorded old workings in the prized Trencherbone seam. The seam outcropped to the north of the site and these old headings were getting very close to the outcrop. Probably dating to the late nineteenth century, they were probably driven 'on the sly' and not declared to the landowner, as they did not even feature in the abandonment plans for the Trencherbone seam. The seam, along with the Arley and Rams, was a high-carbon coal leaving little ash. Here, site visitors stand on top of the seam, which was about 5 feet 6 inches thick, dipping around 1 in 5 ½ from the NW to SE. (Alan Davies, 1985)

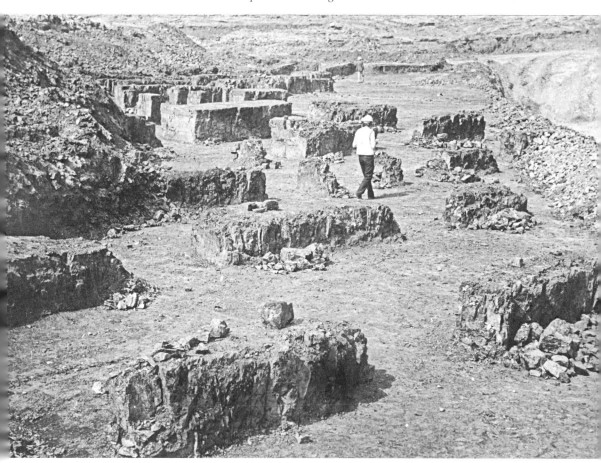

The Alexandra opencast site, Whelley, Wigan, of 1989 worked seams to the immediate north of the former colliery site. Being within the ancient Haigh estate where mining dates back, it is thought, to the late fourteenth century, old workings were only to be expected. Haigh was famous for its Cannel seam, mentioned by the itinerant Leland in 1540 as 'the choicest coal in England'. Cannel is very clean burning leaving virtually no ash, formed from settled lake sediments. Being very dense, it could be worked into ornaments and turned on lathes, keeping a few craftsmen in business in Wigan from the seventeenth to nineteenth centuries. Miners used to wear facemasks similar to fencers to protect themselves form the very sharp splinters the coal broke up into when worked with a pick. Here, pillars of Cannel in mid-eighteenth-century workings have been cleared by excavators. (Tony France, 1989)

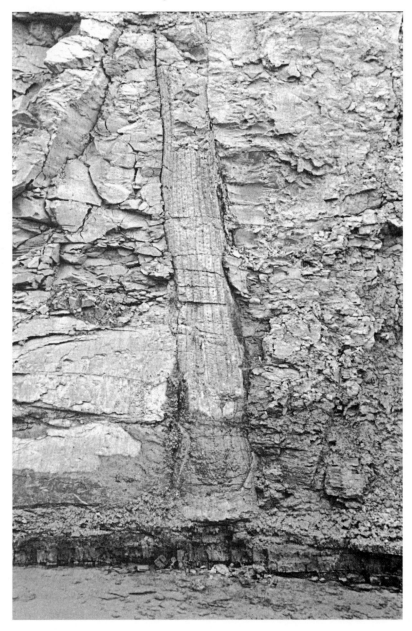

The Alexandra opencast site of 1989 became a Mecca for geologists and geology students due to the fossil horizons and standing trees exposed. On the western standing wall, a row of *Sigillaria* trees around 10 to 15 feet in height could be seen, stood on top of the Ashclough coal-seam. The clubmoss trees of the genus *Sigillaria* formed an important part of the coal swamps in the Late Carboniferous period. This example had been swamped by mud and silts 260-300 million years ago. *Sigillaria* was a tree-like plant, with a tall, sometimes-forked trunk lacking wood. Support came from a layer of closely packed leaf bases just below the surface of the trunk, while the centre was filled with pith. The old leaf bases expanded as the trunk grew in width, leaving a diamond-shaped pattern seen in fossils. The trunk had photosynthetic tissue on the surface, suggesting it was probably green. *Sigillaria* could grow up to 100 feet in height. The heavy rock bases of these fossil trees, hidden by thin roof coal left in place, often fell out of the roof at the coalface killing unwary miners. (Alan Davies, 1989)

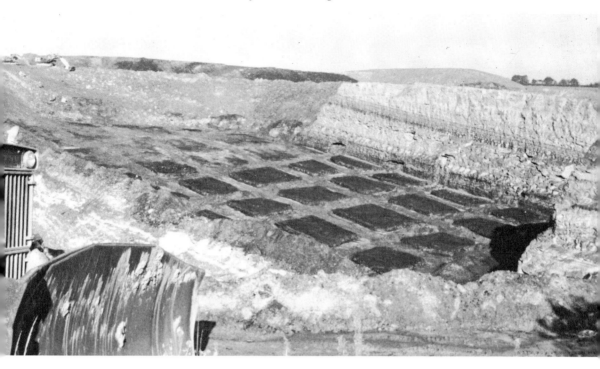

The north Leyland Green opencast site, Leyland Green, south of Winstanley, Wigan, of c. 1995 uncovered a superb example of pillar and stall workings with very large pillars left to support the roof. To have left such large pillars, the roof must either have been very poor or the colliery intended to rework the pillars with total extraction. This involved allowing the roof to collapse by removing supports in a controlled manner from the boundary of the coal panel. On the right boundary old roadways can just about be seen cratering upwards.

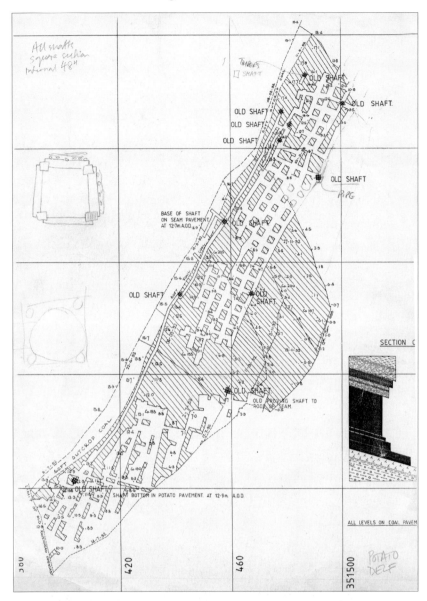

The St Helens Ravenhead/Timberyard/Greenbank land reclamation and opencast site of 1992-94 was the most spectacular as regards mining archaeology in the nearly forty years I have been recording sites in Lancashire. The credit for recognising this must go totally to the enthusiastic and skilled surveyor and site engineer, Fred Lowell. Fred had seen ancient old workings up in Scotland, where he originated from, and had a very keen eye for evidence of mining techniques and artefacts amongst the mud and rubble of the opencast site. He meticulously surveyed remaining pillars of coal using state-of-the-art laser equipment and also noted down features he felt he could interpret. The end result was a complete documentation of the site. Here is his plan of old workings in the Potato Delph seam, thought to be late sixteenth century. The shaded areas are solid coal. Fred has sketched top left a typical 4-foot-square timber-lined shaft, eleven were found just in this small area. His plan shows the coal to be not fully worked, possibly due to an inrush of water, an explosion or the inability of the tree-trunk water pump to cope with water ingress from the waterlogged surface drift sands into the steep workings. (Plan surveyed and drawn by Fred Lowell, 1993)

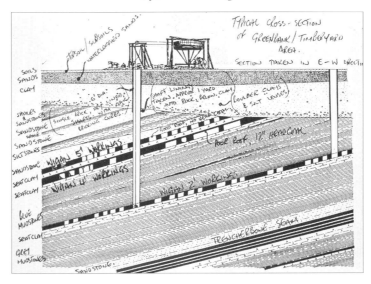

St Helens Greenbank/Timberyard opencast site (1992-94) site engineer Fred Lowell was talented in being able to visualise in 3-D a cross-section of the workings in the various seams present, based on the types of workings he had uncovered and his surveys. He noted that some seams (the Wigan Two Feet) had no pit props to support the roof, not being needed, whereas others (Wigan Five Feet and Four Feet) did. He also noted the geological succession of strata along the edge. Fred envisaged a horse winding gin in the late eighteenth century winding a shaft which accessed workings of that period. (Fred Lowell, 1993)

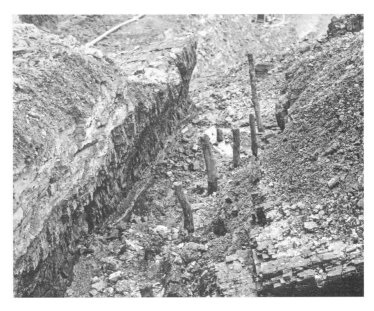

St Helens Timberyard opencast site (1992-94). Looking down into a roadway in the ancient (possibly late sixteenth century) Potato Delph workings, scoured clear after a downpour. By doing so, the props were left in place rather than being moved by the excavators. The silver birch props (still with their bark on) were centrally placed and the roadway was arched in solid coal, pointing to great age. Arched roads were based on architectural practice before the days of developed mining knowledge and organised timber support systems. (Alan Davies, 1994)

St Helens Timberyard opencast site (1992-94). At the lowest point in the Potato Delph workings, a pump shaft was found complete with bored-out tree trunks, shaped to fit into each other. An endless rope or chain with leather or rag-stuffed balls wrapped round it circulated the shaft. At the base, it entered the sump, pushing water up the pump tree pipe range. The water emerged at the surface to be channelled away. Here is the end tapered section of one of the pump trees which would locate into the adjacent one. The timber was as solid as the day it was worked. (Alan Davies, 1994)

Items found at the St Helens Timberyard opencast site (1992-94) were rescued and formed part of an exhibition at the Lancashire Mining Museum in 1995. Top left is a colliers side support stool, used as he lay down swinging his pick (Wigan Four Feet workings c. 1740), three wrought-iron coal wedges and hammer used to prise coal down after being undercut by pick (Wigan Four Feet workings c. 1740), early length of square section bar rail with chair (Wigan Four Feet workings c. 1740), four designs of miners tally sticks attached to baskets of coal so that the banksman on the surface would know whose coal was being sent up (Potato Delph workings around late sixteenth century), and a shoe sole from the same Potato Delph workings. (Alan Davies, 1995)

Items found at the St Helens Timberyard opencast site (1992-94) in the Wigan Four Feet workings of the 1740s. From the left: three wrought-iron coal wedges, a collier's pick, left still standing in an intact roadway leaning against the side. Top right is a coal 'riddle' or sieve frame for separating out small coal, left below ground in old roadways. Bottom right is a heavy stone pick for removing dirt bands or bringing roof rock down. (Alan Davies, 1995)

St Helens Timberyard opencast site (1992-94). The joint between two sections of eighteenth-century shaft curbing ring complete with carpenters marks, used when laying the complete circle out on the surface beforehand. Curbing rings were set into the rock every 6 feet or so as a base for bricking upwards to the previous one. In this way, there wasn't a lengthy and very heavy brick column in the shaft, which may come loose, the shaft sides caving in. The timbers, probably oak, were as solid as the day they were cut. (Alan Davies, 1995)

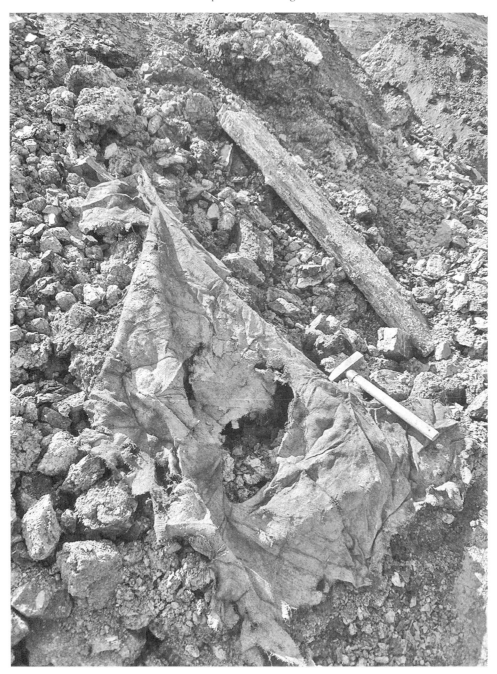

This may seem like a pile of rubbish to the less keen eyed, but my heart stopped when I spotted this ventilation 'brattice' sheeting near an old timber roof bar (the sheeting was rescued) at the UK Coal Cutacre opencast coal site, Little Hulton (2009-10) in early 2010. Seen amongst the debris of old Brassey seam workings of Wharton Hall Colliery dating back to the 1880s, this coarse textile sheet had been nailed to the roof timbers by a miner to divert the air flow to where it was needed. It is probably the only such example ever to have survived, normally having rotted away as the roadways flooded after the colliery closed. The roadways here had remained dry, being close to the surface. (Alan Davies, 2010)

Mines Rescue

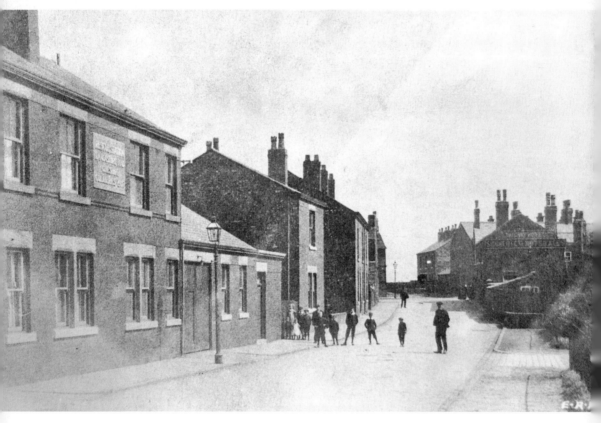

In 1886, a Royal Commission recommended the establishment of Mines Rescue Stations. By 1902, the first rescue station in Britain was set up at Tankersley near Barnsley, an adapted house. In 1906, a committee had been set up by the Lancashire & Cheshire Coalowners Association to enquire into rescue equipment and techniques which might be employed in an organised manner in Lancashire. The result was the establishment of the first purpose-built Central Mines Rescue Station at Lovers Lane, Howe Bridge, Atherton, in 1908 (on the left). This provided training and emergency cover for most of the Lancashire and Cheshire coalfield. The buildings survive today.

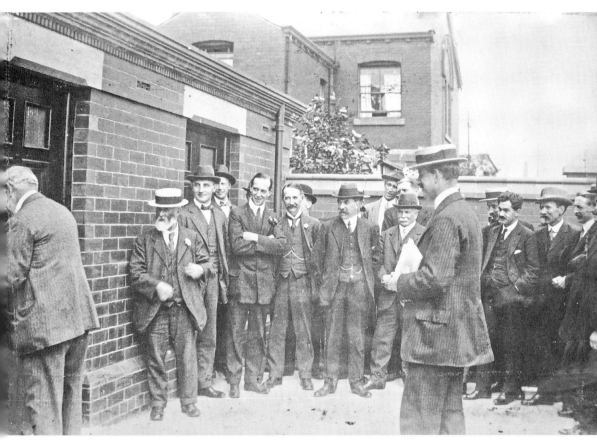

The official opening of Howe Bridge Rescue Station, 2 April 1908. The small man second left is John Gerrard, HM Inspector of Mines. He had the Maypole disaster, Abram, Wigan, (seventy-five killed) four months later to deal with, then Lancashire's greatest ever disaster at Pretoria Pit on 21 December 1910 (344 killed). Other mining VIPs present were W. Garforth, President of the Mining Association of Great Britain, Henry Hall, HM Inspector, scientist Dr Haldane, Charles Pilkington of Clifton & Kersley Collieries, Ralph Fletcher and J. S. Burrows of Atherton Collieries and others.

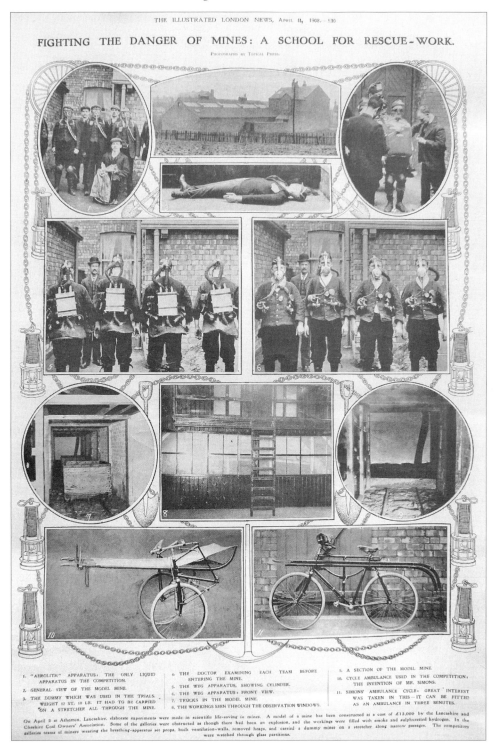

The *Illustrated London News*, 11 April 1908, ran a special feature on the opening of Howe Bridge Rescue Station with a full-page illustrated layout. At the top is the rescue station from behind, men displaying WEG breathing apparatus, the training galleries and an ingenious folding ambulance stretcher cycle.

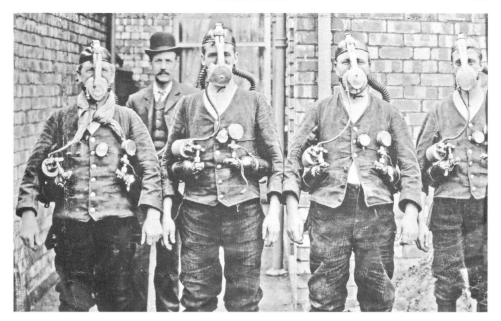

Howe Bridge Rescue Station. Miners trialling the WEG apparatus during the competition on the opening day. This was to find the equipment the committee felt most suitable to use at the station and on call out. Others included Siebe Gorman's Fleuss, Draeger, Clarke Steavenson and Valor designs. The Fleuss 'Proto' apparatus came out that winner.

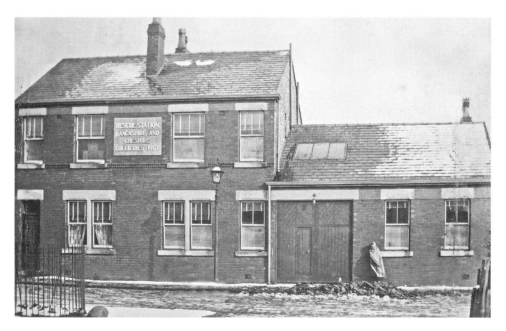

This lady with distinctive shawl is standing outside the newly opened Howe Bridge Rescue Station, Thursday 2 April 1908. A wintry day with snow on the ground, the coal delivery has just been tipped in front of the lady on the road. Nothing spectacular about the architecture, basically a couple of terraced houses with a large shed behind, but this was state of the art at the time and of national importance. The building was completed in late 1907 hence the date board predating the opening.

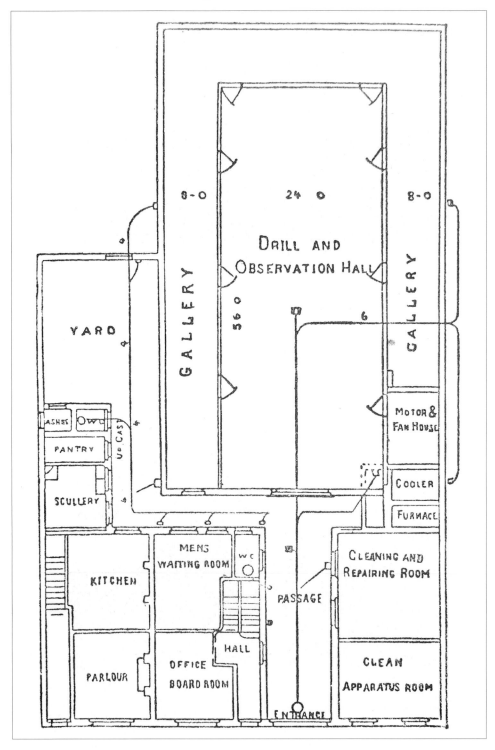

Howe Bridge Rescue Station layout 1908. Rooms for maintaining and cleaning breathing apparatus, a main drilling and practice observation area, and training gallery tunnels which could be light-free and filled with obstructions and fumes. Eight doors allow various stages of an exercise in the galleries to be observed by instructors and men in the observation hall.

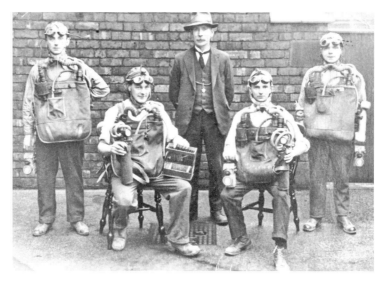

Denton Collieries rescue team after a training session at Howe Bridge Rescue Station in 1921. The men are wearing 'Proto' re-breathing apparatus. This could be used for a minimum period of two hours' hard work. The wearer breathed the same air repeatedly. At each exhalation, the air was purified of its carbon dioxide via absorbent caustic soda. Immediately before inhaling again, a small amount of oxygen was added to the purified exhaled air, to take the place of the oxygen absorbed into the body at the previous breath. The men have early electric rechargeable hand lamps; the second man from the left has a canary cage in his hand. The canary dropped off its perch before a man would pass out through the presence of carbon monoxide, signalling a retreat to the fresh-air base. It was to be 1987 before Proto sets were replaced with SEFA sets (see later).

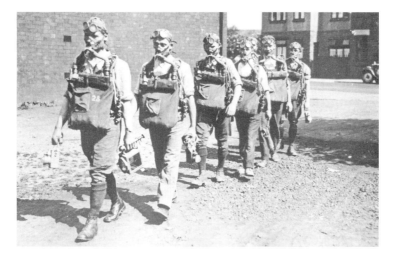

In 1932, a permanent full-time rescue brigade for the coalfield was established at Howe Bridge Rescue Station. Here they are having a training walk near the station with their apparatus donned. These men might have to enter a mine on fire with dense fumes, full of gas or low in oxygen after an incident, wearing breathing sets. Working through a mass of damaged ironwork and equipment to reach men took nerves of steel, strength and stamina. To get the 'dead weight' of a casualty still alive to the fresh-air base, up and down inclines and over rough ground was challenging to say the least.

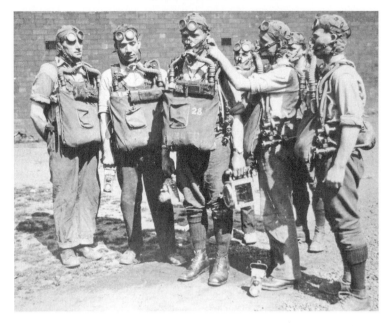

Mines rescue men have always relied on each other to check the fitting of and set-up of their breathing sets. The man being checked at Howe Bridge in 1932 is carrying a canary reviving cage with combined oxygen cylinder and also an electric hand lamp of a 'bulls eye' type designed by Barnsley firm CEAG. By 1932, animal rights groups had insisted that the canaries be revived after passing out due to carbon monoxide poisoning. The result was the carrying of a heavy metal cage as compared to the old lightweight wooden cage.

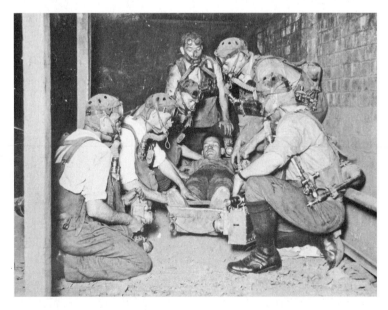

Rescue men in the side training gallery at Howe Bridge Rescue Station in 1932 place a man in the stretcher while wearing their breathing apparatus. The stretcher is a lightweight alloy semi-circular design with four carrying shackles. A year after this photograph was taken, the new Boothstown Mines Rescue Station, Ellenbrook Road, close to the new East Lancashire Road (A580) opened becoming the Central Rescue Station for the Lancashire Coalfield.

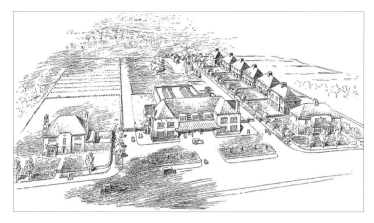

Boothstown Mines Rescue Station, Ellenbrook Road, Boothstown, Worsley, featured in the opening ceremony brochure of November 1933. The superintendent's house is to the left, the main station, with garage at the front and training galleries behind, is central, and the permanent rescue men's houses are to the right. Allotments were provided for the men (top left). If I must claim fame for anything, it was being instrumental in securing conservation status for the site, which British Coal would have demolished. The finest former mines rescue station in Britain is now listed.

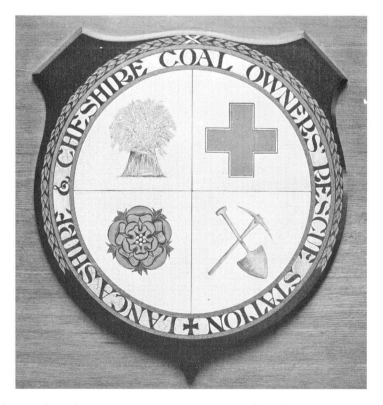

The boardroom of Boothstown Mines Rescue Station was furnished with the best Waring & Gillow of Lancaster tables and chairs, Gillows also making the snooker table in the men's rest room. In the boardroom was this wooden painted plaque dating back to the station opening in 1933. (Alan Davies, 1994)

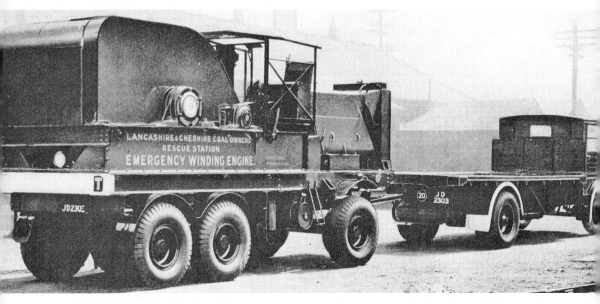

The anticipated war and the aerial threat to surface structures at British collieries, especially winding headgears, were assessed in 1939. The Lancashire & Cheshire Coal Owners Association asked Walker Bros of Wigan to design a mobile winding engine, delivered to Boothstown Rescue Station in early 1940 (photographed there in September 1940). This weighed 24 tons and was towed by a standard Walker's wagon. The tyred road wheels could be removed to reveal standard-gauge railway wagon wheels on the same axle. The winder had a 4-foot-diameter, cast steel parallel drum with 1,250 yards of 5/8-inch diameter locked-coil, steel winding rope. Power came initially from a 205-hp Gardners of Patricroft diesel engine. All the usual safety and warning devices found on winding engines at collieries, including overspeed, overwind and slow banking equipment were present, including a depth indicator and electronic signalling system. The towing wagon carried two steel 'hoppits', one of which could carry eight men and the smaller four men. When rigged up for winding, the hoppit chains and plate were attached to an Ormerod detaching hook in case of overwind. For refresher training purposes or attending old shafts, a small, wooden headgear complete with a single pulley could be erected over a shaft at a disused colliery, Ashtons Field, Little Hulton, for example. The winder can be seen at the Astley Green Colliery Museum, although not yet restored (2010).

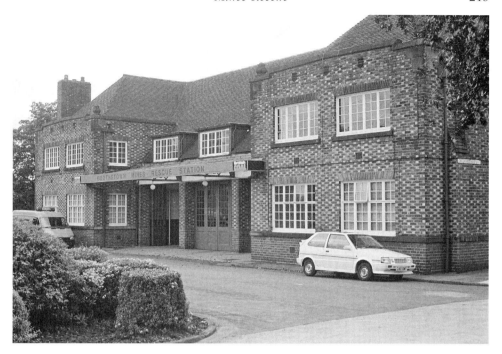

A view of the front of Boothstown Mines Rescue Station after the closure announcement of early 1994. Architects Bradshaw, Gass & Hope of Bolton, 1933. (Alan Davies, 1994)

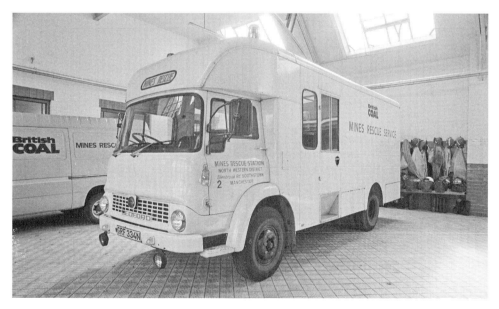

Boothstown Mines Rescue Station, 1994. A Bedford truck specially kitted out for attending incidents, its license issued in Sunderland between August 1974 to July 1975. Some of the older vehicles at Boothstown headed off to Chatterley Whitfield Mining Museum, Stoke-on-Trent. That museum closed in 1991, resulting in material from Boothstown being auctioned off, an unprecedented tragedy in mining history terms. The volunteers at Astley Green Colliery raised funds, added Science Museum, London, funds and purchased the Mobile Emergency Winding Engine. (Alan Davies, 1994)

Boothstown Mines Rescue Station, 1994. A view into Orchard Avenue, off Ellenbrook Road. One of the two instructors' semi-detached houses is on the right. The men in the permanent corps occupied the six pairs of semi-detached properties. Now an architectural conservation area. (Alan Davies, 1994)

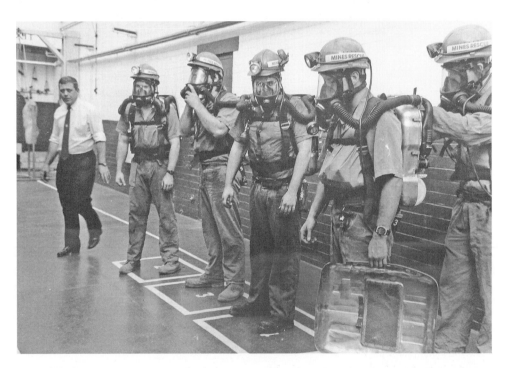

One of the last teams ever on a refresher course at Boothstown Mines Rescue Station a few months before closure in 1994. The men are equipped with SEFA breathing sets (Selected Elevated Flow Apparatus). This was developed by British Coal Mines Rescue Service and Sabre Safety of Aldershot, introduced at Boothstown in 1987. Total weight was around 33 lb, fully charged. The set gave two hours plus thirty minutes minimum reserve. Being permitted for use underwater, teams from Boothstown occasionally held exercises at Worsley Pool. To the left is experienced senior instructor Graham Gannon. Graham was very keen to record the activities of the station for posterity, allowing me to visit many times. (Alan Davies, 1994)

APPENDIX

Mining Deaths, Accidents and Disasters in the Coalfield

Parish Registers were first ordered to be kept by Thomas Cromwell, Vicar General of King Henry VIII in 1538. The majority of registers just recorded the death but occasionally the cause of death was also added:

> 21 Nov 1622 Ffrancis Taylior of Bradford [Manchester] killed with a fall to … coale pitte, was buried at Manchester Collegiate Church [Manchester Cathedral].
> 16 Jan 1661 or 1662 Thos. son to John Hilton slaine at Bradford coal pitt.
> 10 Nov 1664 Thos. Greene slaine at Bradford coal pitt.

Records start to appear in the Wigan All Saints burial registers from the 1670s onwards of individuals being killed by falls of coal at the coalface, explosions, suffocation or even by falling down shafts. Over the centuries, thousands of individual men, women and children have died in the Lancashire and Cheshire collieries, their causes of death going unrecorded. The following list focuses on multiple deaths which newspapers or the concerned felt the need to highlight. After 1850, the Mines Inspectorate documented mining deaths, although often individuals featured as a statistic, being commonplace.

ALKRINGTON. Nr Middleton, 2 June 1774;
 'a terrible accident happened at Alkrington coalpit by the works falling in owing to the negligence of one of the workmen by which three of the Poor Coaliers were terribly hurt, limbs and back broak and other ways sadly bruised so that their lives were dispared of …'
WHISTON, June 1806.
 Explosion, sixteen killed.
PEMBERTON, Wigan, 24 April 1830.
 Explosion, nine killed.
HAYDOCK, Haydock, May 1831.
 Explosion, possibly twelve killed.
HAYDOCK, Haydock, September 1832.
 Explosion, six killed.
LITTLE LEVER, Bolton, 1835.
 Approximately seventeen killed, inrush of water from the river.
UNNAMED, Wigan, 1835.
 'Considerable' number of lives lost.
BLACKROD, Bolton, 6 October 1836.
 Twelve killed.

RUSHY PARK, St Helens, June 1838.
Explosion, six killed.

WINSTANLEY, Wigan, 20 November 1843.
'Several killed'.

NEWTON, Haydock, 5 November 1845.
Explosion, thirteen killed.

BURGH, Coppull, 24 November 1846.
Eight killed.

PARR, St.Helens, January 1847.
Explosion, five killed.

WESTLEIGH, Leigh, 28 January 1847.
Explosion, five killed.

GERARDS BRIDGE, St. Helens, 2 June 1847.
Explosion. Eight men and boys killed.

KIRKLESS HALL, Wigan, 28 June 1847.
Fire after shotfiring, thirteen killed.

INCE HALL, Wigan, 30 November 1847.
Inrush of water. Six men and boys killed.

VICTORIA PIT, Dukinfield, 23 February 1848.
Explosion, seven killed.

ALBION, Hindley Green, 28 August 1848.
Explosion, five killed.

SENELEY GREEN, Ashton-in-Makerfield, 24 October 1848.
Explosion, five killed.

VICTORIA, Ashton-under-Lyne, February 1849.
Explosion, five killed.

BIRD-IN-TH'-HAND, Eccleston, 26 February 1849.
Explosion, seven killed.

INCE HALL, Middle Patricroft Pit, Hindley, 6 March 1849.
Explosion, twelve killed.

LAFFACK, St Helens, 23 June 1849.
Explosion, eight killed.

CHOWBENT, Gib Field Pit, Atherton, 11 February 1850.
Explosion, five killed.

ROCK PIT, Haydock, March 1850.
Explosion, thirteen killed.

TOWN HOUSE, Burnley, 12 April 1850.
Explosion, six killed.

BENT GRANGE, Oldham, 9 October 1850.
Explosion, seventeen killed.

HAYDOCK No.13, Haydock, 8 November 1850.
Explosion, ten killed.

HEYS, Ashton-under-Lyne, 17 March 1851.
Explosion, six killed.

INCE HALL, Wigan, 22 December 1851.
Explosion, thirteen killed.

ROSCOE'S, Rochdale, 18 February 1852.
Inrush of water, eight killed.

NORLEY, Wigan, 24 April 1852.
Explosion, twelve killed.

COPPULL, Coppull, 20 May 1852.
Explosion, thirty-six killed.

INCE HALL, Wigan, 24 March 1853.
 Explosion, fifty-eight men and boys killed.
BENT GRANGE, Oldham, 1 July 1853.
 Explosion, twenty killed.
INCE HALL, Wigan, 18 February 1854.
 Explosion, eighty-nine killed.
BELLFIELD, Rochdale, 11 November 1854.
 Shaft accident, seven men and boys killed.
TOWNHOUSE, Burnley, 13 November 1856.
 Explosion, five men killed.
HINDLEY, Wigan, 26 April 1857.
 Explosion, nine men and boys killed.
BARDSLEY, Nr Oldham, 2 February 1858.
 Explosion. Fifty-three killed.
YEW TREE, Tyldesley, 11 December 1858.
 Explosion, twenty-five men and boys killed.
AGECROFT, Pendlebury, 4 January 1859.
 Overwind, seven killed.
WINSTANLEY, Wigan, 3 August 1860.
 Explosion, thirteen men and boys killed.
LINNYSHAW, Worsley, 27 February 1861.
 Explosion, eight killed.
SHEVINGTON, Wigan, 1 November 1861.
 Explosion, fifteen killed.
BLACKLEYHURST, Ashton-in-Makerfield, 1 July 1864.
 Cage collision in the shaft, six killed.
DOUGLAS BANK, Wigan, 4 January 1865.
 Shaft collapse, five sinkers killed.
CALIFORNIA, Aspull, 12 September 1865.
 Winding rope accident, eight killed.
HIGH BROOKS, Ashton-in-Makerfield, 23 January 1866.
 Explosion, thirty killed.
GARSWOOD PARK, Ashton-in-Makerfield, 4 May 1866.
 Explosion, sixteen killed.
BANK, Little Hulton, 10 December 1866.
 Explosion, eight killed.
MESNE LEA, Worsley, 30 May 1867.
 Explosion, seven killed.
VICTORIA PIT, Dukinfield, Cheshire, 14 June 1866
 Explosion, thirty-eight men and boys killed.
GARSWOOD PARK, Ashton-in-Makerfield, 20 August 1867.
 Explosion, fourteen killed.
HINDLEY GREEN, Wigan, 25 November 1868.
 Explosion, sixty-two killed.
NORLEY, Wigan, 21 December 1868.
 Explosion, eight killed.
QUEEN PIT, Haydock, 26 December 1868.
 Explosion, twenty-six killed.
RAINFORD, Rainford, 16 January 1869.
 Fire then explosion, eight killed.
HIGH BROOKS, Ashton-in-Makerfield, 1 April 1869.
 Explosion, thirty-seven killed (twenty-nine in the disaster, eight due to injuries later).

QUEEN PIT, Haydock, 21 July 1869.
 Explosion, fifty-nine killed.
LOW HALL, Wigan, 15 November 1869.
 Explosion and fire, twenty-seven killed.
BRYN HALL, Ashton-in-Makerfield, 2 June 1873.
 Explosion, six killed.
MESNES, Barebones Pit, Wigan, 21 November 1873.
 Explosion, seven killed.
ASTLEY DEEP, Dukinfield, Cheshire, 14 April 1874.
 Explosion, fifty-four killed plus one rescue man.
INCE HALL, Saw Mill Pit. Wigan, 18 July 1874.
 Explosion, fifteen killed.
ALEXANDRA, Wigan, 4 December 1875.
 Cage collision, seven killed.
STONEHILL, Farnworth, 23 January 1877.
 Fire, eighteen killed.
FOGGS, Darcy Lever, 7 February 1877.
 Fire, ten killed.
GREAT BOYS, Tyldesley, 6 March 1877.
 Explosion after shotfiring, six killed.
PEMBERTON, Wigan, 11 October 1877.
 Explosion, thirty-six men and boys killed.
WHISTON, Whiston, 17 February, 1878.
 Explosion, seven killed.
UNITY BROOK, Kersley, 12 March 1878.
 Explosion, forty-three killed.
WOOD PIT, Haydock, 7 June 1878.
 Explosion, 189 men and boys killed.
ALEXANDRA, St Helens, 22 October 1879.
 Overwind, seven killed.
KERSLEY, Kersley nr Farnworth, 24 December 1879.
 Explosion, eleven men and boys killed.
ABRAM, Wigan, 19 December 1881.
 Explosion, forty-eight killed.
NELSON, Tyldesley, 2 October 1883.
 Winding rope broke, six men killed.
MOORFIELD, Accrington, 7 November 1883.
 Explosion, sixty-eight men and boys killed.
CLIFTON HALL, Manchester, 18 June 1885.
 Explosion, 178 men and boys killed.
BEDFORD, Wood End Pits, Leigh, 13 August 1886.
 Explosion, thirty-eight killed.
DOUGLAS BANK, Wigan, 6 April 1888.
 Shaft sinking accident, five killed.
HYDE, Hyde, Cheshire. 18 February 1889
 Explosion, twenty-three killed.
BAMFURLONG, Ashton-in-Makerfield, 14 December 1892.
 Fire, sixteen killed.
SHAKERLEY, Tyldesley, 1 October 1895.
 Explosion, five killed, manager, undermanager, two deputies and a day wage man.
WESTLEIGH, Leigh, 20 February 1896.
 Winder wound men wrong way, cage detached, eight killed.

OLD BOSTON, Haydock, 29 June 1900.
 Outburst of gas during shaft sinking, eight killed.
GARSWOOD HALL, Ashton-in-Makerfield, 2 April 1902.
 Explosion, fourteen killed.
BOLD, St Helens, 20 January 1905.
 Overspeed during winding, five killed.
NEW BOSTON, Haydock, 16 July 1905.
 Roof fall, five killed.
FOGGS, Darcy Lever, Bolton, 4 October 1907
 Shaft cage collision, ten killed.
MAYPOLE, Abram, nr Wigan. 18 August 1908.
 Explosion, seventy-five killed.
HULTON No. 3, Pretoria Pit, Over Hulton nr Atherton, 21 December 1910.
 Explosion of gas and coal dust, 344 men and boys killed.
CRONTON, Widnes, 11 December 1917.
 Explosion, eight killed.
PENDLETON, Pendleton, 4 November 1925.
 Sudden upheaval of floor, emission of gas and explosion, six killed.
LYME PIT, Haydock, 26 February 1930.
 Explosion, five killed.
BICKERSHAW, Leigh, 10 October 1932.
 Overwind, men in bottom cage plunged into shaft sump, nineteen drowned.
EDGE GREEN, Garswood Hall No. 9, Ashton-in-Makerfield, 12 November 1932.
 Explosion, twenty-five killed.
BICKERSHAW, Leigh, 30 April 1934
 Shotfiring explosion, six killed.
ASTLEY GREEN, Tyldesley, 7 June 1939.
 Fire after shotfiring, six killed.
JOHN PIT, Standish nr Wigan, [?] 1941.
 Explosion due to shotfiring, two killed.
BICKERSHAW, Plank Lane. Leigh, 7 January 1942.
 Explosion while sealing off district, five killed.
GIANTS HALL, Wigan, [?] 1944.
 Explosion after shotfiring, two killed.
LYME PIT, Haydock, 16 September 1949.
 Explosion after sealing off district, two rescue men killed.
MOSLEY COMMON, nr Tyldesley, [?] 1952.
 Manriding train accident, two killed.
MAINS COLLIERY, Wigan, 1954.
 Explosion, two killed.
CHANTERS, Atherton, 6 March 1957.
 Explosion, eight killed.
PARKSIDE, Newton le Willows, nr Leigh, [?] 1957.
 Shaft sinking accident, two killed.
BICKERSHAW, Leigh, 10 October 1959.
 Heating, five killed including two members of the Boothstown Mines Rescue team.
HAPTON VALLEY, Burnley, 22 March 1962.
 Explosion, nineteen killed.
GOLBORNE, Golborne, 18 March 1979.
 Explosion, ten men killed.

Bibliography of Consulted Works and Other Sources

Research material on coalmining in Lancashire and Cheshire compiled by Alan Davies, 1970 onwards, from all manner of sources.

The History of the British Coal Mining Industry. Vol. 1. Before 1700. Dr J. Hatcher, (Oxford UP, 1993).
The History of the British Coal Mining Industry. Vol. 2. 1700-1830. M. W. Flinn, (Oxford UP, 1984).
The History of the British Coal Mining Industry. Vol. 3. 1830-1913. R. Church, (Oxford UP, 1986).
The History of the British Coal Mining Industry. Vol. 4. 1913-1946. Prof. B. Supple, (Oxford UP, 1987).
The History of the British Coal Mining Industry. Vol. 5. 1946-1982. W. Ashworth, (Oxford UP, 1986).

Anderson, Donald, *The Orrell Coalfield* (Moorland, 1975).
Anderson, Donald, *Coal - A Pictorial History of the British Coal Industry* (David & Charles, Newton Abbot, 1982).
Anderson, Donald, & Lane, J., *Mines and Miners of South Lancashire 1870-1950*, (Donald Anderson, 1980).
Arnot, R., *The Miners, A History of the Miners Federation of Great Britain, 1889-1910* (Allen & Unwin, London, 1949).
Arnot, R., *The Miners, The History of the Miners Federation of Great Britain, from 1910 onwards* (Allen & Unwin, London, 1953).
Arnot, R., *The Miners, In Crisis and War from 1930 onwards* (Allen & Unwin Ltd).
Ashton, T. S., & Sykes, Joseph, *The Coal Industry of the Eighteenth Century* (Manchester University Press, 1964).
Benson, Neville and Thompson, *Bibliography of the British Coal Industry* (Oxford UP, 1981).
Bulman, H. F., *Coal Mining and the Coal Miner.* Methuen & Co.. London, 1920.
Bulman, H. F. & Redmayne, R. A. S., *Colliery Working and Management* (3rd edn., 1912).
Burton, Anthony, *The Miners* (Futura, London, 1977).
Challinor, R., *The Lancashire and Cheshire Miners* (F. Graham, Newcastle 1972).
Crofton, H. T., *Lancashire & Cheshire Coalmining Records* (trans. *Lancashire and Cheshire Antiquarian Society*, 1899).

Davies, Alan, *The Wigan Coalfield* (Tempus, 1999-2009).
Davies, Alan, *The Pit Brow Women of the Wigan Coalfield* (Tempus, 2006).
Davies, Alan, *The Atherton Collieries* (Amberley, 2009).
Duckham, Helen and Baron, *Great Pit Disasters – Great Britain, 1700 to the present day* (David & Charles, Newton Abbot 1973).
Dunn, Matthias, *A Treatise on the Winning and Working of Collieries* (2nd edn, Newcastle upon Tyne, 1852).
Ezra, Sir Derek, & Others, *Coal - Technology for Britain's Future.* (Macmillan, London, 1976).
Galloway, R. L., *A History of Coal Mining in Great Britain*, (1882, Repr. David & Charles, 1969).
Galloway, R. L., *Annals of Coal Mining and the Coal Trade*, 2 vols. (1898, Repr. David & Charles, 1971).
Griffin, Dr A. R., *Coal Mining* (Longman, 1971).
Grimshaw, Peter, *Opencast Coalmining in Britain 1942-1991* (British Coal Opencast 1992).
Hayes, Geoff, *Collieries in the Manchester Coalfields* (Landmark, 2004).
Hickling, George, *Lancashire Sections of Strata* (Lancs & Cheshire Coal Association 1927).
Holland, John, *Fossil Fuel, the Collieries and Coal Trade* (1841).
Holland, John, *The History & Description of Fossil Fuel, The Collieries, & Coal Trade of Great Britain* (Whittaker & Co., London, 1835).
Howarth, Ken, *Dark Days* (Greater Manchester County Council, 1978).
Lewis, B., *Coal mining in the Eighteenth and Nineteenth Centuries* (Longmans, London, 1971).
Mining Association, *Historical Review of Coal Mining* (Fleetway, c. 1924).
Nef, J. U., *The Rise of the British Coal Industry* (1932, Routledge, 1952).
Nelson, A., *Dictionary of Mining* (George Newnes, 1964).
Pamely, Caleb, *The Colliery Manager's Handbook* (Crosby Lockwood c. 1904).
Percy, C. M., *Mining in the Victorian Era* (Thos Wall & Sons Wigan, 1897).
Preece, G., *Coalmining* (City of Salford Cultural Services Dept, 1981).
Raistrick & Marshall, *The Nature & Origin of Coal & Coal Seams* (Engish Univ. Press, 1939).
Redmayne, R. A. S., *Men, Mines and Memories* (Eyre & Spottiswood, 1942).
Redmayne, R. A. S., *Modern Practice in Mining series* (Longmans Green & Co., 1911).
Redmayne, R. A. S., *The Problem of the Coal Mines* (1945).
Sinclair, J., *Coal Mining Law* (Pitman, 1958).
Townley, Appleton, Peden, Smith, *The Industrial Railways of the Wigan Coalfield* series, parts 1 and 2, The Manchester Coalfield parts 1 and 2 (Runpast, 1994, 1995).

Catalogue of Plans of Abandoned Mines, HMSO 1928.
Colliery Year Book & Coal Trades Directories, 1943 to 1963.
Guide to the Coalfields (Colliery Guardian, 1948 to 1996).
Memoirs of the Geological Survey, HMSO, sheets 84/1938, 85/1931.
Colliery Guardian.
Lancashire and Cheshire Miners' Federation minutes.
Lancashire Record Office, estate deposits, NCB records.
Manchester Collieries Magazine 1944, 1945, 1946.
NCB Coal Magazine 1947-1960.
NCB Anderton House, Lowton archives (until c. 1989)

North Western Coalfields Regional Survey Report, Ministry of Fuel & Power, HMSO 1945.
Reports of The Inspector of Mines, 1850 onwards, HMSO.
St Helens Mining Society, Transactions 1954-1961
The Coal Authority Mining Record Office, Mansfield.
The Children's Employment Commission (Mines) 1842, HMSO London, 1842.
The National Archives London, NCB records.
Transactions of the Institute of Mining Engineers.
Transactions of Manchester Geological Society.

The Internet & Google, excluding Wikipedia!